Great Photographers

Other Publications:
THE CIVIL WAR
PLANET EARTH
COLLECTOR'S LIBRARY OF THE CIVIL WAR
LIBRARY OF HEALTH
CLASSICS OF THE OLD WEST
THE EPIC OF FLIGHT
THE GOOD COOK
THE SEAFARERS
THE ENCYCLOPEDIA OF COLLECTIBLES
THE GREAT CITIES
WORLD WAR II
HOME REPAIR AND IMPROVEMENT
THE WORLD'S WILD PLACES
THE TIME-LIFE LIBRARY OF BOATING
HUMAN BEHAVIOR
THE ART OF SEWING
THE OLD WEST
THE EMERGENCE OF MAN
THE AMERICAN WILDERNESS
THE TIME-LIFE ENCYCLOPEDIA OF GARDENING
THIS FABULOUS CENTURY
FOODS OF THE WORLD
TIME-LIFE LIBRARY OF AMERICA
TIME-LIFE LIBRARY OF ART
GREAT AGES OF MAN
LIFE SCIENCE LIBRARY
THE LIFE HISTORY OF THE UNITED STATES
TIME READING PROGRAM
LIFE NATURE LIBRARY
LIFE WORLD LIBRARY
FAMILY LIBRARY:
 HOW THINGS WORK IN YOUR HOME
 THE TIME-LIFE BOOK OF THE FAMILY CAR
 THE TIME-LIFE FAMILY LEGAL GUIDE
 THE TIME-LIFE BOOK OF FAMILY FINANCE

This volume is one of a series devoted to the art and technology of photography. The books present pictures by outstanding photographers of today and the past, relate the history of photography and provide practical instruction in the use of equipment and materials.

LIFE LIBRARY OF PHOTOGRAPHY

Great Photographers

Revised Edition

BY THE EDITORS OF TIME-LIFE BOOKS

TIME-LIFE BOOKS, ALEXANDRIA, VIRGINIA

Revised Edition. First printing.
Printed in U.S.A.
Published simultaneously in Canada.
School and library distribution by Silver Burdett
Company, Morristown, New Jersey 07960.

For information about any
Time-Life book, please write:
Reader Information, Time-Life Books,
541 North Fairbanks Court,
Chicago, Illinois 60611.

TIME-LIFE is a trademark of
Time Incorporated U.S.A.

Library of Congress Cataloguing in Publication Data
Main entry under title:
Great photographers.
 (Life library of photography)
 Bibliography: p.
 Includes index.
 1. Photography, Artistic. 2. Photographers.
I. Time-Life Books. II. Series.
TR650.G732 1983 779'.092'2 83-415
ISBN 0-8094-4440-2
ISBN 0-8094-4441-0 (lib. bdg.)

ON THE COVER: These great masters
span sevenscore years of photography
— from Hippolyte Bayard's earliest
experiments to Lee Friedlander's latest
urban landscape. In between came
Julia Margaret Cameron's serene
Victorian portraits, William Henry
Jackson's American frontier and Eugène
Atget's beloved Paris. Erich Salomon
and Henri Cartier-Bresson caught the
candid or decisive moment; Mathew
B. Brady and Donald McCullin, although
a century separated them, found a
common subject in warfare.

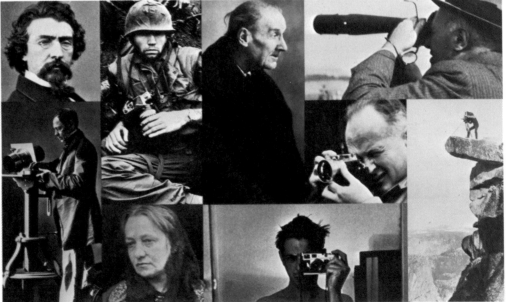

Mathew B. Brady Donald McCullin Eugène Atget Erich Salomon William Henry Jackson
Hippolyte Bayard Julia Margaret Cameron Lee Friedlander Henri Cartier-Bresson

Contents

Introduction		7
1840 to 1860	1	9
1860 to 1880	2	41
1880 to 1900	3	75
1900 to 1920	4	93
1920 to 1940	5	117
1940 to 1960	6	161
1960 to 1980	7	203
Bibliography		243
Acknowledgments and Picture Credits		245
Index		247

The 200-odd photographs in this book had to run an arduous gantlet of editorial selection. For each one that was chosen for publication, thousands were examined, some never before seen in this century. Those that survived represent the work of 83 great photographers; hence the title of the book.

What makes a photographer great? Not one great picture; hundreds of people, by design or by accident, have achieved or stumbled upon an image that others consider great. Rather, inclusion in this collection signifies that a photographer accumulated a body of great work during his career.

In photography, as in any field, greatness is a quality more easily demonstrated than defined. Yet in researching this volume, the editors encountered several factors that, taken in combination, appeared to form a definition.

The first is intent. What did the photographer have in mind? When Alexander Gardner shows us an empty Civil War battlefield, he intends us to feel the sense of loss and tragedy he found there; when Lewis W. Hine poses a child beside an open door he intends us to ask, "Where does the door lead?" And when Yousuf Karsh shows us the broad brow of Nikita Khrushchev he intends that we feel the public power, wisdom and aggressiveness that are stored up behind it.

The second factor is skill. A great photographer must be able to execute his intention. He has to master all the tools at his command. He must exploit the qualities of light and film; must understand human nature, and know how to be patient at one moment, spontaneous at another. Without these skills even the noblest intent is unfilled.

Finally, the great photographer must execute his intention with a consistency lesser photographers cannot approach. The great photograph is no accident in the hands of these men and women. Whenever possible, the editors have looked at the whole life's work of each photographer represented here: With only a few exceptions, the early pictures and the late ones share the successful mark of their maker.

Intent, skill, consistency: However different the photographers in this book seem, they all share these qualities.

None of the 83 great practitioners discussed in this book are from the staff of *Life*. It seemed inappropriate to mention them in a series of books that bears the magazine's name.

The Editors

The First Artists with a Camera 12

Albert S. Southworth and Josiah J. Hawes 14

Carl Ferdinand Stelzner 18

William Henry Fox Talbot 20

David Octavius Hill and Robert Adamson 22

Hippolyte Bayard 24

Charles Nègre 26

Gustave Le Gray 28

Philip Henry Delamotte 30

Thomas Keith 32

Maxime Du Camp 34

Francis Frith 35

Louis Auguste Bisson and Auguste Rosalie Bisson 36

Roger Fenton 38

Photographers represented in this chapter include: ▶

Albert S. Southworth	1
Josiah J. Hawes	2
Carl Ferdinand Stelzner	3
David Octavius Hill	4
Robert Adamson	5
William Henry Fox Talbot	6
Charles Nègre	7
Maxime Du Camp	8
Hippolyte Bayard	9
Philip Henry Delamotte	10
Thomas Keith	11
Gustave Le Gray	12
Francis Frith	13
Roger Fenton	14

(Not shown are Louis Auguste and Auguste Rosalie Bisson; no photograph of them is known to exist.)

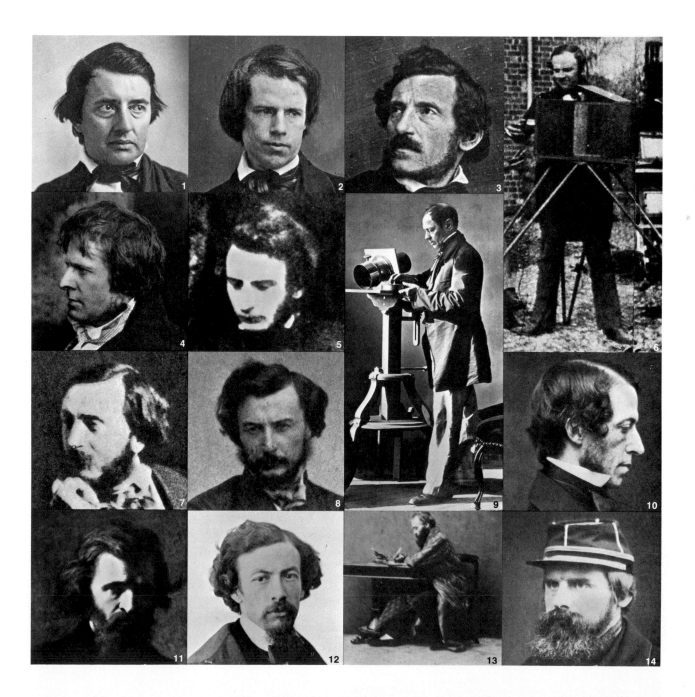

The First Artists with a Camera

An hour after the public announcement of Louis Daguerre's photographic process was made in Paris on August 19, 1839, opticians' shops all over the city were jammed with customers shouting out orders for picture-taking equipment. That was just the beginning: The popularity of photography increased so rapidly that in 1847, less than a decade later, 2,000 cameras and more than half a million photographic plates were sold in Paris alone. The excitement and the activity swept all over the world. In 1853, no fewer than 10,000 American daguerreotypists produced three million pictures. Londoners could rent a glass house for taking pictures and a darkroom for developing them, and the University of London added photography to its curriculum in 1856. A new vocation—and avocation—had been born.

It was an occupation of many facets and inexhaustible variations. It was open to people in all walks of life, a game any number could play. Many of its finest practitioners began as amateurs and quickly became professionals. It was an art that went hand in hand with scientific discoveries and technological developments.

The invention that began it all—the daguerreotype—was a silver-coated copper sheet that had been made sensitive to light, exposed in a camera and developed by mercury vapors. The image that materialized on the silvered surface had brilliant clarity and minute detail—detail that stood inspection under a magnifying glass. Its accuracy, hard to surpass even today, astounded and delighted the 19th Century public, for whom the exact, true-to-life reproduction of nature was the highest function of art. Here was a miraculous way to turn out anything that a painter could do—and do it faster, less expensively and more faithfully.

Many a painter took up the new craft at once—some to make preliminary studies for paintings, some to make more money than they could at painting —and many another took alarm. One of the latter, Maxime Du Camp, scoffed at defecting "daubers who drop the palette to enter the darkroom, abandoning their vermilions and browns for silver nitrate and hyposulfite of soda." But eventually Du Camp himself dropped his palette and entered the darkroom. Such defection was often irresistible, not only because of the infinite variety of the new craft itself, but because of the obviously greater profit to be made in photography. Portraiture proved to be the most lucrative of photography's many branches. In 1849 some 100,000 Parisians had themselves daguerreotyped, caught up in a mass enthusiasm that provoked the critic Charles Baudelaire to deplore "our squalid society that rushed, Narcissus to a man, to gaze at its trivial image on a scrap of metal."

In spite of its popularity, the daguerreotype was obsolescent in a decade. Just three weeks after Daguerre's coup, another one was achieved in England, where William Henry Fox Talbot, an aristocratic man-of-all-interests,

announced that he had created permanent images on paper instead of on copper plates. A year and a half and many experiments later, Talbot devised what came to be known as the calotype; it employed the negative-positive process on which modern photography was to be based. The image of the calotype was not so precise as that of the daguerreotype—it was the premature counterpart of Impressionist painting, due to arrive in the 1860s—but its very softness had an appeal. Its major advantage was that any number of prints could be made from a negative; each daguerreotype had been unique and unreproducible. But the calotype, too, quickly became obsolete as methods were found for making negatives on glass plates; they produced sharper prints and, perhaps more important, permitted shorter exposures.

In 1851 another Englishman, Frederick Scott Archer, invented collodion —a viscous liquid that could be spread on glass and coated with light-sensitive chemicals. Collodion plates had to be exposed while moist and developed immediately, because the coating's sensitivity to light deteriorated as it dried; thus it was called the "wet-plate process."

Such inventions followed one another year after year. Photography was still a highly experimental craft, and anyone taking it up had to master all its phases personally. Photographers had to be able to mix their own solutions, grind powders, assemble lenses, treat and print their copper, paper or glass—for the wherewithal of photography did not yet come packaged. Yet an amazing number of these innovators were true artists as well as craftsmen, and they explored the esthetic possibilities of the medium as imaginatively as they did its technical potential. During these first 20 years, almost every type of picture now in the photographer's repertoire was attempted—landscapes, still lifes, documentation, portraits. And the results were often astonishingly successful. The landscape scenes recorded by Gustave Le Gray *(pages 28-29)* and the Bisson brothers *(pages 36-37)* are as dramatic as any made later. And the masterly portraits of Southworth and Hawes *(pages 14-17)* and many of their contemporaries are still as powerful and perceptive in their revelation of human character as any portraits ever taken.

These pioneers, though hampered by clumsy equipment and balky processes, set a high standard for succeeding generations. And it is this standard that establishes the criterion for this book. The photographs shown here were made by men and women whose work continues to be an inspiration and a challenge. These great photographers are grouped chronologically, in seven sections covering 20 years each. (Photographers are placed in the period in which they did their major work, and if their career spanned more than 20 years, some of their photographs may bear dates outside their assigned periods.) The double-decade grouping is an arbitrary device—a convenience for displaying some 220 of the finest photographs ever made.

Albert S. Southworth and Josiah J. Hawes

Within five years of the invention of the daguerreotype, two New England Yankees set about raising the French process to new heights of technique and artistry. One was Albert S. Southworth, formerly a small-town druggist; the other was Josiah J. Hawes, a onetime miniature painter. They went into partnership in Boston about 1844, and they soon made Southworth & Hawes the most eminent daguerreotype firm in Boston. At a time when daguerreotype studios were proliferating by the dozen, Southworth and Hawes could count among their clientele such luminaries as Henry Wadsworth Longfellow, Harriet Beecher Stowe and former President John Quincy Adams.

From the upper floors of their studio they shot pictures of Boston's historic narrow streets *(right)* and its harbor filled with clipper ships. They were not bound by the limits of the brightly sky-lighted studio, either; they took their cameras across town to record schoolgirls in the classroom with on-the-spot indoor pictures *(page 16)*.

But their major achievement was their portraiture. They made the camera capture such unexpected and fleeting moments as the breeze riffling the hair of a stern and unyielding clergyman *(opposite)* and a baby wriggling in her mother's arms *(page 16)*, achieving an informality and depth of character that were novel at the time.

Southworth and Hawes aimed their camera through the open window of their studio in 1855 to take this daguerreotype of the funeral cortege of one of the leading merchants of Boston, Abbott Lawrence. The horse-drawn carriages are proceeding through Brattle Street from the old Brattle Street Church (center background). The street signs read backward because the image in daguerreotypes is reversed, as in a mirror.

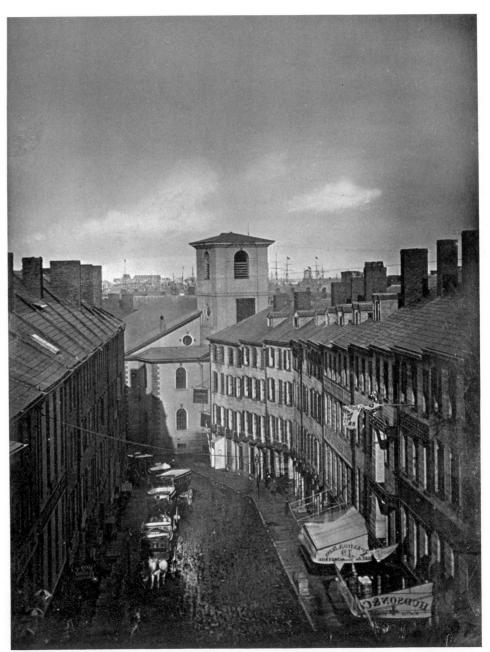

Brattle Street, Boston, 1855

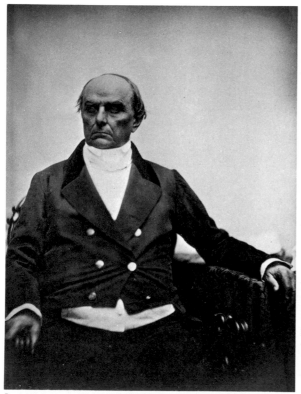

Daniel Webster, c. 1851

The renowned Senator Daniel Webster was
daguerreotyped in 1851 by Hawes, who placed his
sitter in a firmly assertive pose under the strong
overhead illumination from the studio skylight.
Southworth and Hawes were among the first
photographers in the United States to build a
studio with a skylight, a light source that was
invaluable in a day when there was no electricity.
The toplighting underscored the determined lines
around the nose and mouth of the statesman.

This study of the Reverend Daniel Sharp, a
Baptist whom a contemporary described as
"a perpendicular gentleman, of the noblest class,"
was photographed against a dark background that
accents his wispy white locks and lofty forehead.
The tight lips and grim jaw portray his sternness,
though he also had to hold perfectly still for
an exposure of somewhere up to 25 seconds.

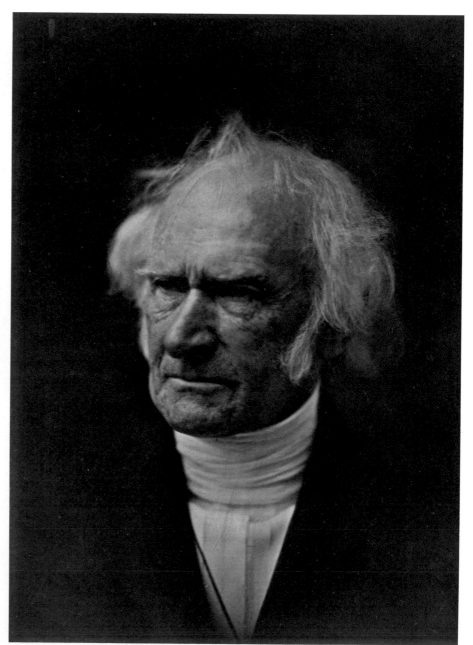

The Reverend Daniel Sharp, c. 1850

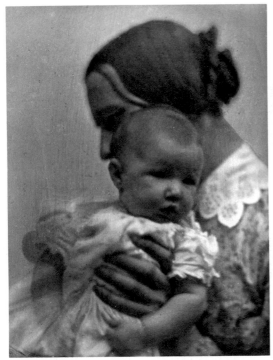

Mother and Child, date unknown

It was easy for Southworth and Hawes to meet their stated aim of "reading the character of the sitters" in the tender study above, for they knew the subjects well. The young mother was Hawes's wife and Southworth's sister, Nancy; the baby she held was her daughter Alice.

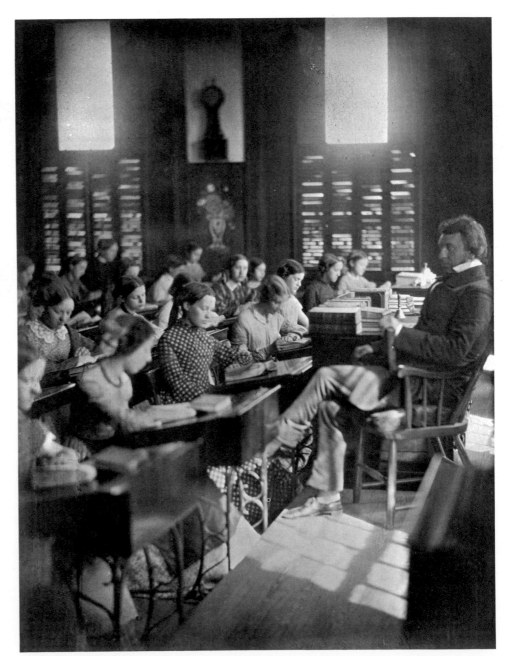

Among the first photographs to show scenes of real life in unposed informality is this daguerreotype of a sunlit classroom in a Boston girls' school. Southworth and Hawes were able to achieve its relaxed air because they could reduce exposure time to under 25 seconds, using a method they kept secret. They advertised such candid views of youngsters as "instantly taken."

Emerson School, date unknown

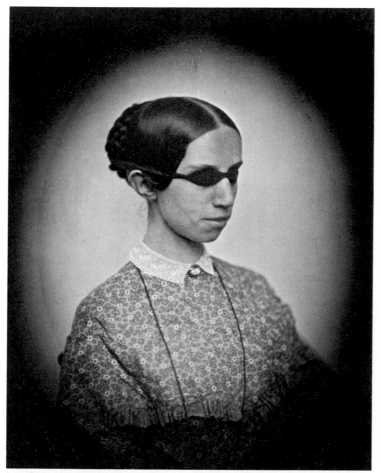

Laura Bridgman, date unknown

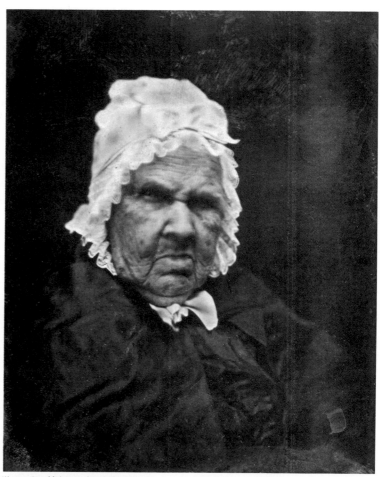

Woman in a Mobcap, date unknown

Both a sense of admiration and attention to detail are combined in this portrait of Laura Bridgman. Though blind (and wearing eye patches), as well as deaf and mute, she taught sewing in a Boston school for the blind. Why the photographers masked out all but a circle of light in their portrait of her is not known. They may have intended to provide a halo effect, or a sense of inner light amidst a world of darkness. Whatever their intention, the result is a warmly ennobling portrait of a courageous young woman.

Though many famous people sat for them, and they commanded a five-dollar fee — a high one for the time — Southworth and Hawes did not limit their trade to celebrities. Some of their most interesting portraits are mercilessly revealing studies of people whose names are long lost — like the elderly matron above, whose furrowed and craggy visage stares unflinchingly at the camera with a look of grimly concentrated distaste.

Carl Ferdinand Stelzner

One of the many artists who gave up painting for daguerreotyping was Carl Ferdinand Stelzner, an itinerant miniaturist with a reputation of sufficient luster to earn him a clientele among the European nobility. On hearing of the daguerreotype process and perceiving its potential as a means of making cheap and accurate portraits in only a few minutes' time, he went to Paris to learn at first hand how to use a camera. Back in Germany some months later, he opened a studio in Hamburg.

Stelzner had what would later be known as a nose for news. In the first week of May 1842, when a three-day fire ravaged a part of the historic city, he and his partner lugged a heavy camera, silvered plates, a dark tent and an assortment of chemicals to the scene and made numerous plates of the gutted landscape. These may well have been the world's first on-the-spot photographs of an epochal event. But newspapers could not reproduce photographs, and the Hamburg Historical Society, to which they were offered, did not think them worth the friedrichsdor (about $5) asking price, and so the pictures went unused.

In matters of composition and rendition of character, Stelzner never lost his artist's eye (though, ironically, he eventually went blind from the fumes of silver iodide and mercury used in coating his plates). He achieved in his pictures both design and character, as well as a feeling for place and time.

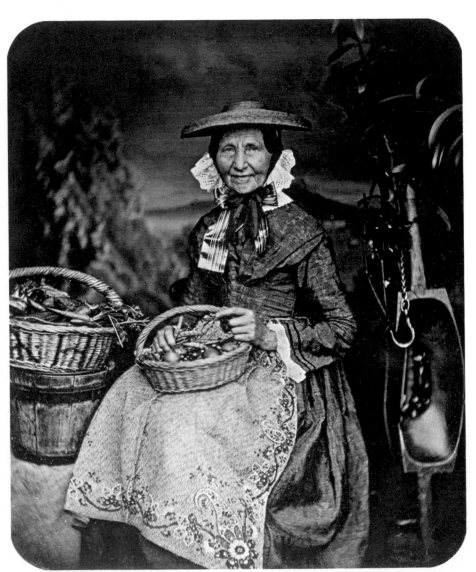

Mother Albers, Hamburg, c. 1850

Stelzner was a successful and fashionable photographer when he made this daguerreotype of the woman who sold vegetables to his family. It reflects his abiding affection for the peasants whom he had painted in his youth, when he traveled through the countryside as a miniaturist.

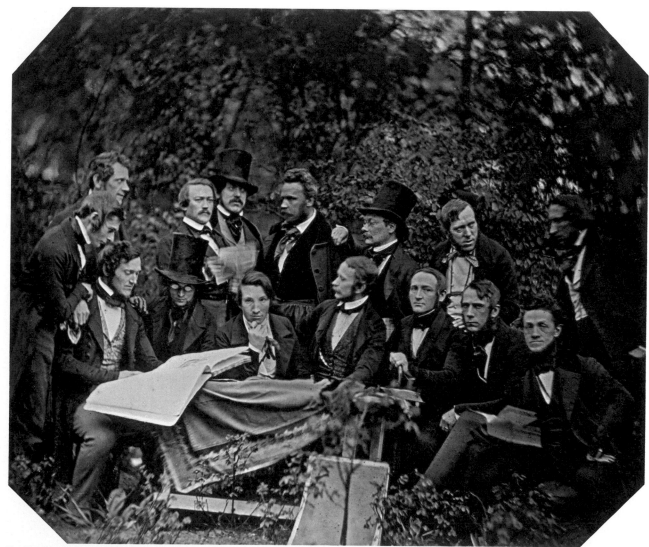

The Hamburg Art Club's Outing, Hamburg, 1843

This picture was exposed in less-than-ideal light after 5 o'clock on a May evening, but it turned out so well that Stelzner touted it in a newspaper ad. The varied, seemingly unstudied poses of most of the young men give the composition a liveliness quite rare in early group portraits.

William Henry Fox Talbot

The inventor of the process on which modern photography is based was not Daguerre, whose techniques led to the pictures shown on the previous pages, but a plump English aristocrat by the name of William Henry Fox Talbot. A Cambridge-educated gentleman scientist proficient in mathematics and Assyrian, Talbot started experimenting with photography on his honeymoon trip to Italy. Later, after he and his wife settled down in the Talbot ancestral home, Lacock Abbey, he succeeded in making good images on paper—but in announcing his invention to the public he was too late by a few weeks to beat Daguerre to the honor of being acclaimed photography's inventor.

Talbot's process, called the calotype in its final form, produced negatives on coated paper, from which any number of paper prints could be made. To demonstrate the practical uses it could be put to, he published *Pencil of Nature* in 1844—the first book that was ever illustrated with photographs. They ranged in subject matter from cabinets full of household china (photographs to aid in taking inventory) to views of the boulevards of Paris (photographs to soothe the wanderlust of stay-at-homes). But the most notable pictures are his intimate, informal studies of the Lacock Abbey household—images that provide a charming, often arresting glimpse into the domestic life he cherished.

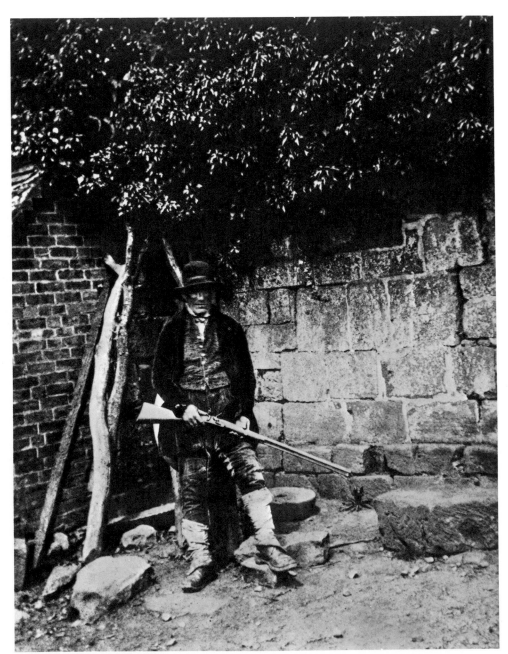

Gaitered and holding the gun with which he presumably made his rounds, the Lacock Abbey gamekeeper held still for a one-minute exposure. The contrast between the small-brick masonry at left and the large stone blocks forming the wall at right illustrates the abbey's variety of building styles (some of which date from the 13th Century)—and the quality of the calotype.

The Keeper of Lacock Abbey, c. 1845

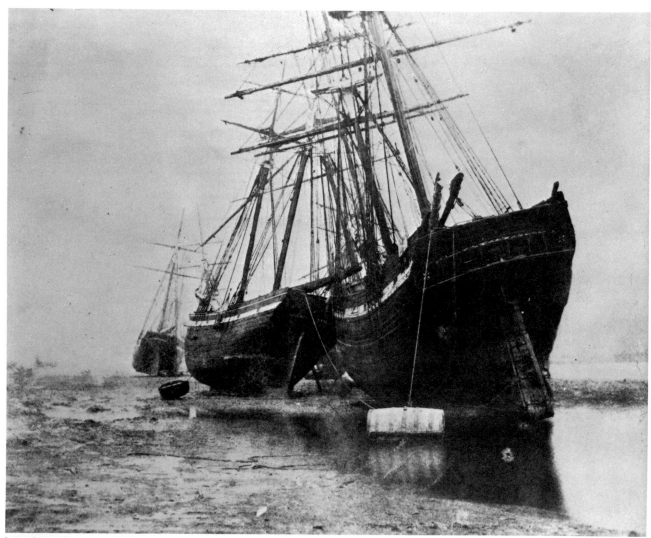

Sailing Ships at Swansea, c. 1850

The calotype was a fine medium for lending a sense of atmosphere to a seascape like this view of massive ships outlined against the sky on the coast of Wales. The paper negative's fibers diffused the light rays sufficiently to soften the image. This effect created a picture with both ample detail—particularly noticeable in the rigging and reflections—and a pleasant charm.

David Octavius Hill and Robert Adamson

Two men who quickly learned to make the most of the impressionistic images made by the calotype process were David Octavius Hill and Robert Adamson, a team of Scots who turned out, in less than five years' time, close to 2,500 pictures of extraordinary merit. Hill, a handsome, ruddy, blue-eyed extrovert in his early forties, was a successful landscape painter when he took up photography. Adamson, a thin youth in his twenties with black hair and dark, introspective eyes set against an unhealthy pallor, who was too frail for heavy work, had opened a calotype studio in Edinburgh.

The two men met in 1843, when some 500 clergymen withdrew from the Presbyterian Church and assembled in Edinburgh to establish the Free Church of Scotland, and Hill decided to paint a massive group portrait to mark the event. He went to Adamson's studio to propose that the latter take individual calotypes that he could copy for the faces in the portrait. Adamson agreed, but the calotypes turned out so well that 23 years went by before Hill ever finished the painting; instead he took up photography with the technical assistance of Adamson. The partners are best known for their expressive and forceful portraits, but they were also uncommonly skillful at capturing the charm of the Highlands and coastal villages.

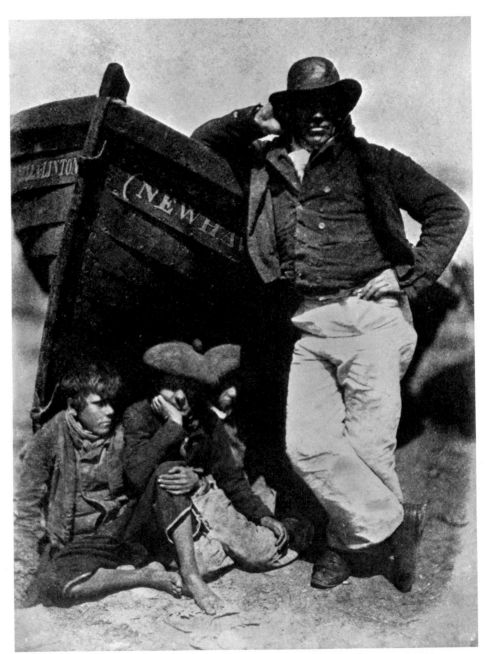

For this calotype, part of a series made in the harbor village of Newhaven, a young fisherman named James Linton and three "water rats" held still with the aid of a beached boat. The two photographers are thought to have intended the Newhaven pictures to be sold to raise money to help the fishermen refurbish their boats, many of which had recently been beached as unsafe.

Newhaven Fisherfolk, 1845

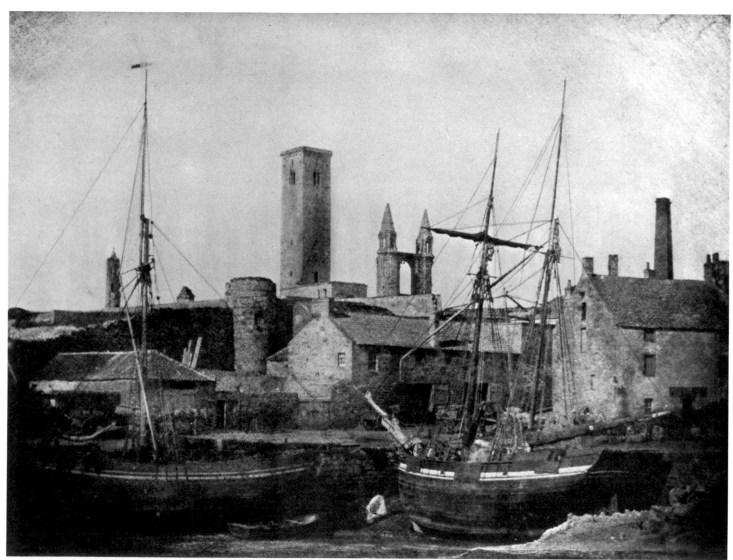

St. Andrews Harbor, c. 1846

The partners made this romantic view from the
deck of a small craft in the waters of the bay that
fronts the old, gray city on the east coast
of Scotland. Behind the fishing boats looms the
Romanesque tower of St. Regulus (center), for
eight centuries a beacon and a navigational aid to
sailors on the stormy waters of the North Sea.

Hippolyte Bayard

The announcement in January 1839 by the French government of the invention of the daguerreotype was a bitter pill for one of the government's own employees. He was Hippolyte Bayard, a clerk at the Ministry of Finance. Since 1837 he had been experimenting with the effects of light on sensitized paper, using a process similar to the one with which William Henry Fox Talbot *(page 20)* was experimenting, though he did not know of Talbot. On hearing about Daguerre, however, he got busy and in 16 days he had succeeded in producing positive images directly on paper. He showed his invention at a charity bazaar in Paris the following June, some two months before Daguerre gave his first official explanation of how his method worked.

But Bayard was a timid man. When he took his invention to a government official, hoping for state support, the official—who was a friend of Daguerre's—persuaded him to keep silent. By the time Bayard made his invention public, the following year, the daguerreotype had been used all over France, and Daguerre was a national hero and the beneficiary of a sizable lifetime pension from the government.

Bayard bore a grudge against the government for the rest of his life, but that did not turn him away from the practice of photography. After 1842 he adopted Talbot's negative-positive method and was one of the first in France to make calotypes that rivaled those being produced in England. Bayard was an early exponent of photography that recorded simple scenes and that evoked mood by means of expert lighting effects and artistic composition, such as the pictures shown here.

Self-portrait, c. 1846

Bayard took his self-portrait sitting in a sunny doorway with the calotype method invented by William Henry Fox Talbot. Bayard's closed eyes indicate that the exposure was a long one.

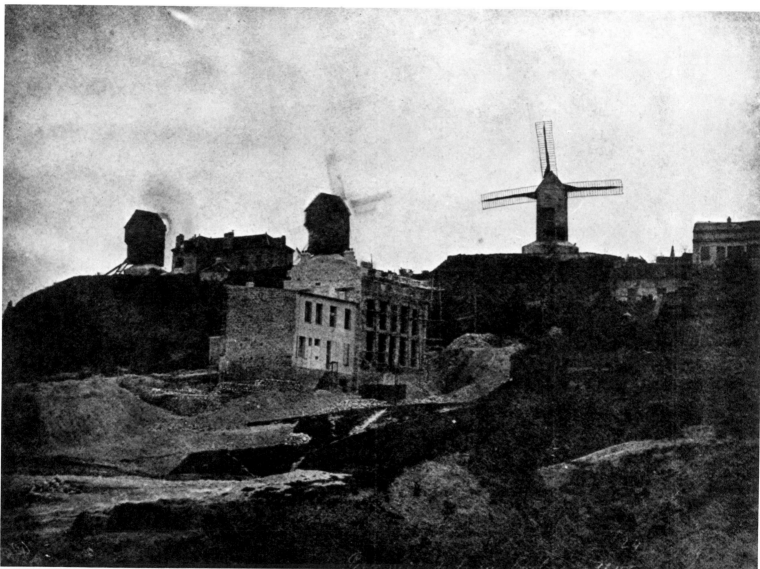

Montmartre, 1842

When it was a community of flour millers, this hilltop had been crowded with windmills, but by 1842, when Bayard made this study, only a few remained, and Montmartre's occupants were chiefly artists attracted by its low rents.

Charles Nègre

It was not long before photographers began to go beyond the portrait and the landscape and to use the eye of the camera as their own, to pick up the passing scenes around them. One of the first to do so was Charles Nègre, a young French painter specializing in pictures of people engaged in their everyday occupations.

Intending to use photographs as preliminary studies for his paintings, Nègre roamed the working-class districts of Paris, photographing the chimney sweeps, urchins and Seine bargemen he found there. He painted copies of a few but he was quick to see that the photographs were works of art in their own right, and he concentrated on making them. They constitute a record of daily life in Paris that won Nègre a place in history as one of the first photographers to see the beauty to be recorded in scenes of ordinary people doing ordinary things.

His pictures also gained him the notice of the authorities, and in 1860 Napoleon III, a ruler who knew the uses of publicity, commissioned him to take photographs at the Vincennes Asylum, a hospital the Emperor had recently founded for disabled workmen.

There, using collodion-coated glass plates *(page 13)*, which permitted sharper rendition of detail than paper negatives, Nègre indulged his fascination for texture, picking up with unexpected clarity the folds in freshly ironed linen and the gleam of kettles hanging on kitchen walls *(right)*. But his real forte was human interest, and because he was quick on his feet as well as innovative with his camera, he caught the picture at right, which foreshadows the era of photojournalism.

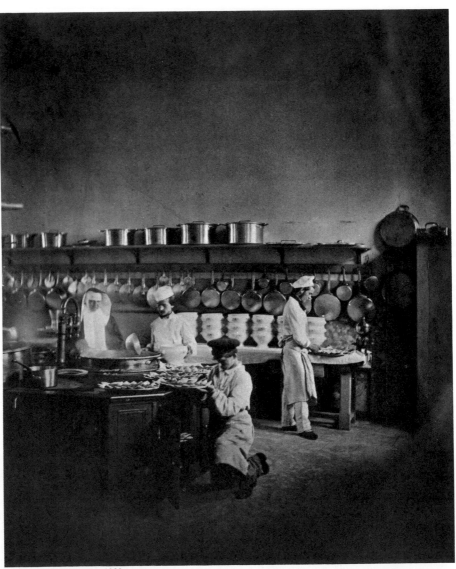

The Kitchen at Vincennes, 1860

Nègre's enthusiasm for photographing people at work was complicated by the limitations of his equipment, which forced his subjects to hold still during lengthy exposures. Here, Vincennes's adolescent cooks obligingly froze for his camera while preparing a meal for the patients.

When a dray horse collapsed on the Quai Bourbon outside his studio door one day in 1851, Nègre, ever on the alert for realistic street scenes, moved his camera and tripod onto the pavement and took this picture of a group of waterfront idlers superintending efforts to raise the animal.

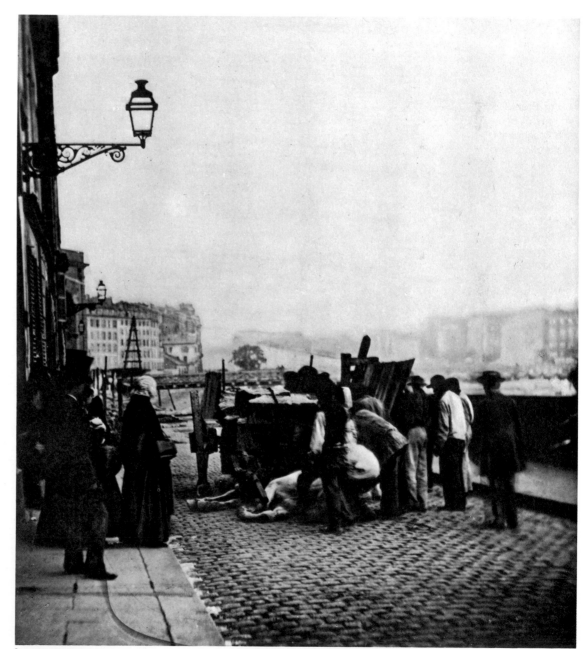

Street Incident, 1851

Gustave Le Gray

Many artists initially took up photography as an aid to their painting, never expecting to become absorbed in the new invention for its own sake. A different case was that of Gustave Le Gray. He was an unsuccessful painter who turned to photography in the hope of making money; in 1848, when he was 28 years old and trying to support a family, he borrowed capital to open a portrait studio in Paris.

But portraiture proved no more profitable in the new medium than it had in the old. Customers were few, business remained slow and Le Gray turned to architectural views and scenes of the outdoors. With these subjects he achieved effects that made his pictures a critical success when they were put on exhibit—success that was due in part to Le Gray's artistic eye and in part to his being a gifted technician able to make effective use of light. He was also an influential teacher, and many French photographers of the day—including Nègre *(pages 26-27)* and Du Camp *(page 34)*—learned from him.

Le Gray was successful for less than a decade. Like the Bisson brothers *(pages 36-37)*, he found that his business fell off when customers began to favor prints in sizes so small that his sweeping, detailed views lost all their effect. Closing his studio in 1861, he went to Egypt, where he taught drawing for a year in Cairo before he was killed by a fall from a horse.

Like most early photographers, Le Gray was preoccupied with light. His particular interest was in testing the ways light showed up on newly invented collodion (page 13), as in this picture taken at dawn, before mist had risen from the plain. As the troops recede and the mist between them and the camera thickens, the clarity of the images fades. The sense of depth caught by the camera and reproduced by the collodion was new and remarkable at the time. The scene was the plain of Châlons in northern France, where Napoleon III had established a 29,650-acre army camp. Le Gray took the picture while the Emperor was visiting there on a tour of inspection.

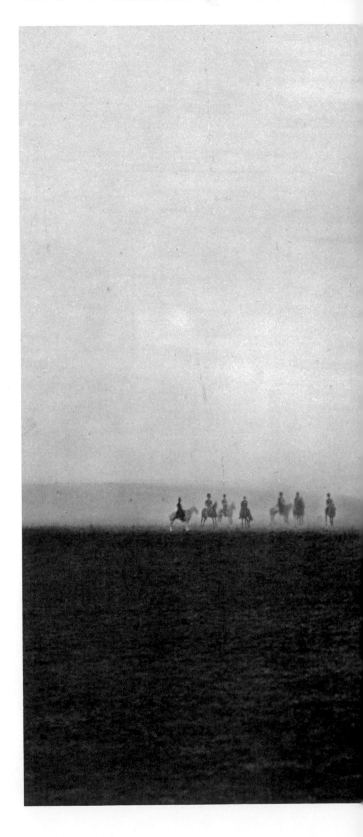

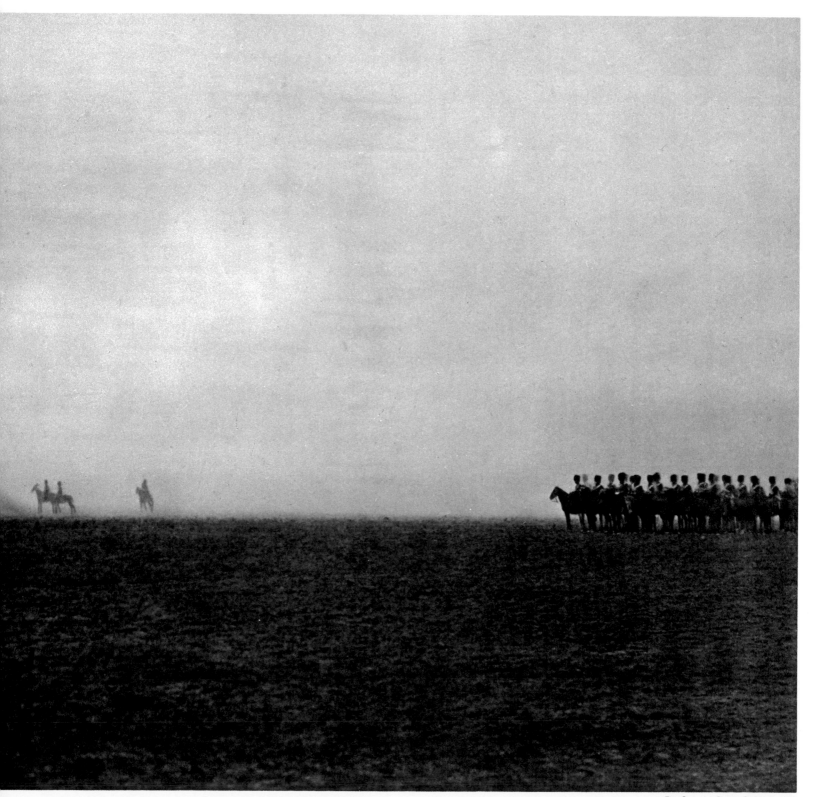

The Guard at Dawn, Châlons, 1858

Philip Henry Delamotte

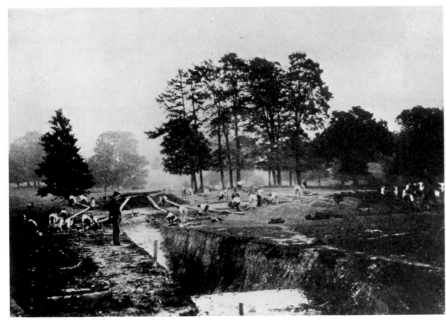

Workmen Beginning on the Rebuilding, 1851

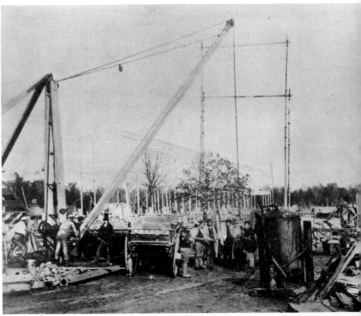

Commencement of the Front of the Building, 1852

In London the big news of the year 1851 was the Great Exhibition, that marvel of world's fairs. So successful was the exhibition's show of industrial achievement that when it closed in October after a five-month run, some British businessmen undertook to preserve the glory of it all. They bought 349 acres of land in Sydenham, outside London, and arranged for the transportation and re-erection of the glass and iron components of the fair's crowning jewel, the Crystal Palace.

They also hired a photographer to make a record of the undertaking. He was Philip Henry Delamotte, a landscape painter and professor of drawing, who turned in a monumental job of his own. Every week for two and a half years, from the ground-breaking *(above)* in late 1851 to the ceremonial dedication by Queen Victoria in June 1854, Delamotte was on hand with his camera. His careful work documented everything from overall views of the massive structure to the daily minutiae of the workmen's labor. No corner was left unseen, no activity went unnoticed. The bad was recorded with the good; when some scaffolding collapsed—a calamity in which 12 people died—Delamotte's roving camera caught that, too *(opposite page)*.

In the end Delamotte had more than a record of the preservation and growth of an edifice to which much public sentiment was attached. He had shown how photography could preserve the flavor and meaning of a period piece for the enjoyment of future generations.

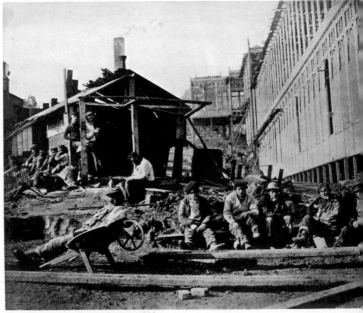

Dinner Time at the Crystal Palace, 1852

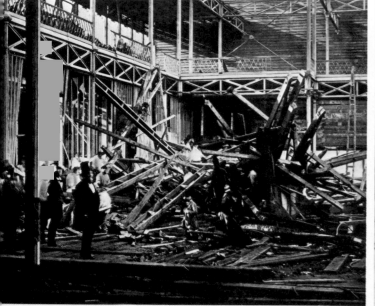

Fall of Scaffolding, 1853

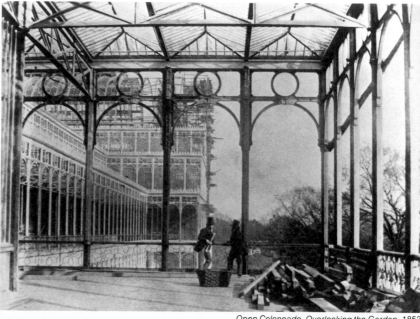

Open Colonnade, Overlooking the Garden, 1853

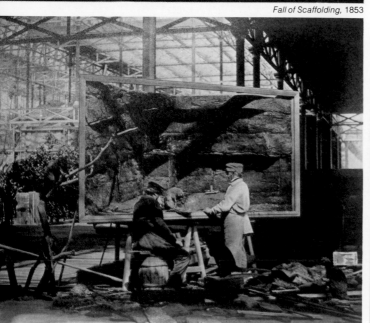

Preparing a Natural History Exhibit, 1853

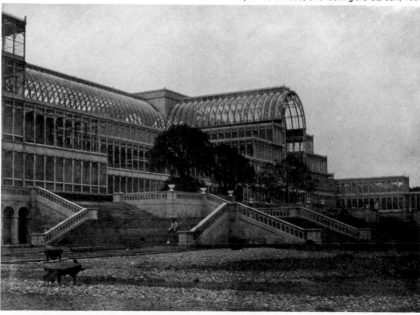

Front of the Crystal Palace, 1853

Thomas Keith

"The very air of Edinburgh," one Scotsman has written, "is thronged with ghosts." What better city, then, for using the camera to play the ghostly against the live, imagery against reality —juxtapositions that fascinated 19th Century folk everywhere. No one made more of this opportunity than Dr. Thomas Keith, a tall, lank surgeon who was born in a Highland hamlet and went to Edinburgh to study medicine. The city's Old Town fascinated him, with its dark, narrow closes and steep, gable-roofed houses. He took 220 photographs in two years' time, before the call of his patients and his own poor health forced him to give up his hobby.

Unlike most photographers, Keith continued to use the paper negatives of the calotype method even after the more sophisticated collodion process was invented. "If you were to ask me to what circumstance I attribute my success," he wrote, "I should say that I never expose my paper unless the light is first-rate." He photographed only in the summer, mostly before 7 a.m. or after 4 p.m., when "the light is softer and the shadows larger." At his death in 1895 he left a pictorial record of Edinburgh and its environs unsurpassed for its evocation of the city's spirit.

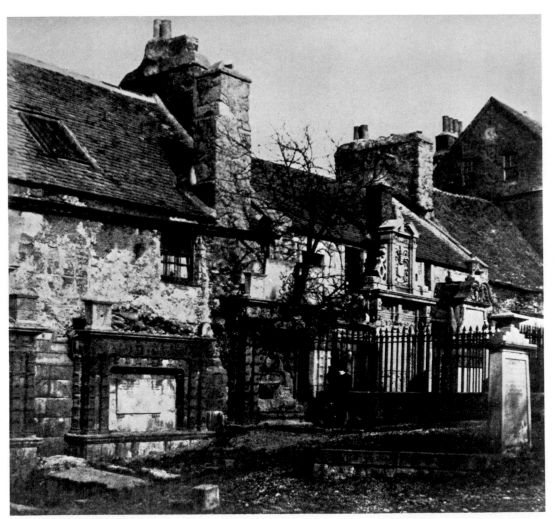

Greyfriars Churchyard, c. 1855

A lone, top-hatted Scotsman sits in Edinburgh's graveyard in the somber study above, in which the contrasting rough masonry of the house walls and elaborate carving on the tombstones —brought out in a sharpness of detail not often seen in calotypes —form a visually arresting pattern of diverse styles of architecture.

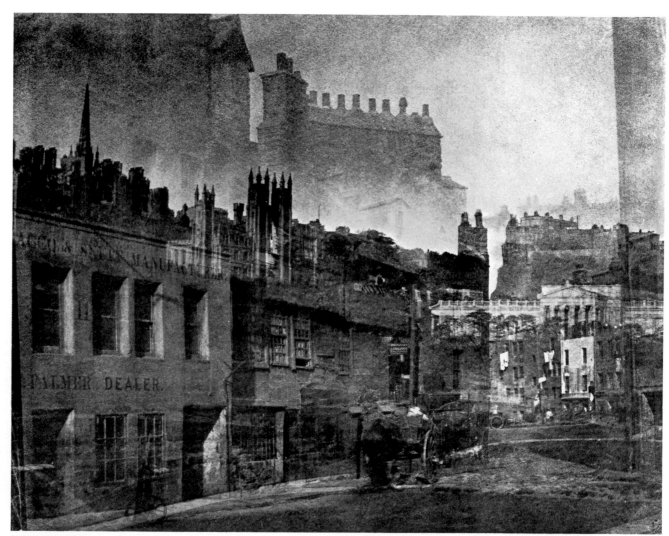

Edinburgh, c. 1855

To get this composite of Edinburgh — one of the first montages ever done — Keith exposed his negative six times. The combination of images sets Old Town landmarks, which date from medieval times, against New Town buildings erected in the 1850s, as though the dim past of the 1,000-year-old city could be seen in its newest structures.

Maxime Du Camp

Maxime Du Camp was an impatient dilettante with an ambition to be the first man to photograph the antiquities of Egypt. The orphaned son of wealthy parents, he had the money and connections to go where he wanted, and in 1849 he persuaded the French Ministry of Education to send him on an archeological tour of the Middle East. With him went a close friend for whom he wangled a job as a reporter—Gustave Flaubert, the novelist.

When they returned after 21 months Du Camp had 220 calotypes and the makings of an album of photographic prints, *Egypt, Nubia, Palestine and Syria,* which he brought out in 25 weekly installments of five plates each. Many, like the picture at right, were carefully planned to show in minute detail the inscriptions and pictorial decoration on the ancient monuments. They were not the first photographs ever made of the Middle East, for a few daguerreotypists had beaten Du Camp to his subjects; but their work was not reproducible and his was, giving armchair travelers their initial glimpse of an exotic civilization. At a price of 500 gold francs (roughly $100) a complete set of Du Camp's pictures was a luxury only the rich could afford.

Du Camp gave up photography after he returned from Egypt, and devoted the rest of his life to literary work, writing fiction, poetry, history and criticism.

Du Camp set his camera close to get a clear, realistic view of the carvings on ancient Egyptian monuments like the granite column at right. This one was built in the reign of Tuthmosis III, the pharaoh who unified the Egyptian empire in the 15th Century B.C. The carving shows the pharaoh being greeted by Hathor, goddess of love.

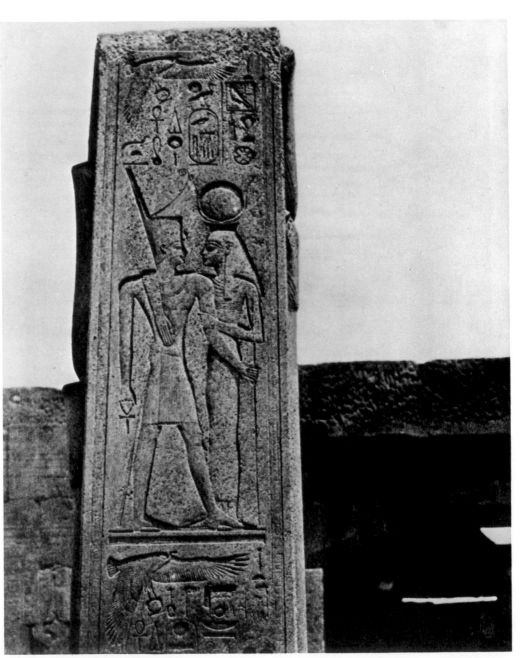

Column from Temple at Karnak, Egypt, c. 1850

Photography has always been a business as well as a science and an art. One of the first of its big-time entrepreneurs was Francis Frith. A onetime grocer's apprentice who owned a printing firm in Liverpool, he made a hobby of photography, and in 1856 he went on a trip to Egypt to take photographs that he hoped could later be sold in stereoscopic and album form.

Frith traveled up the banks of the Nile River in a wicker carriage that served as a darkroom-on-wheels, carrying along with him no fewer than three cameras: a standard studio camera using plates of 8 x 10 inches, a bigger one for 16 x 20-inch plates, plus one with a dual lens that made side-by-side stereoscopic pictures for three-dimensional views. In spite of the heat, which sometimes reached 130° F. and boiled the collodion coating of his plates, and in spite of the ubiquitous sand, which pitted the plate surfaces, Frith returned to England with many handsome images of the great Egyptian monuments. The exoticism of the subject matter thrilled the Victorian public and made his volumes of photographs and his stereoscopic views extremely popular; Frith the businessman made the profit he hoped for. But Frith at his best was also an artist, and his clear and intelligent sense of composition gave his pictures a life that endures.

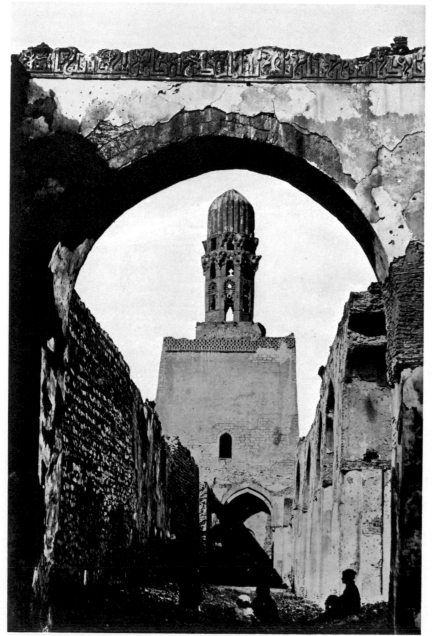

Mosque of El-Hakim in Cairo, 1858

Frith, who traveled through Egypt a few years after Du Camp (opposite), saw the land with a different eye, finding design in the lines cast by walls and a tower seen through an archway (left). The tower belongs to a mosque that had been erected in the 11th Century at the behest of the mad tyrant El-Hakim some years before he was assassinated.

Louis Auguste Bisson and Auguste Rosalie Bisson

When Napoleon III ascended the Alps to look over his newly acquired province of Savoy in 1860, he included in his entourage two eminent Paris photographers, Louis and Auguste Bisson. They brought back stunning views of snowy scenery *(right)*. The trip whetted the brothers' appetite for more, and a year later Auguste went back, this time to make the 16,000-foot ascent to the peak of Mont Blanc. The task was a formidable one. It took 25 porters three days to lug his cameras, tripods, glass plates, collodion solution, tents and hardware to the summit. There, in spite of fatigue and cold-stiffened fingers, Auguste exposed three 8 x 10-inch plates, developing them in a flimsily erected tent and rinsing them in melted snow.

Four years later, the brothers quit photography. By that time the card-sized photograph known as the *carte-de-visite* had become the rage—it was cheap and it was easy to paste in an album. The brothers were not willing to reproduce their Alpine scenes on *cartes-de-visite;* their spectacular panoramas, with their subtle shadings of ice and snow, were best seen as large mounted prints. The Bissons' business fell off and their fame died away.

The Bisson brothers clamped the French tricolor in a conical pile of snow in the Alpine Mer de Glace (Sea of Ice), which is dramatically flanked by black glacial deposit. They gallantly titled their overpowering scene of rock and ice The Empress' Pyramid, in honor of Napoleon III's glamorous Spanish wife Eugénie, and published it in an album that was issued to commemorate the royal couple's mountain-climbing excursion.

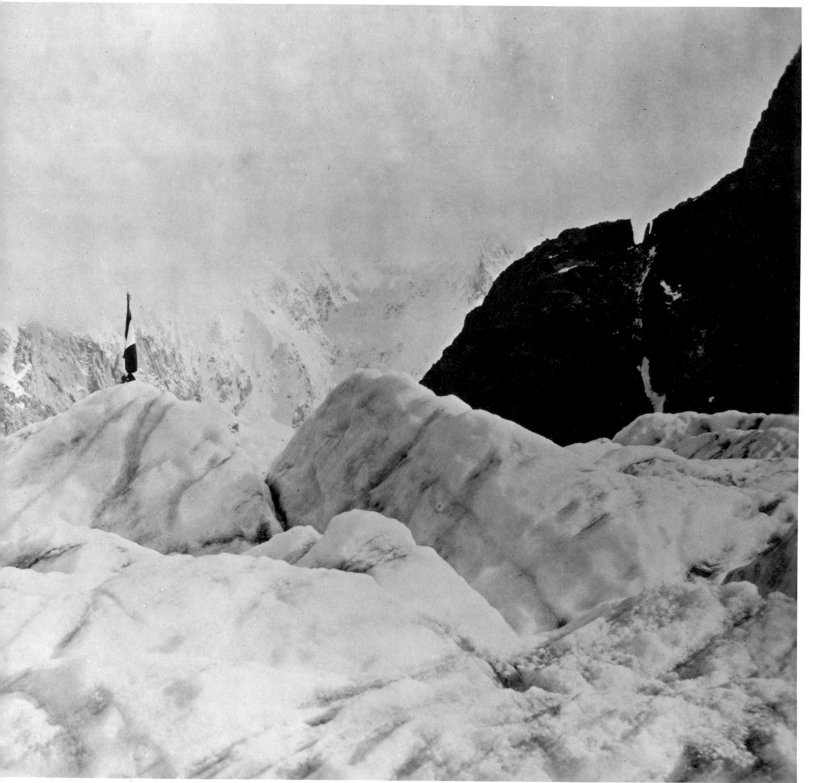

Pyramide de l'Impératrice, 1860

Roger Fenton

As the first 20 years of photography drew to a close, photographers were ranging farther afield to exploit their medium. Their efforts were summed up in the work of Roger Fenton, a Victorian man-of-all-trades who was prolific, versatile and fashionable.

Along with making the portraits and landscapes on which Victorians doted, Fenton successfully exploited another contemporary fad, the still life (right), with a finesse that critics and public alike applauded. But his chief fame rests upon his government-sponsored record of the Crimean War, a grim assignment from which he returned a victim of cholera.

Though the war photographer's role had its compensations (page 40), Fenton had to endure an often-drunk assistant, heat so intense he could work only from five to ten in the morning, and incessant interruptions from soldiers wanting their pictures taken.

But Fenton's principal obstacle was his position as an official photographer representing a government that was trying to justify a badly bungled war. He kept his camera turned away from war's horrors, and trained on colorful formations or soldiers relaxing off duty. His 360 pictures provide a romantic account of a campaign in a far-off land, but reporting on the realities of combat awaited the work of others.

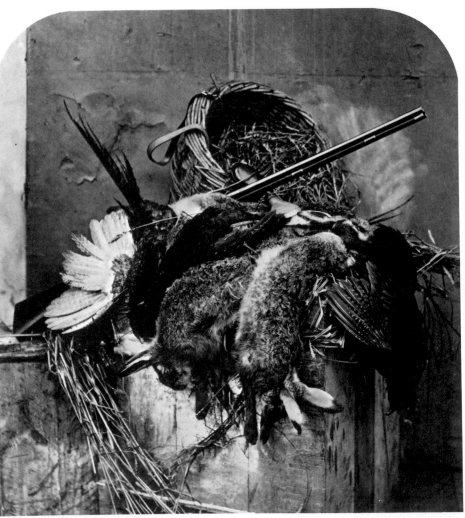

Still Life, c. 1860

Making a still life like this one in the 1860s, some 20 years before photographers had the use of electric lamps, required knowledge, skill and, not least, patience. To pick up the details as sharply as he did, Fenton had to arrange the bird, the rabbits, the gun and the basket just so — and then shoot at the precise moment when the sun coming in through the window would strike them all.

This photograph, made at the Earl of Harewood's ▶
classic-revival estate near Leeds, was one of the few Fenton pictures that did not please his public, who wanted a landscape photograph to look like a landscape painting, with rivers winding into the distance. This view seemed only a geometric pattern, and one critic scored its "offensive . . . parallel lines one above the other."

Terrace and Park of Harewood House, 1860

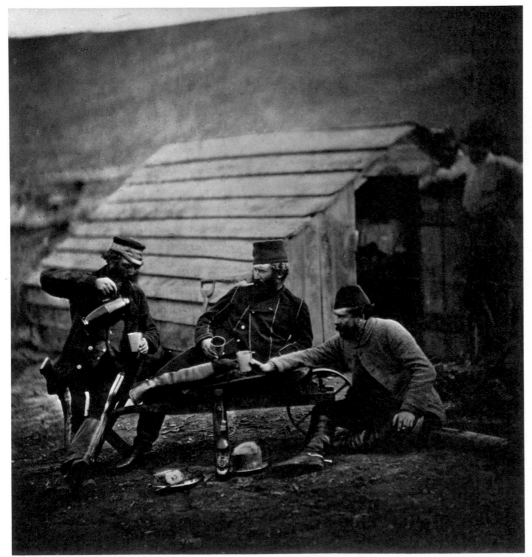

Hardships of Camp Life, 1855

*Fenton set his camera for a lengthy exposure,
then posed himself (center) and his assistants in
front of it, near a Crimean War battlefield. The title
he gave the picture was meant as irony; it
underlines the special privileges he enjoyed, one
of which was taking mess with the officers,
complete with champagne and after-dinner cigars.*

The Search for Photography's Role 44

Carlo Ponti 46

Charles Marville 47

Mathew B. Brady 50

Alexander Gardner 54

George N. Barnard 56

Timothy H. O'Sullivan 58

Nadar (Gaspard Félix Tournachon) 60

Étienne Carjat 62

Julia Margaret Cameron 64

Henry Peach Robinson 66

Oscar Gustave Rejlander 68

William McFarlane Notman 71

Photographers represented in this chapter include: ▶
Charles Marville 1
Mathew B. Brady 2
Alexander Gardner 3
Timothy H. O'Sullivan 4
Étienne Carjat 5
George N. Barnard 6
Nadar (Gaspard Félix Tournachon) 7
Julia Margaret Cameron 8
Henry Peach Robinson 9
Oscar Gustave Rejlander 10
William Notman 11
*(Not shown is Carlo Ponti; no photograph
of him is known to exist.)*

The Search for Photography's Role

As photography entered its third decade in 1860, photographers had learned a good deal about what their medium could do; now they began to decide what it should be doing. In the next 20 years they broadened the scope of their art as they worked, staking out and discussing the areas in which the true worth of photography could be revealed. There was, of course, no simple or direct answer to the question of photography's role in the world—it varied with each talented person who picked up a camera. But many of the finest practitioners of this period excelled in four major categories: architecture and urban landscape, eyewitness reporting, portraiture and the craft —or art—of making photographs that resembled paintings.

Because of the shorter exposure times made possible by the recently invented wet-collodion process, photographers were no longer restricted to pictures of motionless subjects, as they had been with the daguerreotype. (Further flexibility was gained when Richard Leach Maddox, an English physician, substituted gelatin for collodion in 1871; after that, plates could be both sensitive and dry.) Nevertheless, a number of photographers—particularly in Europe—still did their best work picturing edifices and statues. One even recorded entire areas of Paris, then being torn down to make way for grand-scale rebuilding *(pages 47-49)*. Although it would be reasonable to assume that these urban studies might be of interest today only to students of city planning, the fact is that their high style and historical precision far transcend their limitations, providing loving glimpses of Europe at a time of prosperity and expansion.

In the United States, the Civil War, which began in 1861, propelled teams of adventurous photographers—most of them recruited by the leading portraitist Mathew B. Brady—out of their profitable studios and into the smoke and carnage of the battlefields. As they rode around in their rumbling darkroom wagons, these men gave the world its closest glimpse yet of the agonies of war. Views of the actual fighting were impossible, for even wet plates were not fast enough to stop action, but these photographers still showed warfare in meaningful and poignant terms. They pictured the devastated battlefields and towns, dead and wounded veterans, and the horror of the executions of military criminals—including at least one such event staged during a temporary truce so that soldiers from both sides could cease their mutual slaughter long enough to watch together *(page 51)*. The grim paradoxes of war—its heroism and its savagery—were exposed with truth and passion in works that notably expanded the scope of photography. "Photojournalism" was not yet part of the English vocabulary, but it was already a full-fledged career in the 1860s.

In the hands of a few sensitive photographers, portraiture reaffirmed itself as one of photography's most incisive and popular forms. Sitting for portraits

was now much easier than it had been just a few years earlier, when photographers had to attach braces to the heads of their subjects to keep them still. In America and on the Continent, men like Brady, Nadar (the adopted name of Gaspard Félix Tournachon) and Étienne Carjat turned their lenses on some of the best-known people of the times, making likenesses startling in their character revelation. In England, Julia Margaret Cameron, one of the most extraordinary figures in the history of photography, produced portraits and allegorical scenes that delighted the Victorian taste for whimsy and romance. These photographs achieved all the dignity and style associated with oil portraits—but they were plainly photographs, not paintings.

The relationship between photography and painting was an ambiguous one, with neither side sure whether the other was ally or enemy. Painters increasingly turned to photography as a handy aid in doing life studies: A model could pose for a series of photographs in a short time and thus avoid repeated, tiresome (and perhaps expensive) sittings. There was another boon, as the French painter Edgar Degas discovered: He found he could get special angles and perspectives with the camera, and he applied the new vision to his painting. But in the minds of most painters, photography was a stepchild, a mechanical process useful at best as an adjunct to a higher calling—and in some instances, the photographers themselves seemed to agree. A group in Britain used the camera in slavish imitation of brushwork—sentimental paintings of bucolic scenes inspired equally sentimental photographs. The pictorialists, as these imitators came to be called, created their own world in the studio, their ideal being a well-staged photograph that looked just like a painting. Allegories were popular motifs, as were folk tales. Sometimes the intricacies of the plans required more than one plate—as many as 30 separate negatives might be combined to form a single print. The finished photographs were framed in gilt and exhibited in galleries.

Such pictures, no matter how questionable their goal, still can exert a powerful attraction. The photographers who produced them—concerned with detail, obsessed with laws of esthetics and convinced that their work was exalting the medium—charged their photography with a magnetism that belied its contrived nature. And this style of photography, like other styles that were successful during these 20 years, helped lay the groundwork for ensuing generations of artists.

Carlo Ponti

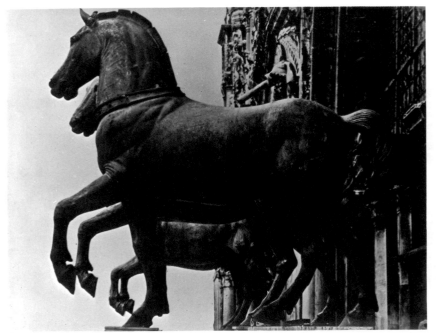

Greek Bronze Horses, Venice, date unknown

These four horses stand at the entrance to St. Mark's Basilica on the main square in Venice. But until Ponti lugged his heavy camera gear to the second story of St. Mark's and along the gallery on its façade, 19th Century Venetians had not seen close-up views of the horses and their fine Fourth Century B.C. detail. The gilded bronze figures, which stand about eight feet high, were cast in the time of Alexander the Great and brought from Constantinople to Italy by the Doge of Venice after the Fourth Crusade in 1204.

Nineteenth Century photographers relentlessly explored the world around them with their cameras, titillating the public with views not only of natural wonders and remote antiquities but also of often-missed details in their home cities—such as a soon-to-be-destroyed street in Paris *(opposite)*, or the majestic bronze horses high above St. Mark's Square in Venice *(above)*. The picture of the horses is the work of Carlo Ponti, who came to photography not by the usual route of chemistry or painting, but by way of instrument making. He was one of Italy's foremost optical craftsmen; he built and sold optical devices in his shop in Venice and in the 1860s was royal optician for the court of King Victor Emmanuel II.

But the work for which Ponti is remembered today is his tasteful documentation of the cities of northern Italy, especially Venice. In 1865 he published a series of photographic albums called *Ricordo di Venezia* (Souvenir of Venice), in which he combined his own pictures with those of several contemporary photographers to show Venice in aspects both small and grandiose —the Grand Canal with its ornamented Renaissance palaces, the hidden alleys with little bridges and footpaths, panoramic views and faithful renditions of the ancient city's architectural details.

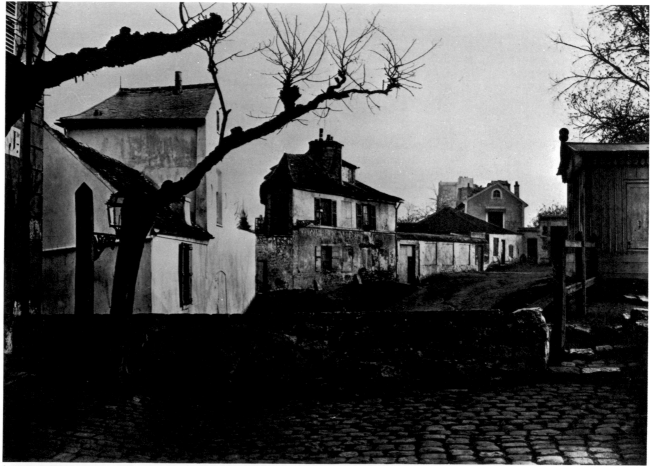

Impasse de l'Essai, Paris, c. 1860

Nostalgia was the aim of this view of an old lane on the edge of the Latin Quarter, photographed just before the houses and barns were torn down for the rebuilding of Paris in the 1850s. The street was the Impasse de l'Essai — the blind alley for trying out. It was a place where horse traders met to buy and sell their livestock.

In France in the 1850s, when Emperor Napoleon III commissioned a rebuilding of Paris under the first of the modern city planners, the Baron Georges Eugène Haussmann, a photographer was on hand to record the progress of this early urban renewal. He was Charles Marville, who was also official photographer of the works of art at the Louvre. As Haussmann's renovation obliterated shuttered cottages and crooked lanes to make way for the broad, sweeping avenues and grassy parks of modern Paris, Marville made a tour of the city with his camera, recording the look of the quaint medieval quarters before they disappeared forever. His pictures, above and on the following pages, were among the first to be placed in government archives.

A picturesque Parisian lane, overhung with a
delicate mist, glistens from a recent rain. The soft,
even light of overcast days particularly appealed
to Marville, who frequently trudged about with
his camera gear after rainstorms to picture
the luminosity of the damp cobblestone streets.

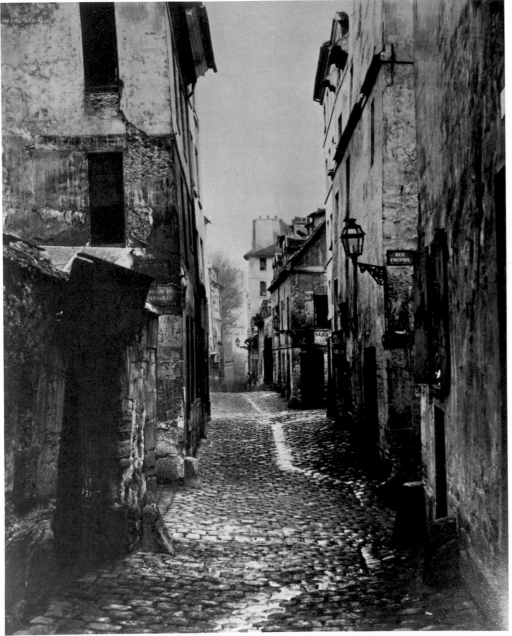

Rue Traversine, c. 1860

Opening of the Avenue de l'Opéra, c. 1860

Mathew B. Brady

While European photographers were recording the look of their cities, Americans were less happily chronicling the worst conflict of their history, the Civil War. Of all the photographers who descended on the scene, none left his name more solidly linked with the War than Mathew B. Brady, an ambitious perfectionist who combined the discriminating eye of an artist with the instinct of a businessman and the inspirational talents of a teacher.

Brady had a crew of some 15 photographers at the battlefield. They moved about in a cumbersome van that the soldiers called a "what-is-it wagon," which the photographers used for on-the-spot developing of their negatives. With unflagging diligence they compiled a comprehensive record of the War, from scorched fields left void of human life to scenes of pathos such as the hanging at far right.

Long before he involved himself in recording the Civil War, Brady was well known as a portraitist. Through compulsive work and consummate skill he had earned such fame of his own that he had other celebrities flocking to his studio to be photographed. Among his sitters were enduring figures such as President Abraham Lincoln and those of ephemeral fame such as circusman P. T. Barnum's curiosities *(right)*.

Though Brady's eyesight failed and he eventually went blind, he continued to direct his staff, which was divided into two galleries, one in New York and another in Washington. Not the least of his legacy was the perfectionism that he instilled in his photographers, many of whom went on to prominence in their own right. Some of their works appear on pages 54 through 59.

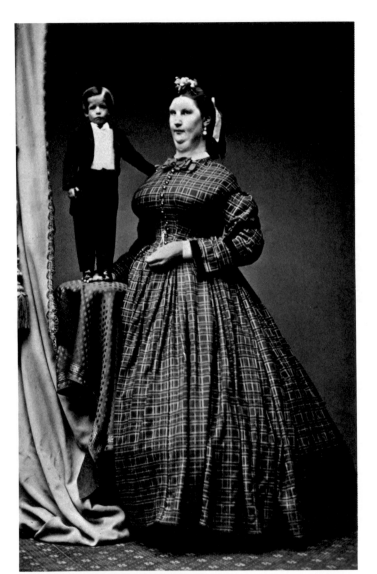

Performers from Barnum's Circus, date unknown

A 7-foot-11-inch giantess and a midget hardly 3 feet tall, both from P. T. Barnum's circus, stand side by side for this startling portrait in Brady's New York studio. Barnum, whose circus was held nearby on Lower Broadway, used the Brady studio for official portraits of his entertainers, many of whom were bizarre studies in abnormality.

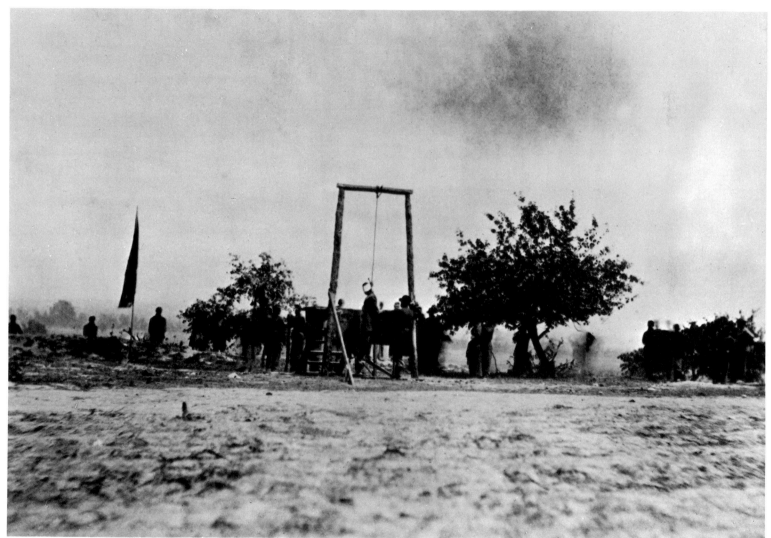

Execution of William Johnson, 1864

For desertion from the Union Army's 23rd Colored Infantry, William Johnson, a Marylander, was hanged in a field at Petersburg, Virginia, in 1864. A truce flag flies a few yards to the left of the scaffold and its blindfolded victim, to allow both Union and Confederate sympathizers to put down their weapons and witness the gruesome event.

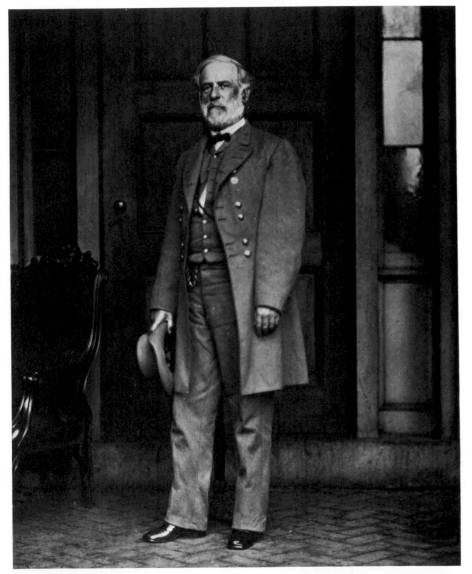

General Robert E. Lee, 1865

Strong in defeat, Confederate leader General Robert E. Lee stands under the back porch of his home in Richmond 11 days after he surrendered to Union General Ulysses S. Grant in 1865. Not surprisingly, he was reluctant to pose and did so only when pressed by Brady, an old friend.

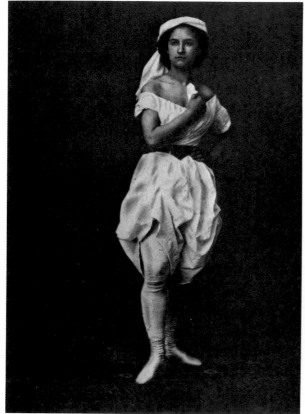

Ella Jackson, c. 1865

Few celebrities of the stage needed persuading to
go before Brady's camera. Above is Ella Jackson,
who in 1862 made a promising debut as a mime
—a popular kind of entertainer of the day—and
then posed in the costume in which she performed.

Walt Whitman, who chronicled the Civil War in
prose and poetry as Brady did in pictures, looks
inquisitively at the photographer. Whitman served
in the Indian Bureau of the Department of the
Interior under President Lincoln, and was a
patron of Brady's Washington portrait gallery.

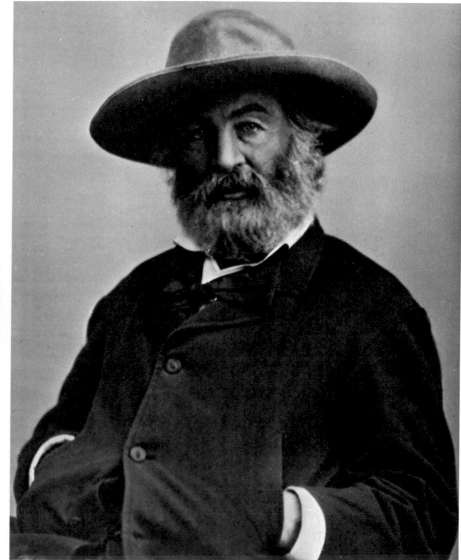

Walt Whitman, c. 1870

Alexander Gardner

Mathew Brady's principal competitor as chronicler of the Civil War *(pages 50-53)* was his onetime assistant, Alexander Gardner, a Scottish-born amateur chemist. Arriving in New York in 1856, Gardner was hired by Brady and within two years was managing Brady's Washington gallery.

When the War came Brady sent Gardner South to help cover it. But their forceful personalities quickly clashed. Gardner wanted a by-line on his photographs; Brady, who directed the operation, said no. So Gardner struck out to chronicle the War and its aftermath on his own. Emulating his master, Gardner shot few of the pictures himself; he usually set up the scene and gave directions, leaving the actual photographing to the staff he assembled—to whom he gave the credit that Brady had denied him. He did, however, process the pictures, calling on his chemistry training.

Back in Washington after the War, Gardner ran a portrait gallery and also found a new use for photography, compiling a rogues' gallery for the Washington police, a practice without which modern police departments and the F.B.I. could hardly exist.

But Gardner's primary contribution was his *Photographic Sketch Book of the War,* a two-volume album with prints pasted onto the pages by hand. By 1866, when it was published, Americans had so tired of the horrors of war that few of them spent the $150 it cost to buy Gardner's volumes. If they had, they would have seen a moving record of debris-strewn battlegrounds, blackened buildings and mortared bridges, and scenes of desolation juxtaposed with the ironies of human behavior—a silent plea for peace.

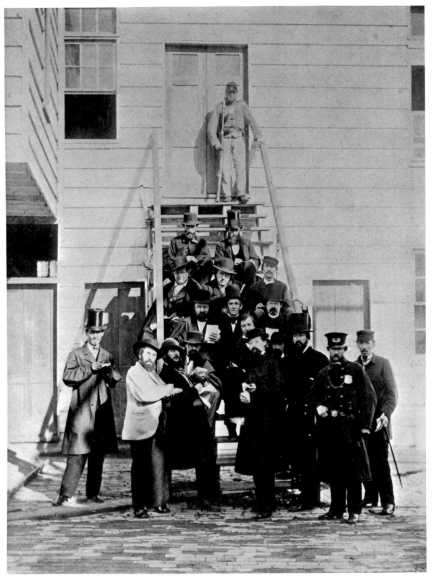

Correspondents at the Wirz Execution, 1865

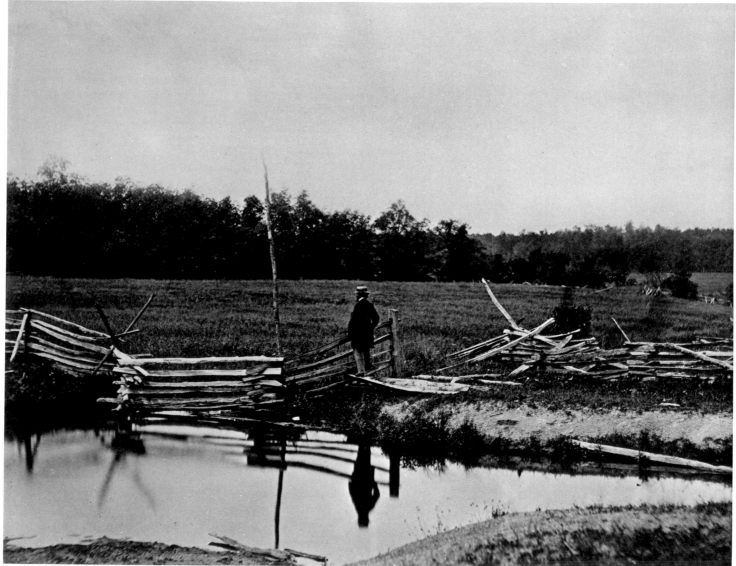

Mathew Brady in Field Where General John Reynolds Died, 1863

Gardner photographed his boss, Mathew Brady (in straw hat, above), at Gettysburg, standing in contemplation of a ravaged field. The Reynolds of the title was a Union general who was as loved and hailed for his service as Wirz was despised.

George N. Barnard

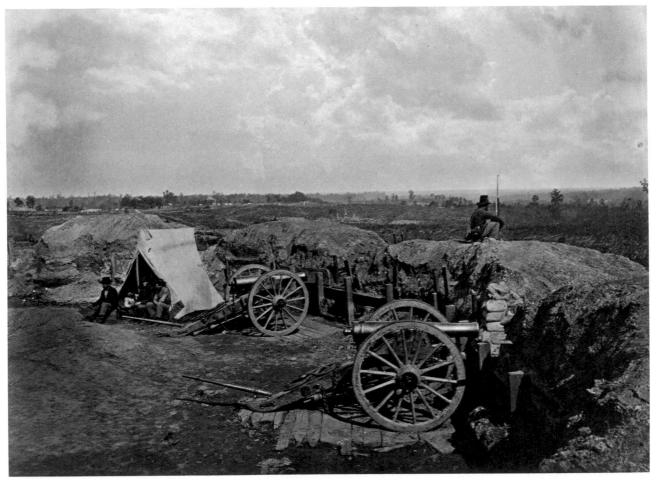

Rebel Works in Front of Atlanta, Georgia, 1864

In the autumn of 1864, when General William Tecumseh Sherman marched through Georgia with 60,000 men, the Army took along an official photographer in the person of George N. Barnard, one more member of the Brady entourage *(page 50)*. Barnard's main assignment—given him by General Orlando Metcalfe Poe, Chief Engineer of the Mississippi Division of the Army —was to photograph bridges, railroads and other Army installations. But as the troops swept through Atlanta and on to Savannah, Barnard also photographed informal scenes of soldiers *(above)* and of the devastated buildings, streets and fields of the Confederacy *(right)*. To facilitate the formidable task that Barnard faced, Army officials outfitted him with two pack mules, an armed escort, a driver and a covered wagon that served as an on-the-scene darkroom.

Barnard's photographs are usually dominated by ominous clouds that lend a sense of doom to the already stricken scenes. These clouds were added separately by double printing in the darkroom, a technique that produced photographs that were among the most dramatic to come out of the Civil War.

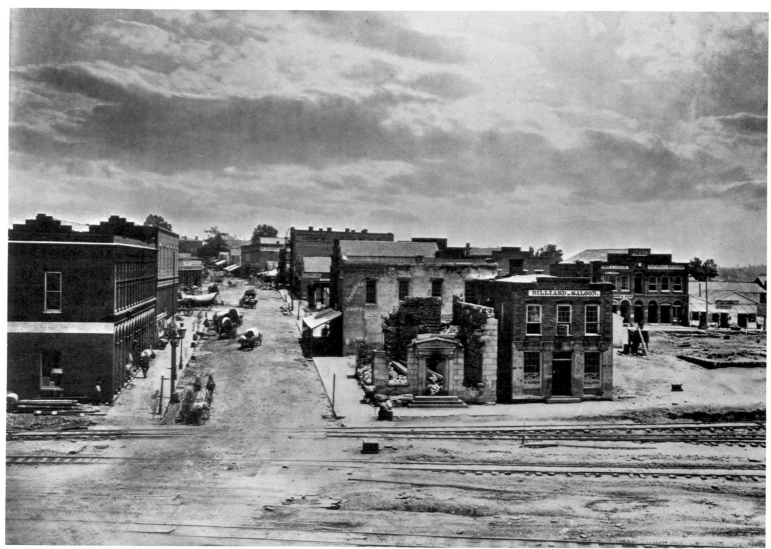

City of Atlanta, Georgia, 1865

◀ *Under a cloud-filled sky —a Barnard hallmark —four weary Union soldiers pass the time in a tent at a makeshift campsite somewhere outside Atlanta, while a single vigilant guard scans the horizon from the top of a row of earthen bunkers recently captured from Confederate soldiers.*

Focusing on the shell of the once-thriving Atlanta Bank standing alongside wrecked railroad tracks, Barnard caught —a year after the burning of Atlanta —a measure of the South's loss. Nearly 75 years later, MGM used this photograph as a model for a set in the movie "Gone With the Wind."

Of all the photographers who documented the Civil War, no other had as dispassionate a view as Timothy H. O'Sullivan, the youngest of the Brady-trained cameramen. Although he did not overlook human interest *(right),* O'Sullivan more frequently chose to portray the impersonal—battlefields cluttered with sprawling corpses, makeshift bunkers long abandoned, and fences and railroads crossing the land.

O'Sullivan went to work in the New York studio of Mathew Brady *(page 50)* as a boy of 15; at 20 he was a key member of Brady's Civil War team. Then, when Alexander Gardner *(page 54)* left Brady in 1863, O'Sullivan went along to act as Gardner's aide. Gardner's *Photographic Sketch Book of the War* includes 45 pictures by O'Sullivan.

When the War was over and Americans turned their attention west, O'Sullivan showed them the look of the land through the eye of his camera. For the government, he went on two expeditions that surveyed the American frontier and another that searched the Panamanian coast for possible canal sites. He pushed deep into the isthmus's jungle; but he discovered that the relentless heat, rain and underbrush made his heavy equipment not only a burden but practically useless. Thereafter O'Sullivan confined his work to the coast, taking informative shots of Indian settlements and beautiful, sweeping views of misty bays *(opposite)* where ships sought harbor.

John L. Burns with Gun and Crutches, 1863

John L. Burns was over 70 years old and a veteran of the War of 1812 when he plunged uninvited —and without a uniform—into the battle of Gettysburg in 1863. He fought valiantly for three days and was wounded three times; O'Sullivan made this character study of him while he was recuperating after the rigors of the battle.

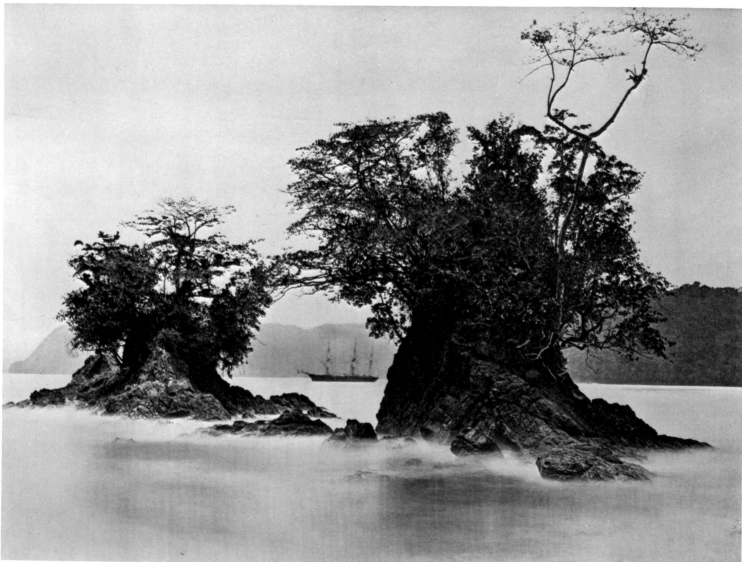

U.S.S. Nipsic in Limón Bay, 1870

In 1870 O'Sullivan accompanied the United States team seeking a site for a canal across the Isthmus of Darién (now Panama). In the scene above, a Navy bark framed by tropical trees rides at anchor in a port on the Atlantic side of the isthmus.

Nadar (Gaspard Félix Tournachon)

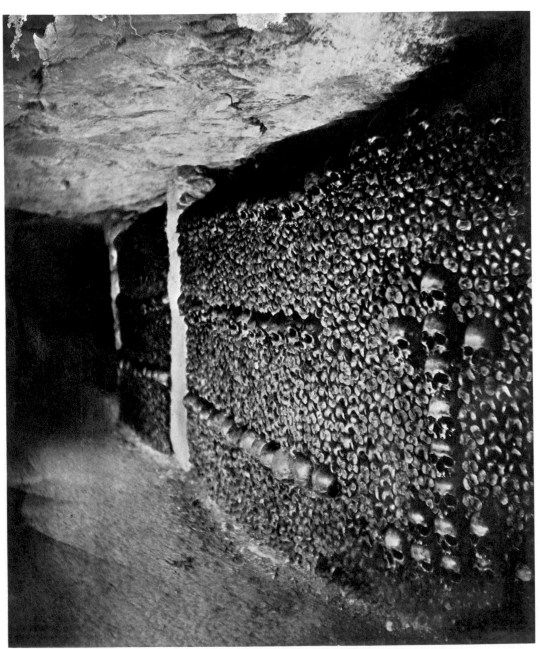

The Paris Catacombs, 1861

In Europe, photographers were beginning to use the camera to evoke the full range of human emotions, from humor to melancholy. One of the most flamboyant, Gaspard Félix Tournachon, a Frenchman who called himself Nadar, had a lust for the unique that drove him to take the world's first photographs underground *(left)* and the world's first from the air. To do the latter he hovered over Paris in a swaying balloon, between shots coating his photographs with wet collodion *(page 13)* in a cloth-draped corner of his precarious craft.

Quite aside from his stunts, Nadar was the most sought-after portrait photographer in Paris. As a former caricaturist he was a perceptive student of human nature, a fact that enabled him to catch unerringly the personalities of his sitters. Soon he was besieged by would-be sitters, and since he was himself a well-known member of the Paris art world, he could confine himself to celebrities. He chose gentlemen sitters at that, disdaining to photograph women because, he observed, "the images are too true to Nature to please the sitters, even the most beautiful."

Nadar had a taste for the bizarre, and in 1861 he was provided with a chance made-to-order when workmen in the Paris sewers uncovered thousands of human skulls and bones stacked neatly along the walls of the early Christian catacombs. Nadar descended into this subterranean world and used the fiery glow from ignited magnesium wire to take the eerie photograph at left.

Along with his macabre bent Nadar had a sure ▶ *grasp of human nature and a talent for putting his sitters—who were usually his friends—at ease before his camera. He caught the alert look of Franz Liszt (right), when the venerable musician was 75 years old and was wearing the habit of the Franciscan order, which he had joined at 50.*

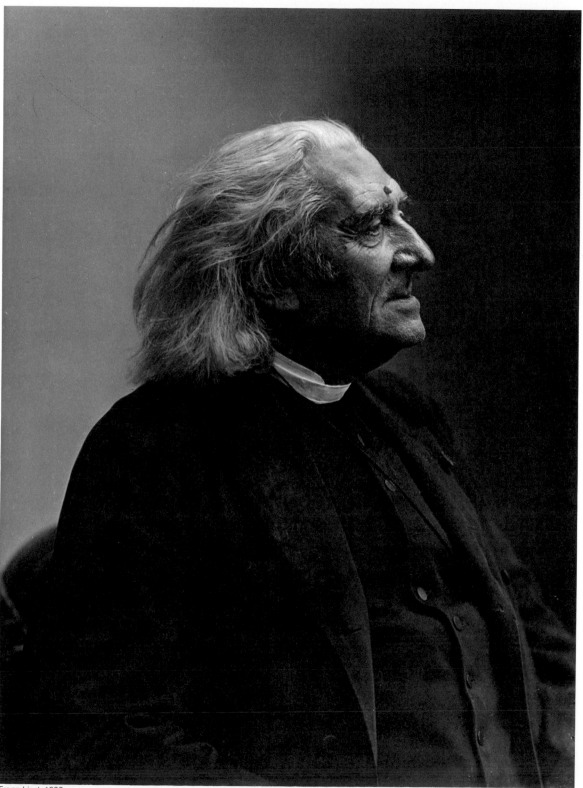

Franz Liszt, 1886

Étienne Carjat

Good portraitists need at least two talents: an understanding of their sitters' nature and the ability to put them at ease. Étienne Carjat had both. Like his contemporary Nadar *(pages 60-61)*, he had spent 10 years at caricaturing and therefore at plumbing human nature. His talent for making his subjects relax was attested to by one of his peers, who said: "He doesn't torture them, dislocate their necks, distort their arms or legs. . . . He only asks them to strike a natural pose, and he thus achieves a kind of physiognomic tracing that is an astonishing likeness."

Carjat had talent to spare, and he spent it in several occupations. He took up photography as a hobby and then made it a profession to which he devoted 20 years. Simultaneously he engaged in journalism, acting and playwriting. By virtue of his ties with the theatrical and literary worlds, he made actors and writers the subjects of many of his portraits. He also photographed celebrities from the worlds of politics and science. All were superb characterizations, achieved through careful attention to both personality and pose.

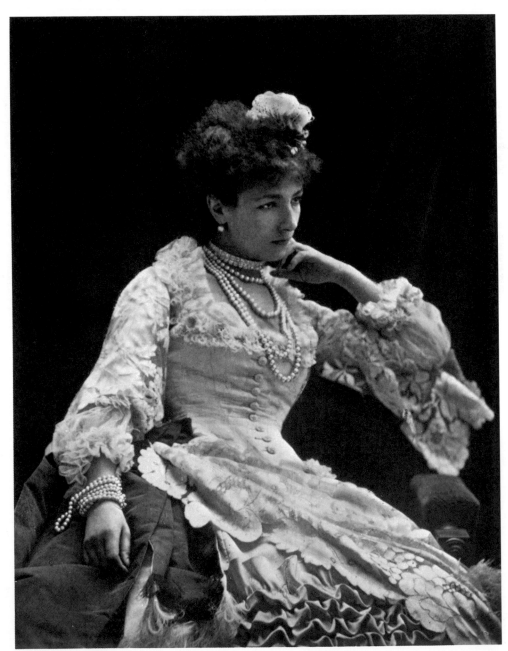

Sarah Bernhardt, the toast of all Paris for nearly 50 years, strikes an intimate and pensive pose. This photograph of "The Divine Sarah," as Parisians called her, appeared in the Galerie Contemporaine, a photographic album published during the 1870s to show Frenchmen what the noteworthy people of their time looked like.

Sarah Bernhardt, c. 1870

*Bathed in a soft halo of light, the brooding poet
Baudelaire — a victim of ill health and drug
addiction — reveals something of his tortured soul
for Carjat's camera. Baudelaire often scorned
photography on the grounds that its sole task
"consists in being the servant of science and art,"
but he consented, out of friendship and respect
for Carjat, to pose for him several times.*

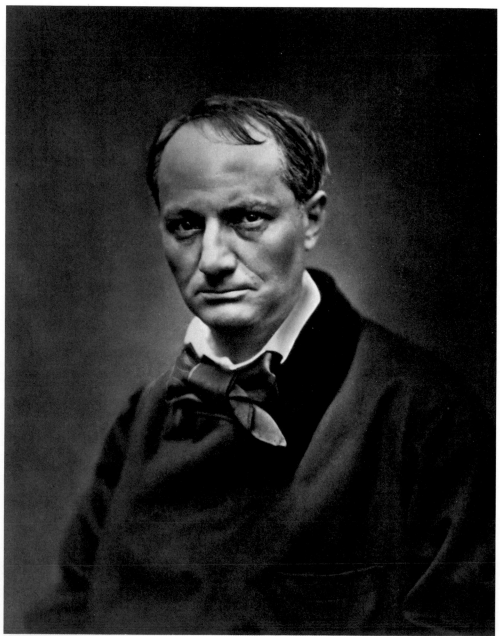

Charles Baudelaire, c. 1863

Julia Margaret Cameron

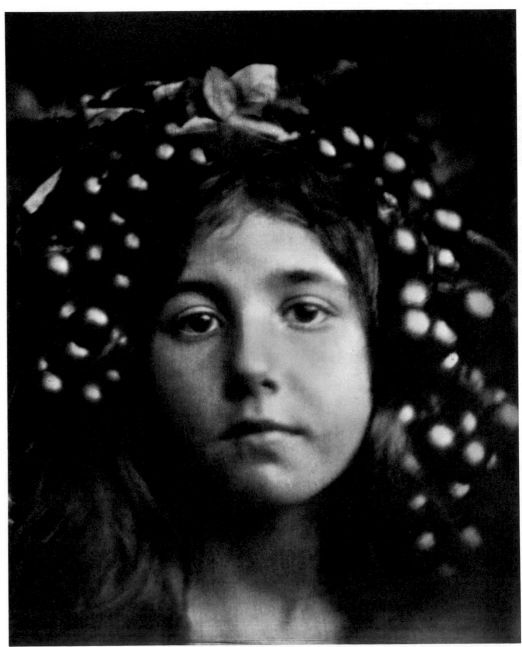

Circe, date unknown

Vivacious and eccentric Julia Margaret Cameron took up photography as an amusement of middle age and soon became a master portraitist. Her technical knowledge was uncertain — most of her portraits were out of focus, apparently not on purpose. She is perhaps most famous for her staged pictures, in which her sitters posed as figures from history and literature. But she possessed shrewd insights into human nature, and she was one of the first to realize how it could be emphasized by lighting effects and close-up views.

A loving woman with a zest for life and people, Mrs. Cameron raised her own six children and several orphaned nieces on her country estate. Then, at the age of 48, she began her career as a photographer when a daughter presented her with a camera. With typical enthusiasm, she lost no time converting a coal shed into a darkroom and a glassed-in chicken coop into a studio. To sit for her she enlisted servants, relatives *(left),* neighbors *(right)* or any stranger who caught her fancy. Her persistence led to a large variety of portraits graced with style, warmth and charm.

The photographer's young niece, decked out in a flocked veil, is meant to represent the sorceress Circe of Greek mythology. But what comes across the years is a soft and loving portrait of a round-faced girl, her huge eyes and classic features conveying the allure and charm of Circe but none of the wickedness.

These young girls wear the demure expressions ▶
that have come to stand for Victorian romanticism. The lighting falls on cherubic faces, paying scant attention to dress. None of the girls gazes into the camera, and their relaxed demeanor suggests a languid day in the country.

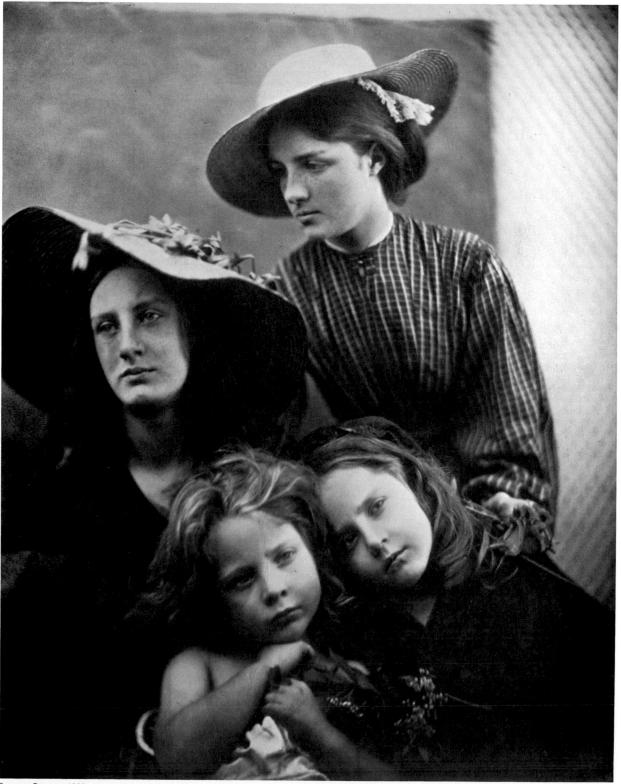

Summer Days, c. 1865

Henry Peach Robinson

In Henry Peach Robinson's time, the most highly praised photographs were those that most resembled paintings — and the master of this imitative art was Robinson. "The high priest of photographic picturemaking by rule and combination," one critic called him.

Robinson went about photography methodically, following then-accepted rules for lighting, the placement of objects and the relation of subject matter. Storytelling pictures were very much in vogue, and he used every device he could think of to tell his tales, whether he was staging a childhood story *(right)* or arranging a pastoral tableau *(opposite)*. He mixed the real and the artificial in the same scene, and combined elements from several different negatives into one composite print. Sometimes as many as 30 pieces went into the making of a single picture.

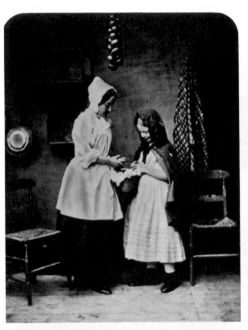 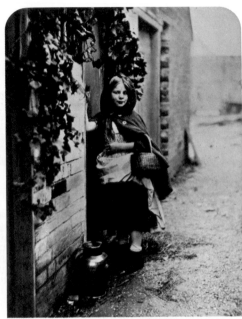

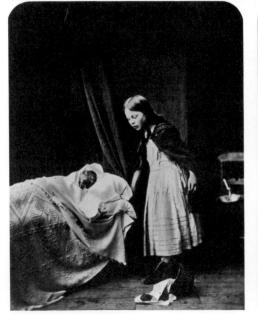 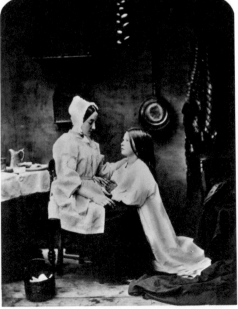

Judicious attention to details of costume and background lends charm and credibility to a sequence based on a children's classic. In the frame at top left, Red Riding Hood says good-by to her mother. Next, she departs from the family's ivied cottage; she hesitantly approaches the disguised wolf in her grandmother's bed and finally the child relates the whole narrowing episode to her mother.

Little Red Riding Hood, 1858

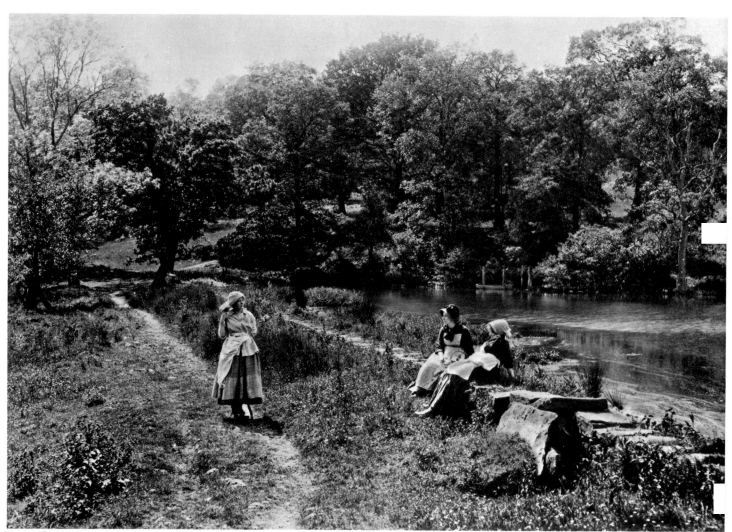

Wayside Gossip, 1883

Sheltered from the outside world by a dense grove of trees, three English farm women seem to have been captured during a casual encounter. As the photographer described this idyllic scene in a handbook he wrote on photography, however, it was anything but spontaneous: "I tried first with the two figures, relying on the bunch of nettles in the left-hand corner for balance . . . and tried again, introducing the third figure. This was better."

Oscar Gustave Rejlander

In a continuing quest to elevate photography to the level of painting, many former artists created complicated allegorical or classical photographs. One such photographer was Oscar Rejlander, who earned his living with portraits and his reputation with composite photographs that combined as many as 30 negatives in a single print.

When it suited his plans, Rejlander produced complete photographs from single negatives, such as the ones that are shown here. But his moralistic pictures usually required preliminary sketches, a series of separate exposures, and then painstaking, section-by-section printing *(page 70)*. The work was tedious, but Rejlander was rewarded by the interest of His Royal Highness Prince Albert, who bought many of Rejlander's composites for his own collection.

Acclaim followed quickly, but after a few years at these time-consuming composites, Rejlander found the work became too great a drain on his energy. In 1859 he wrote of his discontent: "I am tired of photography-for-the-public, particularly composite photos, for there can be no gain and there is no honour, only cavil and misrepresentation." This disenchantment led Rejlander to try to revitalize his portrait business, but to no avail. He died a pauper, leaving a small but significant collection of superbly imaginative photographs.

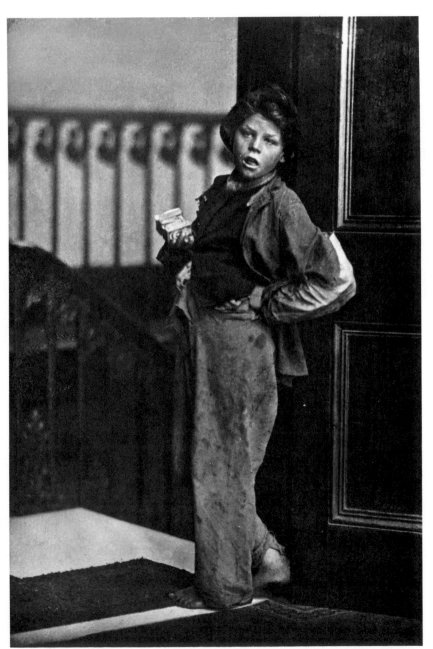

A tattered gamin jauntily turns toward the camera in the doorway of the photographer's London studio, caught where masses of light and shade meet. The shadow patterns make a background for a confident boy showing off his worldliness.

The Match Seller, c. 1870

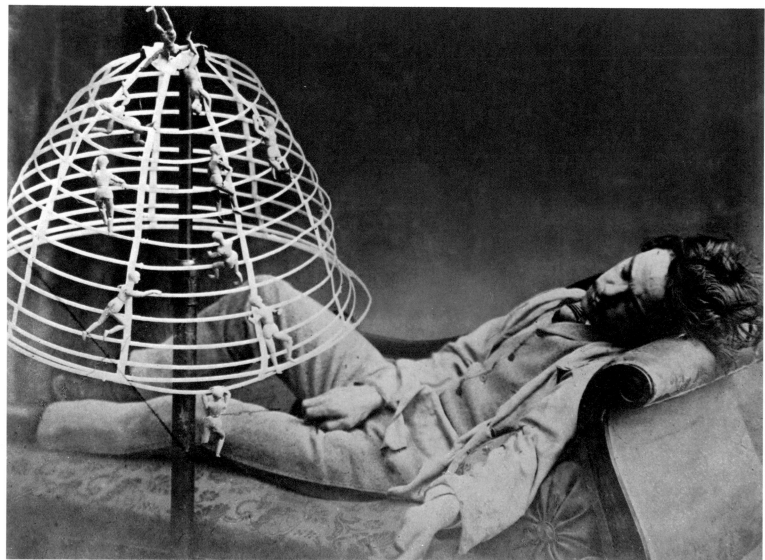

The Dream, 1860

Allegory runs riot in this picture of a furrow-browed sleeper — probably the photographer — menaced by mannequins perched on the frame for a crinoline skirt. The symbolism refers to contemporary jokes about lovers' entanglements.

A poor carpenter broods over his plight as his wife and daughter sleep. The moodiness is increased by superimposed images of the family —the father is also faintly visible above the bed, the wife's nightgowned figure and upturned face merge with his figure and a second image of the child is on the floor near her father's hand.

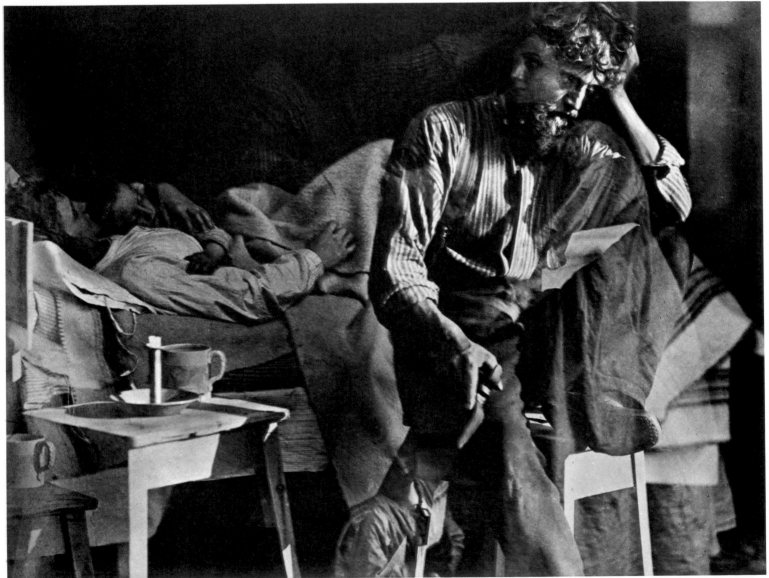

Hard Times: Spiritistical Photo, 1860

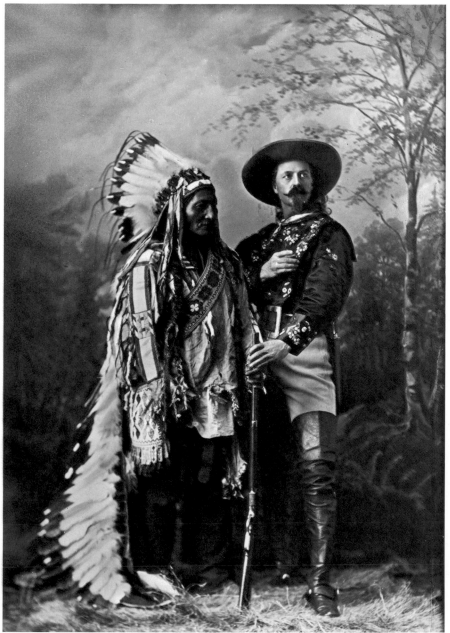

Sitting Bull and Buffalo Bill, 1886

An ambitious photographer with a commercial flair, William Notman chronicled the life and landscape of Canada during the mid-19th Century with verve and enthusiasm. He staged scenes in a complex studio and also crisscrossed Canada to record the large and small moments of its history. The photographs he made are so rich in detail redolent of their times that they can be examined and savored for hours.

Notman, a native of Scotland, settled in Montreal with his wife and firstborn in 1856 and advertised his talent for making photographs of all kinds. To support his claim, he set up a large and versatile studio and in the next decade became Canada's most important photographer. In his studio he could, by his own account, ''build cottages, form sandy beaches with boats drawn up, erect tents, plant trees . . . form snow-wreathed plains or introduce a frozen lake or stream in which a skater may appear to glide.'' The hundreds of pictures he made in these artificial surroundings were always arresting and sometimes surprising *(left)*.

But Notman—and his staff, including three of his sons, who followed him into photography—also made superbly realistic photographs for all kinds of clients in homes, in offices and out of doors, producing during a successful commercial career an unusual record of the life of a young country.

An unlikely couple—Sioux Chief Sitting Bull and Buffalo Bill Cody, who were appearing together in Cody's Wild West Show—stand self-consciously before a painted backdrop in Notman's studio. The picture is notable for its textures: The rude clothes of the defeated chief, offset by his headdress and adornments, contrast with the fancy show garb of the cocky Buffalo Bill.

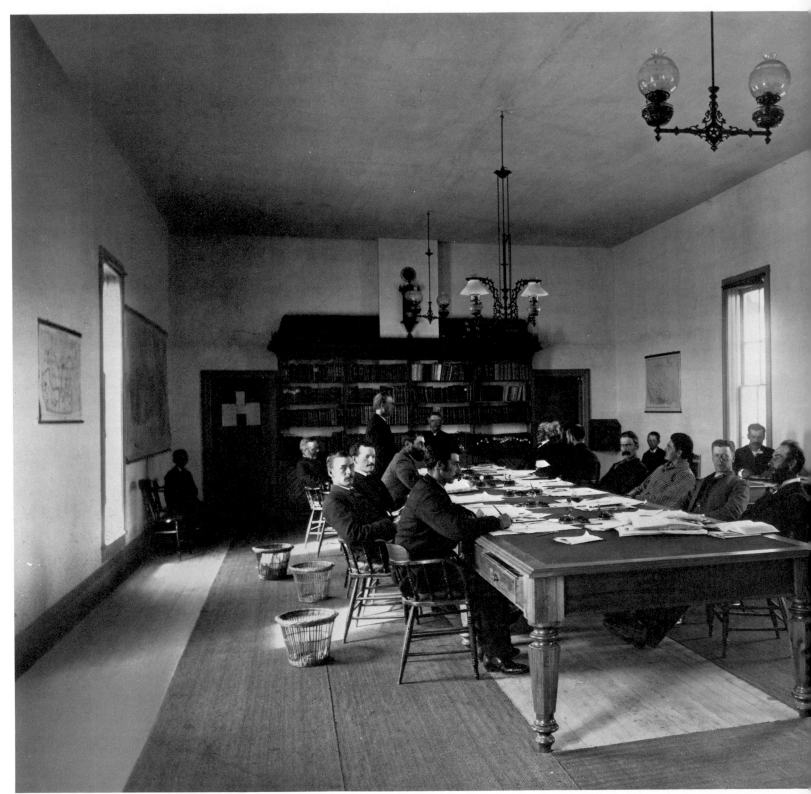

Northwest Council, Regina, Saskatchewan, 1885

Businesslike and intent, the 14 members of a
territorial governing body gather for a meeting in
their unpretentious headquarters. The picture, like
all taken by Notman and his associates, has
a clarity that makes the people and room almost
three-dimensional. This effect is heightened by
the perspective of the table, which seems to zoom
out from the background to extend its solid,
gleaming form in the direction of the viewer.

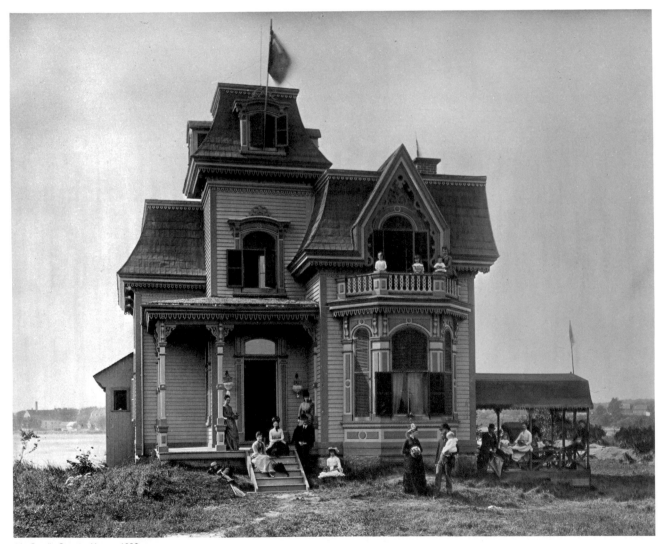

Mr. Gurd's Country House, 1886

With concise photographic elegance, a summer house outside Montreal is displayed with its many occupants. Such beautifully detailed pictures captured a sense of life in Canada. The frontal view of the house gives prominence to the gingerbread trimming of the architecture, while the comfortable, well-dressed people indicate an established way of life in the new land.

Six Crusaders in Pursuit of Realism 78

William Henry Jackson 80

Carleton Eugene Watkins 82

Adam Clark Vroman 84

Peter Henry Emerson 86

John Thomson 88

Paul Martin 90

Photographers represented in this chapter include: ▶
William Henry Jackson 1
Carleton Eugene Watkins 2
Paul Martin 3
Peter Henry Emerson 4
Adam Clark Vroman 5
(Not shown is John Thomson;
no photograph of him is known to exist.)

Six Crusaders in Pursuit of Realism

In the last 20 years of the 19th Century, six great photographers renewed the quest for realism. Three of the six were Englishmen, reacting to predecessors who had tried to make photographs into works of art by doctoring them to look like paintings. The new realists set out to discredit this approach once and for all, creating pictures that showed the world as it was. They did not totally succeed; the arguments about the relative merits of each method raged for years. But they did reestablish a strong current of realism that had been blocked off by the stilted elegance of carefully staged, touched-up work. In America, meanwhile, three other photographers were working in another realistic direction, seeking an honest rendering of one of the country's most exciting and tumultuous epochs—the settling of the West.

The three American photographers who went west were responding to a national obsession with the frontier. Young men were rushing out to the newly opened country in search of gold, land and adventure. For those who stayed behind, the West—especially during the early years—was truly a land of legend. Photographs of the countryside and its people and of the frontier towns and landscapes were still rare. Rumors and hearsay dominated the popular ideas of the region. The photographers changed that. The legend would never die, but William Henry Jackson, Carleton Eugene Watkins and Adam Clark Vroman helped clothe it in reality. In this endeavor, the photographers faced a staggering array of obstacles. The new country was stunningly beautiful, but it was difficult to traverse even by mule cart. The Indians were fascinating, but often unfriendly. The cameras were heavy and cumbersome—enlargements were impractical at the time, so that oversized plates were sometimes the only means possible of capturing the grandeur of the vistas—and an adequate kit for wet-collodion photography was likely to weigh over 100 pounds. But these handicaps were overcome, often by achievements that rivaled the resulting photographs themselves.

Jackson, who was a wiry but physically strong man, lugged his heavy equipment around by mule. But when he wanted a particular panoramic shot, he thought nothing of clambering up a rocky cliff with his bulky equipment strapped to his back. When he had no water he would use melted snow to develop his negatives. He traveled on the railroads by bartering for his trips with pictures of the train crews. The pictures that he and Watkins took on their separate travels helped save the West by convincing Congress back in Washington of the wisdom of setting aside national parks to protect spectacular scenic areas.

Largely unappreciated at the time but equally important were the records that Vroman was making of Indian cultures. The tribes that had occupied these wondrous lands for centuries were being jostled aside onto reservations, while their territories and their cultures were overwhelmed by the

relentless push of the settlers. Their plight was not lost on Vroman. He quietly recorded their life styles, catching in their vanishing world a sense of history and place unnoticed by other visitors. His views of the Indians remain today as poignant reminders of peoples and customs that were trampled in the white man's westward rush.

During the same time, the three English photographers — Peter Henry Emerson, John Thomson and Paul Martin — were reawakening their countrymen to the delights of the everyday world. Emerson was a leader and tireless spokesman for uncontrived and ordinary scenes of daily life. Highly educated, he had so many degrees — among them an M.D. — that his peers dubbed him "Emerson, A.B.C.D.E.F.G."; and he was full of high-flown theories about the science of optics. But for all that, he believed that "Nature should be the first principle of art," and he applied his knowledge so subtly that his pictures are deceptively simple revelations of human character. Thomson, who had a similar point of view, traveled to China, Formosa, Siam, Cambodia and the Malay Peninsula in search of pictures that would portray humanity plainly and honestly. The third of the trio, Paul Martin, pioneered a new kind of photography on vacation trips to England's seaside resorts, where, with his camera ingeniously concealed as a pile of books, he made pictures that heralded the possibilities in the candid photograph. Thus these photographers and their disciples brought realism, alive and well, to the threshold of the 20th Century. To them and the unstaged, honest pictures they took, modern photography owes a major debt.

William Henry Jackson

William Henry Jackson won fame as the man who revealed in pictures the glories of the American West. His photographs of the beauty of Yellowstone helped convince recalcitrant Congressmen to establish the area as a national park in 1872. But his reputation also rests on his brilliant record of the settling of the West by the pioneers who built railroads, industries and cities to establish civilization in the wilderness.

Jackson, a man with a thirst for adventure, was already an accomplished photographer when he drifted west following the Civil War. He settled in Omaha, founded a studio, which prospered, and set out on forays into the surrounding country. He took pictures of the Indians—he was one of the first to show how they actually lived—and produced hundreds of photographs of the Union Pacific railroad line, then inching westward.

This taste of the excitement of the frontier only left him hungry for more, and he became a member of the U.S. Geological Survey team that was mapping and scouting for natural resources. He insisted on dragging along a camera that, even in those days, was unusually large, making 20 x 24-inch negatives. From these outsized plates —and other plates from smaller cameras—the world has gained a legacy of magnificently clear and beautiful views of the grandeur of the Old West.

A solitary mule—part of a train carrying equipment for a surveying expedition Jackson accompanied—peers into the abyss of Cunningham Gulch from a narrow, pitted trail in Colorado. The photographer used the profile of the mountain as an element of design, against which man's intrusion into the setting—his mule —becomes a subtle and telling counterpoint.

Trail in the San Juan Mountains, 1875

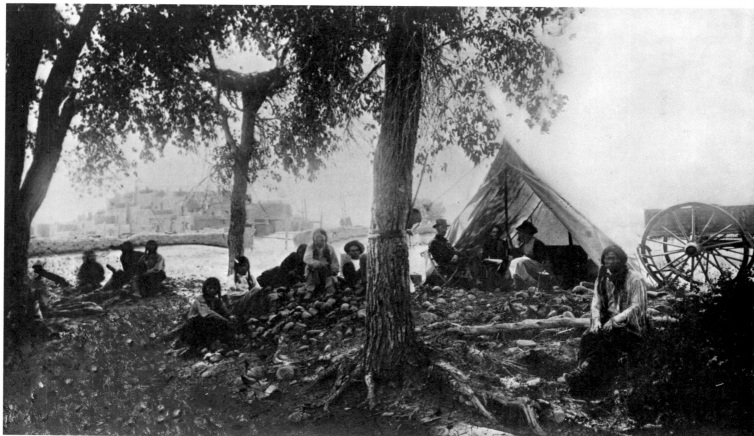

Pueblo Indians of Taos, c. 1885

Pueblo Indians and three white visitors gather in the Sacred Grove of Taos, New Mexico, under a tree supporting a basket for an aboveground burial. The walled pueblo in the background so fascinated the photographer that he took precise compass and tape measurements for reference in building a clay model of the settlement.

Carleton Eugene Watkins

Another Easterner lured westward by dreams of riches was Carleton Eugene Watkins, an upstate New Yorker who went to California in search of gold and stayed to take photographs of the settling and urbanization of San Francisco. While working in a book shop in San Francisco, Watkins met Robert Vance, a respected local daguerreotypist who needed a manager for his gallery in San Jose. Watkins accepted a temporary job there, became enthusiastic about photography and decided to stay.

After several years in San Jose, Watkins opened his own studio in San Francisco; besides making portraits for a living, he wandered about the city shooting scenes of its life and settings. His pictures seem innocent, almost quaint today, but reveal his grasp of the historic moment and appreciation of the power and beauty that can be communicated by a photograph.

When Watkins took trips out of San Francisco, he usually went to the nearby Sierra Nevada, where he was so enthralled with the majesty of the Yosemite area that he renamed his studio the Yosemite Art Gallery. His breathtaking photographs of that region later helped convince Congress to establish Yosemite as a national park in 1890, as William Henry Jackson's pictures had done for Yellowstone 18 years earlier.

By 1906, when the famous earthquake rocked San Francisco, Watkins had amassed a large number of photographs of the West, including a priceless collection of frontier daguerreotypes. The earthquake destroyed the collection—and Watkins as well. Mentally, physically and financially exhausted, he was committed to a state hospital where he ended his days.

Launching of the U.S.S. Camanche, Mission Creek, California, 1864

When the iron-hulled warship, the Camanche, was launched in San Francisco Bay in 1864, the ubiquitous Watkins was on hand to take this photograph of the crowded ceremony. With simple reportorial pictures like this, Watkins established himself as a sharp observer and historian of Northern California. By soaking up the local color with his camera, he left a lasting and valuable record of the settling of the West.

Infatuated by the vistas of his adopted city—and ▶ its architectural eccentricities—Watkins took this photograph of a flat-roofed octagonal house (far right) nestled on San Francisco's Rincon Hill. The house was perfectly designed for the locale, windows on eight sides letting in the sun and affording a variety of views. Other residents shared Watkins' delight with the city, for scenes of San Francisco sold briskly at his gallery.

Octagonal House, San Francisco, c. 1865

Adam Clark Vroman

Hailed today for photographs that show with sympathy and insight Indian life in the American Southwest, Adam Clark Vroman was a Midwestern railroad man who took his bride to California for her health. The trip proved futile: After only two years of marriage, Esther Vroman died of tuberculosis. But her husband remained in his adopted Pasadena and opened a bookstore.

An amateur photographer in his free moments, Vroman went in 1895 on the first of many photographic treks to the Indian lands of the Southwest. There he spent his time among the Hopi, Zuñi and Navajo; photographing their rapidly disappearing ways of life quickly became Vroman's obsession. He returned year after year, each time taking with him as gifts prints from the previous year's shooting—prints made on paper coated with platinum compound rather than with compounds of silver. It was not until the mid-1950s, however, with the discovery of 2,400 negatives, that the elegance, drama and superb documentary style of Vroman's ethnological studies were fully appreciated.

Vroman's success with the Indians owed much to his approach. In 1901 he recounted his technique: "If you are a little patient, and do not try to hurry matters you will have but little trouble. . . . The Indian must always have plenty of time . . .; sit down with him, show him the camera inside and out. . . ."

Between excursions to Indian territories, Vroman photographed Southern California's missions, relics of the days in the 18th Century when Spain exerted its influence there. Most were abandoned, but Vroman found in their ruins appealing scenes from a forgotten epoch in American history.

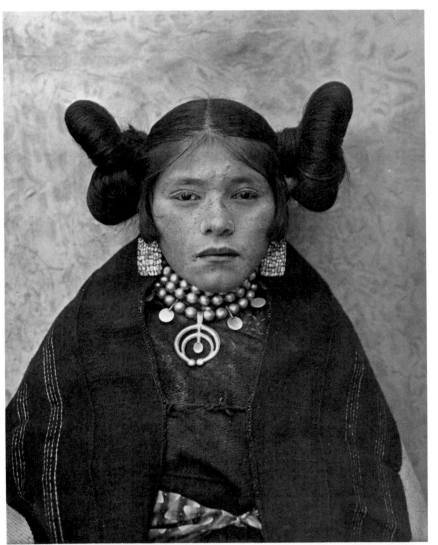

Hopi Maiden with Squash-Blossom Hairdress, 1901

In this simple and honest portrait of a Hopi maiden, Vroman caught the dignity and beauty of the young girl. While others paid scant attention to the Indians, Vroman recorded their faces, costumes and life styles. The girl's hairdo is typical of the Southwest Indians, a ceremonial style traditional for unmarried girls.

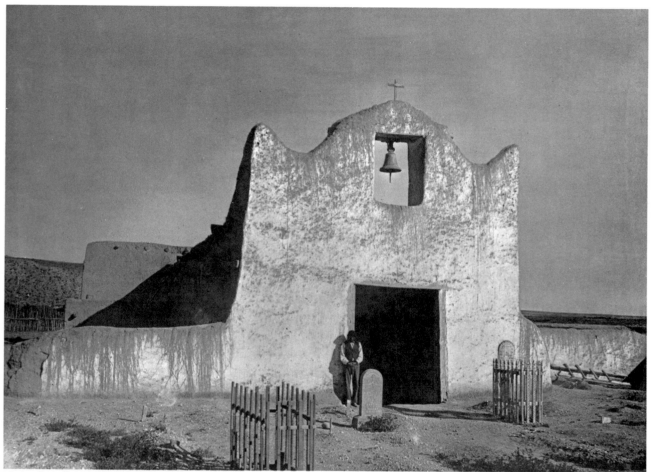

Mission, Santa Clara Pueblo, New Mexico, 1899

An Indian leans languidly against the front of an old adobe mission in the late-day sun of the New Mexican desert. The Western settlers usually ignored the missions, but Vroman appreciated them as interesting architectural exercises in design, their geometric shapes fitting perfectly the stark simplicity of the Southwestern landscape.

Peter Henry Emerson

While American photographers were discovering the wonders of the frontier, some Englishmen were finding new ways to picture familiar scenes of their country. One of them was Peter Henry Emerson, a dogmatic man who upset the English esthetic establishment by launching an attack against the most popular photographic mode of the day —touched-up pictures and composite prints that strove to imitate paintings. Photographs, Emerson said, should not sentimentalize the world by trick or device, but should present real life openly and directly. With this goal in mind he went to rustic East Anglia, a marshland area in southeastern England, where he took hundreds of photographs of common farmers and marshmen pursuing their daily tasks.

Emerson's work—and his vociferous promotion of his esthetic philosophy —roused spirited debate over the true function of the photograph: Could it stand, untouched, as a work of art, or did it have to be embellished so that it resembled a painting?

In the midst of this controversy, Emerson in 1889 published *Naturalistic Photography,* a book detailing his view that a photograph must be faithful to nature—nothing in it must be changed, added to or altered by the photographer. The book caused the debate to grow hotter, but about two years after he published it, the contrary Emerson abruptly reversed his stand. Naturalistic photography, he announced, was dead, for under its rigid discipline "the individuality of the artist is cramped." Emerson's followers—then and later —disagreed. And the ideas he introduced have remained a powerful influence on photographers to this day.

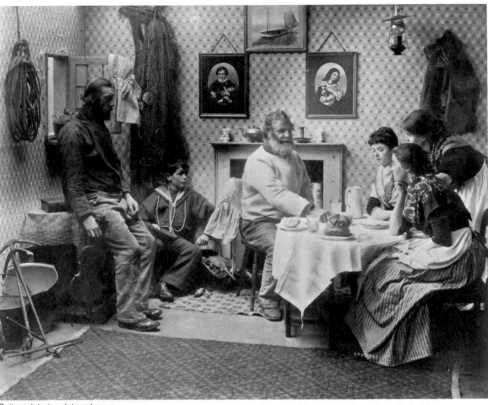

Cottage Interior, date unknown

Surrounded by the nets, baskets and anchors of the marshman's trade, an East Anglian family was photographed by Emerson in a simple cottage. True to his artistic philosophy, he took great pains to make the scene seem natural, although the result has a posed air. But for its time, when subjects usually dressed up and stared fixedly at the camera, this group portrait is informal. Even more radical is the subject matter: Emerson has focused on a workingman and his family, offering them photographic attention usually reserved for those higher on the social scale.

Towing the Reed, c. 1885

The dignity of work was a favorite theme of Emerson, and here he shows a worker bending wearily under a towrope as he pulls a boatload of reeds for roof thatch along one of the waterways in the East Anglian marshlands. In the background other workers place sheaves on a rack, where they will dry before being sold.

John Thomson

John Thomson is best appreciated today for his candid documentation of the poverty-ridden life of industrial London *(opposite).* But during his lifetime the Scottish-born Thomson became famous for his hundreds of pictures of Asians, the fruit of 10 years of travel in the Orient. From 1862 to 1872 Thomson wandered through Asia, perceptively photographing whatever caught his eye *(right).* He did not always get a friendly reception. As he wrote in 1873, "The superstitious influences . . . rendered me a frequent object of mistrust and led to my being stoned and roughly handled on more occasions than one."

On his return to London, exhibitions of his pictures won him an enthusiastic following. He set up a portrait studio and gained a clientele from among London's well-to-do. But the hard-working Thomson did not settle back to ease and affluence. He took his camera out onto the streets to photograph the poor, their trials and their saucy vitality. In 1877 he published *Street Life in London,* a volume of case histories written by a journalist, Adolphe Smith, and illustrated with Thomson's photographs. Each picture displays a spontaneity that brings to life the constant struggle for survival by the underprivileged.

Nanking Arsenal, c. 1865

In China, Thomson visited the Nanking Arsenal, a onetime Buddhist monastery where guns and ammunition were manufactured and stored under British supervision. In this unlikely setting, Thomson could have made the workers at the arsenal strike elaborate poses to bring home the irony of the Chinese in a monastery making weapons. Instead, he arranged his subjects in a natural but carefully proportioned scene. Even though he had traveled halfway around the world, he persisted in showing the citizens of foreign lands unpretentiously, conveying an informal —and truthful—tone that carried Thomson past the mannered photographers of the period.

In London, Thomson continued to render ▶ character and atmosphere in a natural way as he photographed the people of the streets for his book on the city's poor. This picture shows Jacobus Parker, a whitebearded London shoeshine man who was given to extemporaneous orations from Shakespeare. In a seemingly casual street scene that is carefully posed to avoid distracting blur, Thomson's sharp eye found both the dignity and the pathos of the common man.

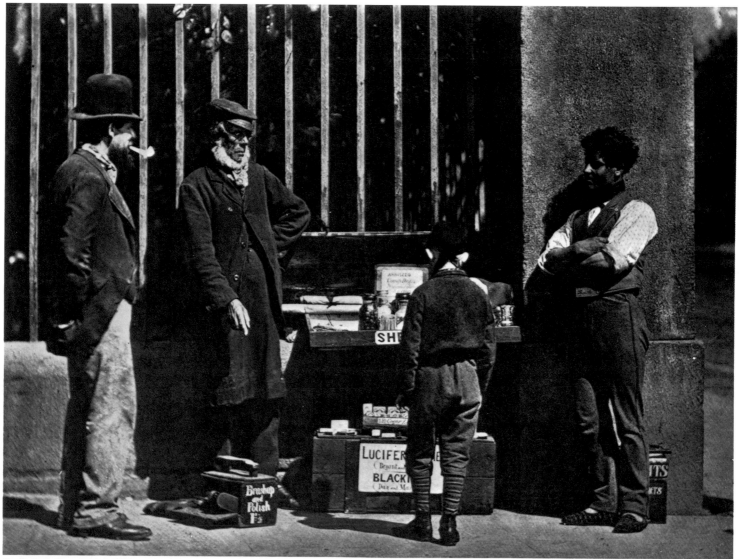

The Dramatic Shoe-black, c. 1875

Martin used his cleverly disguised camera to take this photograph of tourists enjoying a puppet show at an English seaside resort. Using the portable stage as the center of his composition, he neatly caught the mood of the holiday crowd—dressed to ward off the summer sun and totally absorbed by the informal entertainment.

Punch and Judy Show at Ilfracombe, 1894

Paul Martin stated his aim in photography with characteristic forthrightness: He sought "the real snapshot—that is, people and things as the man in the street sees them." The son of a French farmer, Martin migrated to England, founded a photographic firm and spent all his spare time taking pictures.

Martin loved gadgets, and this trait helped him make great photographs —he was able to modify his camera to serve his unobtrusive approach. He devised schemes for muffling shutter noise and even disguised the camera to look like a stack of books. Thus outfitted, Martin made his quiet way among the common people, snapping pictures without attracting attention.

Martin's photographic interests were broad—he was an extremely success- ful photojournalist, recording for the London papers such events as the coronation of King Edward VII and the opening of Parliament. He also experimented, shooting photographs at night during rainstorms—the first photographer to do so—in snowstorms and by moonlight. His crowning achievements, however, were his "real snapshots," devoid of ego but rich in telling detail.

Putting Out the Washing, Hastings Old Town, 1896

Here Martin celebrates the menial task of hanging out laundry. The photograph uses the line of dark and white clothes, the masses of the houses and the textured expanse of a beach to center attention on the face of a weatherbeaten woman.

Feeding Time, 1892

*With affectionate good humor Martin shows a sow
and her dozen piglets foraging in a clearing
surrounded by acres of waving grain. Though his
greatest gift lay in showing people at their most
casual, Martin must have come upon this animal
gathering and found it too captivating to ignore.*

1900 to 1920 **4**

A New Art Form's Fight for Status and Stature 96

Lewis W. Hine 98

Robert Demachy 102

Alvin Langdon Coburn 104

Clarence H. White 106

Alfred Stieglitz 108

Eugène Atget 112

Photographers represented in this chapter include: ▶

Robert Demachy 1

Clarence White 2

Lewis W. Hine 3

Alvin Langdon Coburn 4

Alfred Stieglitz 5

Eugène Atget 6

A New Art Form's Fight for Status and Stature

In the early years of the new century there was no longer any question that photography was here to stay. Its technical foundations had been laid, a number of great photographers had graced the medium with their art, and George Eastman's Kodak had put picture taking on the way to being a hobby for the masses. But if anybody could snap a shutter, where did that leave the serious artist? "Now every nipper has a Brownie," one of the period's master photographers, Alvin Langdon Coburn, complained, "and a photograph is as common as a box of matches." Making a picture, he wrote, had become "too easy in a superficial way, and in consequence is treated slightingly. What we need is more respect for our medium." He was not alone: Many of the best amateurs and professionals were confused about what photography did, or could, amount to. They were pretty sure it was not just a poor relation of the art of painting, and not merely a mirror held up to life. But what was it?

A man came along to help resolve the uncertainty. He was Alfred Stieglitz *(pages 108-111),* who had been schooled in 19th Century traditions of art but had grown beyond them in creating a personal style. More than anyone else, Stieglitz enabled photography to shake off the inferiority complex inflicted on it by artists and critics who held that painting and sculpture were legitimate art forms and photography was not. In fighting to have his craft accorded a higher status, he gained in stature himself. Paradoxically, his battles in behalf of photography won victories in America for modern art in general. The famous New York Armory Show in 1913 (in which he was a moving spirit) is usually credited with introducing this country to the modern masters of painting and sculpture. Actually it was Stieglitz personally, through exhibits in his Photo-Secession Gallery, later known as "291," who gave major artists their first American showings: Rodin, Matisse, Toulouse-Lautrec, Picasso and others. In all that he did—in publications like *Camera Notes* and *Camera Work,* in running galleries and exhibitions, in championing struggling artists, and in his own photographic work—Stieglitz pitted his belief in the validity of experimental styles against the general taste for established styles. Eventually he won, and the arts in general and photography in particular have never since had to apologize for expressing an artist's personal view of the world.

It is true that the new century was a time ripe for change and that the entire world of art was in ferment. Though none was to achieve Stieglitz' stature, some other photographers simultaneously were working with intensely personal vision. One was Clarence H. White, who methodically expanded the limits of photography as he experimented with evocative scenes. White's preoccupation with mood coincided with some of the sensitive work being done by Stieglitz and another contemporary, Alvin Langdon Coburn. These men all recognized the winsome qualities of painting, but did not want their pictures to emulate masterworks on canvas. Instead they borrowed esthetic

elements from painting, making pictures that had artistic validity without becoming imitations. Their success was one of the triumphs of this period.

In Europe at the same time, an enthusiastic group of well-to-do photographers were trying to merge art and photography in a quite different way. In the previous 20 years the naturalist photographers, led by Peter Henry Emerson, had dealt a serious blow to the fad for photographs cut and pasted to look like paintings. But now, under the leadership of Robert Demachy, many photographers sought to compete with the other visual arts by interposing their own handiwork between their negatives and their prints. Inventing new or reviving old printing techniques, they varied the finishes, textures and even the images of the final prints. At their best, as in Demachy's work, such photographs were as graphically sophisticated as any ever produced.

Not all photographers of this period were concerned overtly with the medium's art, though the best of them were artists in their own way. Eugène Atget and Lewis W. Hine, for example, concentrated on capturing the world around them and made documentary photographs that are more than mere pictorial records. Atget was a private man who lived austerely and was wholly dedicated to making pictures of Paris. His photographs showed the city and its people in such a straightforward manner that later generations, long accustomed to the clean, uncluttered style of documentary photography, have marveled at his command and prescience. Hine was a restless, questing man who traveled extensively to expose the exploitation of workers, particularly children and immigrants, in the sweatshops of industrial America. He was one of the originators of a tradition in which the photographer became a social critic — a tradition that later produced, during the Depression of the 1930s, some of America's great pictorial commentary. All the same, he was guided by artistic canons; with the work of such masters as Raphael as his model, he organized his compositions on the stern principles of balance, line and form. But the compelling power of Hine's pictures does not derive from his adherence to classical art; it comes from the photographer's sympathy for his subjects. Through similar compassion and intellectual control of their work, all the best photographers of this period exalted their art and sent it confidently into the 20th Century.

Lewis W. Hine

Lewis W. Hine was one of the first—and greatest—of America's socially concerned photographers. He was also a master of composition and mood. Born in Wisconsin in 1866, Hine did not begin to take pictures regularly until he was 37 years old and was asked to double as photographer at a private school in New York City, where he was teaching geography. Two years later and still an amateur, he photographed impoverished immigrants at New York's Ellis Island and was persuaded by their plight to devote himself to recording the trials of the underprivileged. "I wanted to show things that had to be corrected. I wanted to show the things that had to be appreciated," he said.

Hine abandoned teaching to tour the United States for the National Child Labor Committee, documenting the abusive conditions under which children then worked in mills and mines. The Red Cross sent him to Europe in 1918 to record its war-relief work, and during the Depression of the 1930s he photographed the victims of rural poverty for federal relief agencies. An intense and compassionate man, Hine produced photographs that inspire, according to his purpose, sympathy, pride or shock.

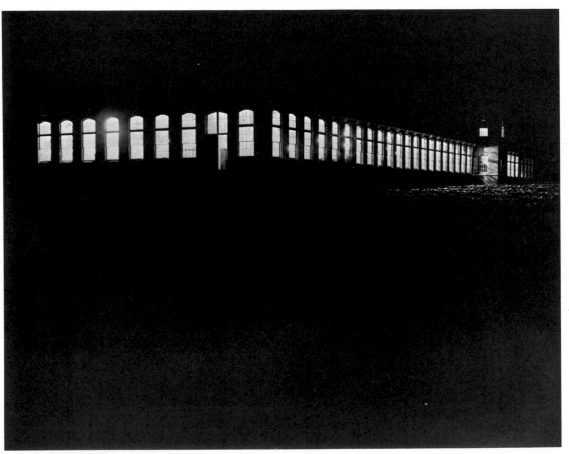

Mill Running at Night, 1908

A glowing rectilinear pattern is formed by light streaming through the windows of a cotton mill going full blast in the black of the winter night. Hine made this elegant picture in Whitnel, North Carolina, while on assignment to chronicle child labor conditions. He could not fail to honor the abstract beauty he saw in the images of industrial society even while his social conscience was repelled by its degradation of human beings.

Without pathos, Hine made a straightforward study of boy laborers in a cotton mill speak plainly of their plight. He put his point across powerfully through masterful lighting. Even though the picture was taken on a May morning, the mill is dark and gloomy, a place of perpetual night. Hine posed the boys beside a white skein of cotton, however, and the light from a window reflected on it to provide a source of contrast.

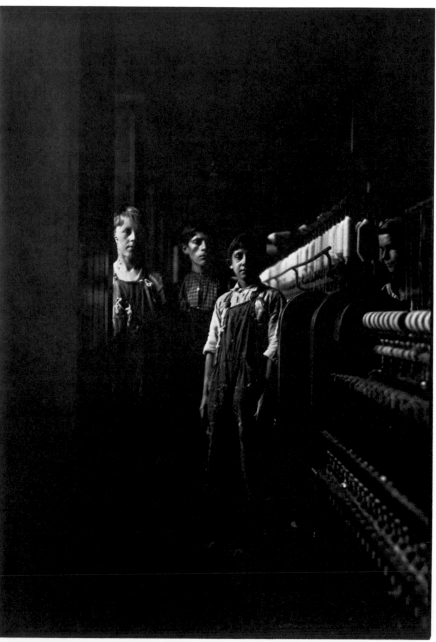

Child Labor in Manchester, New Hampshire, 1909

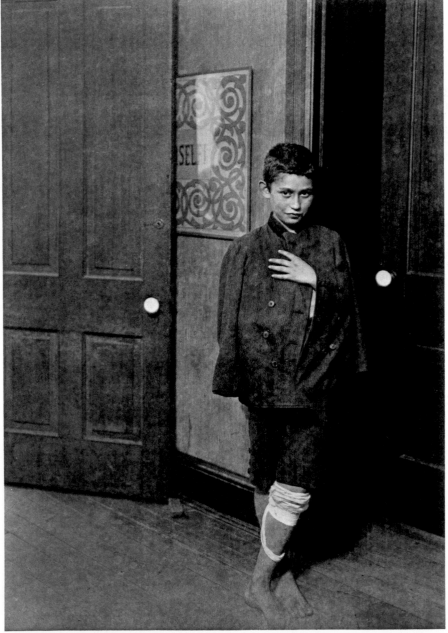

Hine's consummate feel for design is seen in this photograph of an expressive youngster waiting to have his injured leg treated at the clinic in Hull House, the famous settlement house of the Chicago slums. Hine posed the boy so that his dark suit matches the somber wood of the doors and the paneling—yet the darkness is relieved by white highlights: the doorknobs, the boy's hand, the reflected light from the wall and floor and even the bandage. In his placement of the boy, Hine has also posed some visual questions that create emotional tensions within the viewer. Why is the door at the left open? Where does it lead?

Settlement House Boy, 1910

Family Picking Nutmeats at Home, 1911

This picture of women and children shelling and picking the meat from nuts was taken by Hine in a squalid New York City apartment. Although he is showing people doing tedious work at home for little money, Hine converts this muckraking report into a classic portrait. The figures are balanced on either side of the table, the array of nuts connecting them. Even the cluttered background is given unity. The glare from the flash powder illuminating the scene creates a unifying streak of laundry and door reflections.

Robert Demachy

Speed, c. 1904

Like many of his contemporaries, Robert Demachy believed that a photograph could be a work of art only if it resembled an oil painting or drawing. Demachy was repelled by realistic photography that was only a direct copy of nature. He railed against what he regarded as mediocre pictures snapped by inartistic enthusiasts in what he haughtily termed "a bourgeois manner." To make his photographs artistic, he worked over his prints with pigment and chemicals—almost anything that would serve to heighten their effect and result in a picture that the camera alone could not equal. By skillful application he could even create a variety of artistic styles from a single negative.

The son of a French banker, Demachy inherited the financial freedom to experiment with his photography. But unlike many of his friends who were wealthy dabblers in photography, Demachy produced works of real esthetic value. The strength of his photographs comes partly from the fact that he did not imitate then-fashionable art. He adapted to photography the fresh ideas that were revolutionizing art, such as Impressionism *(above)*.

A speeding car becomes an image of momentum in this impressionistically rendered picture. By using rough-textured photographic paper and coating it with an emulsion of gum arabic and potassium bichromate that could be repeatedly thickened or thinned with hot water during the printing process, Demachy blotted out detail. This technique achieved the blurring that makes the pioneer motor car appear to be whizzing down the open road, trailing a cloud of dust.

This portrait of a pretty, soft-profiled girl is one of the most successful of the photographer's many sensuous studies of young women. The gracefully poised head emerges from an ethereal, gauzy background in a photograph that is the epitome of Demachy's style: It imitates the effect of another medium—in this case charcoal drawing—while its unique interpretation of the subject illustrates the photographer's artistic technique.

Primavera, c. 1896

Alvin Langdon Coburn

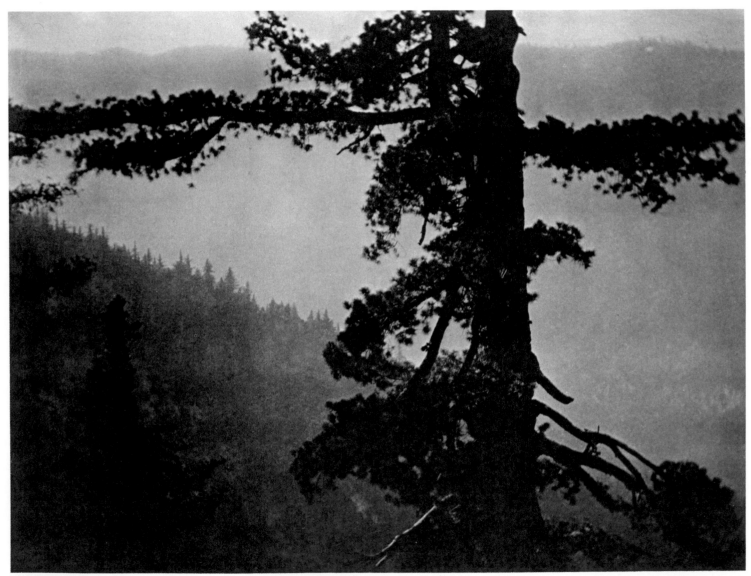

Mount Wilson, California, 1911

A tree shaped like a cross is juxtaposed with the diagonal slope of the mountain in this geometrical view of California's rugged north country. The scene's starkness is softened by the background, a muted sweep of hazy woodlands.

Alvin Langdon Coburn was a contemplative man who won fame with his photographs, then retired to the study of mysticism, only to return to his camera again later in life. Born in Boston, Coburn moved to England as a young man and quickly attracted notice by making a portrait of the writer George Bernard Shaw, himself an enthusiastic amateur photographer. Shaw was so pleased with the result he called Coburn "one of the most accomplished and sensitive artist photographers now living." With this endorsement, Coburn went on to become famous as the photographer of eminent European, English and American writers and painters. He also won praise for his stunning cityscapes and landscapes (left).

In his search for new ways to express himself, Coburn began experimenting with abstract photographs such as the multiple-image portrait at right. He devised a lens attachment, the Vortoscope, to produce abstract pictures semiautomatically. Made of three mirrors fastened together in a triangle, the Vortoscope fractured the lens image in kaleidoscopic fashion.

Coburn settled in Wales with his wife, and in 1919 he began, he said, to "investigate the hidden mysteries of nature and science," stimulated by such influences as Freemasonry, Christianity and Zen Buddhism. His photographic output was small until the mid-1950s when he picked up his camera once more to make pictures that were notable for their serenity.

Influenced by modern artists, particularly the Cubists, Coburn made this abstract portrait of poet Ezra Pound. The multiple-image style was fitting — Pound was known for his multisided nature that delighted in stirring controversy.

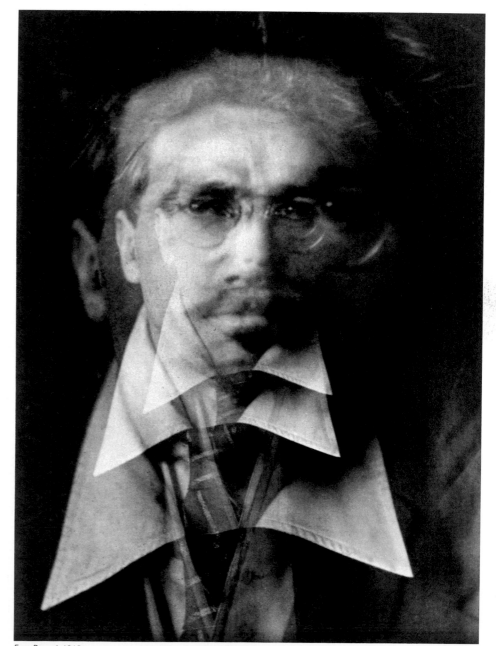

Ezra Pound, 1916

Clarence H. White

Clarence H. White was one of those modest photographers who lived quietly and photographed only simple subjects, but whose work had a profound effect on the course of modern photography. White, perhaps more than any of his contemporaries, demonstrated what could be achieved by finicky attention to detail. He knew exactly the effect he was after, and to get it he insisted on controlling every part of the process from lighting to printing. He would even have costumes made especially for his models to help create a mood or texture *(far right)*.

A native of Newark, Ohio, White wanted to become a painter, but his father forbade it, saying he would have "no paupers in the family."

Instead, White became a bookkeeper at a local grocery concern. He began taking pictures when he was 23 and within four years his work was exhibited at a Philadelphia salon. In 1906 he settled in New York City, became a teacher of photography and eventually founded his own school. Teaching occupied much of his time, and he made little more than commercial portraits in his later years.

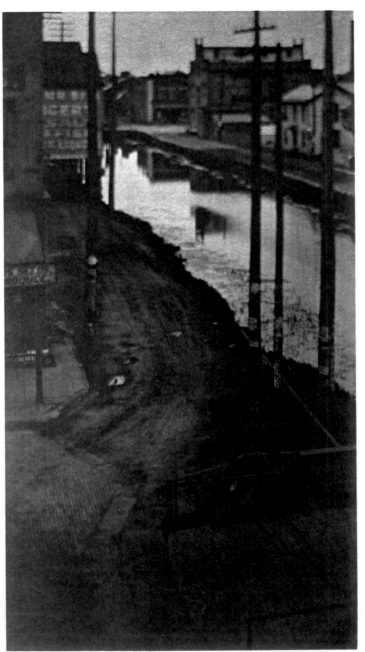

White's preference for unassuming subjects is seen in this view of his hometown, Newark, Ohio. With meticulous care, he creates a still life of geometric patterns, exaggerating the foreground for effect and cropping the width of the print to accentuate the tall, skinny telephone poles.

The Canal, 1899

A nude acquires a sensuous, secretive appearance from the use of a single, relatively weak sidelight. The ability to arrange illumination so that it contributed to the mood of his pictures was one of the photographer's greatest strengths and became a hallmark of his work.

In this virtuoso photograph, illumination from the single window helps create a triangular composition. The window is one point of the triangle; the model, with sunlight reflected onto her face from a hand-held mirror, is another; the third is the chair, which catches the sun's rays.

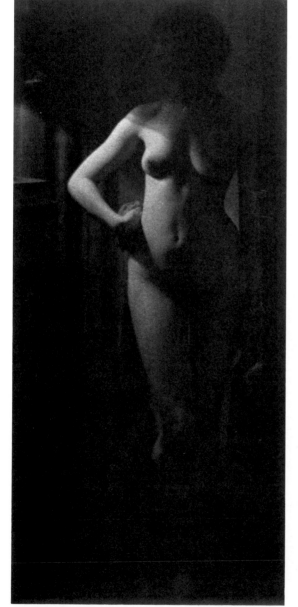

Nude, c. 1908

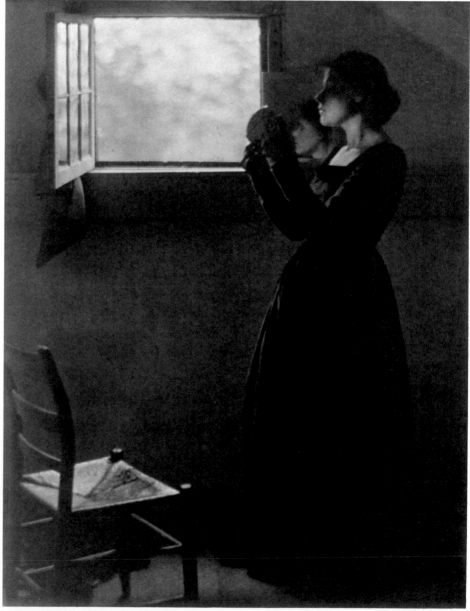

The Mirror, 1912

Alfred Stieglitz

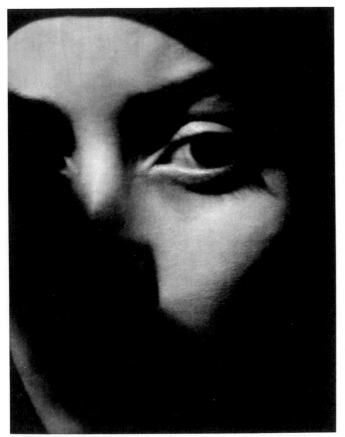

Portrait of Dorothy Norman, 1931

The face in this cryptic portrait is just partly revealed; only a band of light catches the warm intelligence of the sitter's eyes. A close friend and associate of Stieglitz, Mrs. Norman held still through a long exposure time that was made necessary by the photographer's dislike of artificial light. He believed the best prints came from shooting in natural light, with the camera aperture stopped down as much as possible. As a mark of his esteem, Stieglitz presented Mrs. Norman with some of his greatest photographs, including those which were selected for this book.

When the young Alfred Stieglitz returned home from studying in Europe in 1890, he brought with him the conviction that photography was an art form. He never gave up on that belief. He edited magazines, ran galleries and, most important, did pioneering camera work that helped secure photography as an art, distinct from painting and with an esthetic all its own. A persistent and strong-minded yet tolerant man, Stieglitz throughout a long career that spanned some 60 years made pictures that relied heavily on patience. He would literally stand for hours awaiting "the moment when everything is in balance," the moment of equilibrium, before pressing the shutter button.

In his later years Stieglitz felt no need to go far afield for his subject matter, preferring what he called the "exploration of the familiar." A native of Hoboken, he regularly turned his camera on New York City *(right)*, where he had grown up; the city was an endless source of fascination for him. So were the qualities of human faces. People associated with him were often the subjects of his portraits *(left)*, in which he strove always to reveal the character of the person. And some of his finest photographs he found in nature; he came to call these pictures "equivalents" because he saw them as the external counterparts of interior experiences. His way of photographing nature—raindrops, trees, the sky *(pages 110-111)*—reflected a grandeur that in its mysterious way gave his prints a new dimension and helped define a style that was wholly original to the medium. After Alfred Stieglitz no one ever again needed to question whether photography could stand on its own as creative art.

Stieglitz was both exhilarated and disturbed by ▶ the soaring massiveness of the modern metropolis. In this photograph he has caught the looming shapes of New York skyscrapers with their gleaming façades rising from black shadows. Two tall office buildings in Rockefeller Center flank a third building that is actually about a block and a half closer to the camera.

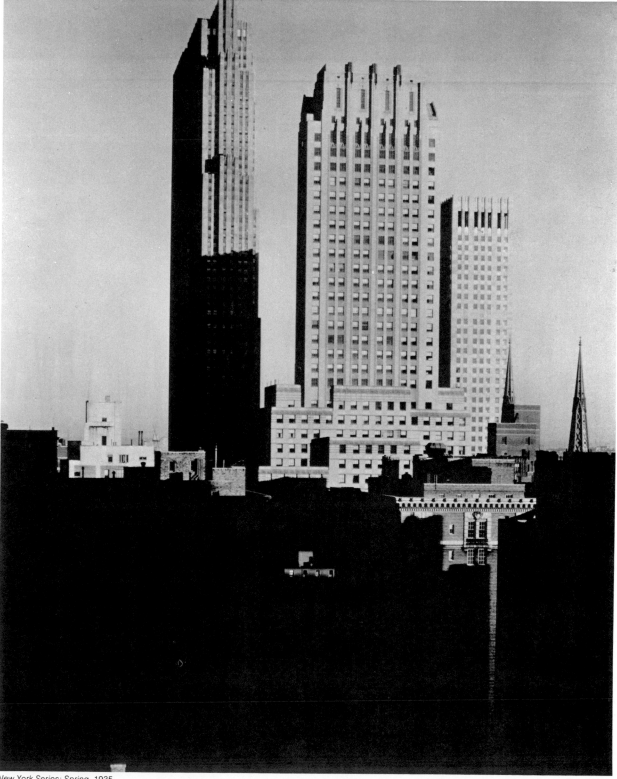

New York Series: Spring, 1935

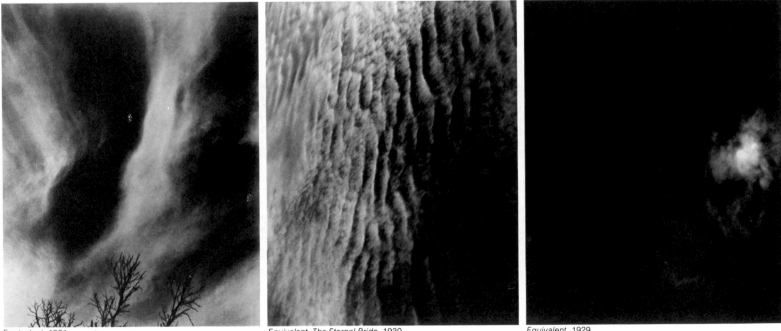

Equivalent, 1931

Equivalent, The Eternal Bride, 1930

Equivalent, 1929

*Since the "equivalents" were personal statements
by the photographer about his innermost
feelings, they have no precise definitions. In the
three photographs on this page, each made on a
different occasion, Stieglitz saw some of his
own experiences mirrored in the sky. The one at
left above is full of contrasting blacks and
grays, the center one has a subtler range of grays
and a rippled surface of clouds, and the one
at right pictures the blackness of the heavens,
broken only by a sunburst. At the emotional
level, they had another meaning to Stieglitz, who
saw them as "revelations of a man's world
in the sky, documents of eternal relationship."*

Equivalent, Before Boston, 1, 1931 *Equivalent, Before Boston, 2, 1931* *Equivalent, Before Boston, 3, 1931*

Unlike the "equivalents" on the opposite page, these were made in sequence to record the subtle differences seen within a few moments in the sky. During the photographing of the sequence, the sun turned from bright to hazed, while the shapes formed by the clouds shifted, joining and separating in response to the winds. Such natural occurrences are hardly startling, yet this sequence transcends its subject matter and invites the viewer to a realm where literal forms, substance and even orientation are altered.

Eugène Atget

A fiercely independent man, Eugène Atget had an extraordinary eye for detail and a sense of design that was far ahead of his time. With religious dedication, he trained his camera on his beloved Paris, often shooting its buildings and boulevards at dawn before they were thronged with people. But he did not ignore the city's people, for he also pictured its common folk and back streets with great sensitivity—and he occasionally went outside the metropolis to make a neatly composed landscape *(right)*. Atget's work is notable for its artful use of design to reveal the inner life of a city and people while seeming merely to document their external appearance. He pioneered an approach that was to be developed by the photojournalists of later decades.

Orphaned young, Atget went to sea as a boy and remained a sailor until he was about 30, when he became an actor. For a dozen years he toured the provinces playing character parts; and then he settled in Paris with his mistress. He did not turn to photography until he was 42 years old.

Atget's photographs won him little notice during his lifetime. He scratched out a living by selling his pictures for pennies to artists, architects and editors. His life style, like his photography, was disciplined—for 20 years he subsisted on a deliberately austere diet of milk, bread and lumps of sugar.

In 1926 Atget's mistress died; desperately lonely, he survived her by only a year. He died in the small fifth-floor walk-up in Paris where he had lived for nearly 30 years. His passing was little noted, but he left behind thousands of neatly catalogued negatives that bear the touch of a master.

Tree Outside Paris, date unknown

An unfailing grasp of the structure and design of a scene is revealed in this landscape study. The tree, its bare branches a mass of finely drawn lines, is paired with the haystack, while a winding road links the hills to the foreground.

Café La Rotonde, Boulevard Montparnasse, date unknown

An uncluttered street in Paris in the early morning,
with its graceful trees, broad sidewalks and
empty cafés — usually so crowded with people —
speaks eloquently of the quiet dignity, pervasive
charm and architectural harmony of the city.

113

Prostitute, 1921

This photograph of a prostitute is one of a series recording brothel life commissioned by the artist André Dignimont, who was compiling an illustrated book on prostitution. Dignimont expected little more than a pictorial record, but the camera has been set up so that the cobblestones on the street and the very angle of the scabrous walls lead to the woman. And her casual pose makes her seem utterly at home in these dreary surroundings—here is Paris far from the fashionable gloss of the boulevards.

Reflections of buildings, tree and street so ▶ obscure the display in this shopwindow that the photograph was thought to be a mistake. But Atget seldom made mistakes of that kind; looking at the ground-glass screen of his view camera he was able to see clearly the entire picture. He photographed what he undoubtedly meant to photograph: a ghostly view of a Paris populated only by a group of smartly dressed mannequins.

Haberdashery, c. 1910

Saint-Cloud, date unknown

The park of Saint-Cloud, outside Paris, is peopled
solely by classical statuary, lonely and remote
in the background against the looming shapes of
the trees and their reflections in the pool.

Meeting the Challenge to Show the World as It Is 120

Edward Steichen 122

Paul Strand 126

Man Ray 130

László Moholy-Nagy 132

André Kertész 134

Erich Salomon 138

Brassaï (Gyula Halász) 140

August Sander 142

Josef Sudek 144

Edward Weston 146

Manuel Alvarez Bravo 150

Albert Renger-Patzsch 152

Alexander Rodchenko 154

Dorothea Lange 156

Walker Evans 158

Photographers represented in this chapter include: ▶

Edward Steichen	1
Paul Strand	2
Man Ray	3
László Moholy-Nagy	4
André Kertész	5
Erich Salomon	6
Brassaï (Gyula Halász)	7
August Sander	8
Josef Sudek	9
Edward Weston	10
Manuel Alvarez Bravo	11
Albert Renger-Patzsch	12
Alexander Rodchenko	13
Dorothea Lange	14
Walker Evans	15

Meeting the Challenge to Show the World as It Is

At the beginning and at the end of the 1920-1940 period, the world was war-torn; in between, it experienced anarchy, disillusionment, false prosperity, a crash into gritty depression and, finally, a disastrous race to arm for battle — more, in retrospect, than any world should be expected to survive. Not surprisingly, many of the great photographers of this double decade rebelled — against saccharine scenes, imitations of paintings, artificiality and even, paradoxically, against literal realism.

Photography already had begun to move away from prettiness shortly before this period opened. In 1917 Alfred Stieglitz, dean of American art photography, had rejected all but 55 of the 1,100 entries at the Wanamaker Salon in Philadelphia and awarded one of the two main prizes to Paul Strand, an uncompromising realist. Stieglitz, proclaiming his own creed, called "the search for Truth my obsession."

Now the trend intensified. Edward Steichen came back from World War I, where he had been in charge of U.S. Army aerial photography, and burned all his paintings. He vowed to devote himself to "pure" photography, and that summer he photographed a white cup and saucer against graduated tones from black to white more than a thousand times, seeking perfect control in order to attain total realism. Edward Weston, a well-to-do young photographer whose soft-focus technique and striking tonal effects had brought him fat fees from Hollywood for artificially pretty portraits of starlets, became fed up with his retouchings, croppings and special effects. "I have compromised, sold myself," he wrote. At another time he confessed: "I even dressed to suit the part: Windsor tie, green velvet jacket." He scraped the emulsion from his prize-winning negatives, used the blank glass plates to make windowpanes and went off to Mexico to start all over again.

The revolution had come to photography, and not just in America, but around the world. In Germany in the 1920s, Albert Renger-Patzsch said that if photographs were not clinically objective reports about reality, they were nothing. The newly invented miniature camera — small enough to be inconspicuous and fast enough to make pictures under almost any conditions — enabled Erich Salomon to pioneer techniques of photojournalism as a candid cameraman, an eyewitness who caught his subjects without pose. Working unobtrusively and often clandestinely, he photographed diplomatic conferences, criminal trials in progress, even the Supreme Court of the United States in session, taking pictures that were not really artless but natural and utterly credible. Another group of photographers, equally shocked and revolted by the War, used their talents to mystify and scandalize by mocking literal realism. Man Ray and László Moholy-Nagy played the camera like an organ, using double exposures, photomontages, solarizations, stopping at no manipulation to express their scorn for the world and its fake surface val-

ues, to flaunt their own lack of respectability—and to prove their ability to suggest a reality beneath surface appearances.

As Nikolai Lenin once observed, revolutions create even as they destroy, and in time the photographic revolution created its own institutions. Perhaps the most dedicated of all was the so-called f/64 Group, founded in 1932 and named for the smallest aperture setting on most cameras. Such an aperture yields maximum clarity of focus—giving the sharp, fine detail that the group equated with uncompromising honesty. A few years later the United States government itself institutionalized the photographic revolt. When economist Roy Stryker was called in to keep the Congressional budget-ax away from a program for helping poor sharecroppers and tenant farmers, he decided photographs were his best defense. He sent a now-legendary squadron of photographers, including Dorothea Lange, Walker Evans and Ben Shahn, out into rural pockets of poverty. They brought back on film bitter truths about the farmers' plight; their pictures, widely reproduced in newspapers and magazines, not only gave the farm program a respite, but also inspired photographers all over the country to seek and tell the truth.

Spiritually this generation of photography was a thundering success. Materially, it gave little to many of the men and women from whom it asked and got so much. Weston long lived on the edge of poverty, his diary filled with such dismal entries as: "Sunday morn. June 26 [1927]. I have had very bad luck. Chandler lost a $5 bill, just given him for groceries. This was part of $10 received from a print sale . . . enough for me to live on a week." André Kertész prospered while taking fashion pictures for *Vogue, Harper's Bazaar* and *Town and Country*. But one day he greeted a friend by crying out: "I'm dead. You're seeing a dead man." He quit the well-paying magazines and went back to "straight" photography. The realists had a remarkable sense of mission. They wanted to show the world to itself—a postwar world in one decade, a prewar world in the next—as it really was. They succeeded.

Edward Steichen

Sunday Papers: West 86th Street, New York, 1922

In 1901 a critic commenting on some photographs exhibited in Philadelphia wrote: "If I may venture a prediction, I will assert that the maker of these three pictures is destined to rank among the greatest pictorial photographers of the world." He was remarkably prescient. The statement was made about Edward Steichen, a youth from Milwaukee who had snapped his first picture just six years before; soon he was important enough to photograph the actress Eleonora Duse and the banker J. P. Morgan in a single morning.

Steichen excelled in every branch of photography that he took up — and he took up most of them: aerial reconnaissance for the Army in World War I; beautiful clothes and beautiful people for magazines; advertising for Madison Avenue; air warfare for the Navy in World War II. He even excelled as a curator at the Museum of Modern Art. In that post he put on more than 40 shows, the most famous of which was "Family of Man," a moving account of the state of mankind portrayed in 503 photos culled from the work of 273 photographers in 68 countries. Like Steichen's own work, the photographs ranged in style and subject from one end of the spectrum to the other, being constant only in their humanistic view of life.

From his New York apartment window Steichen glimpsed a common American ritual and took the picture at left, compressing in the window frame the spirit of a day. In its simple realism it illustrates one of the many dimensions of Steichen.

How different is this symbolic butterfly. "He ▶ speaks to moths, sunflowers, poppies as if they are kindred humans," Carl Sandburg wrote about Steichen. "A day's work with one butterfly resulted in many prints — and one masterpiece." The contrasting darks and lights and the puzzling shadow cast by the butterfly make the picture as poetically ambiguous as the title Steichen gave it.

Diagram of Doom — 2. New York, c. 1922

Carl Sandburg, Connecticut, 1936

The day after Carl Sandburg finished his classic
"Abraham Lincoln: The War Years," Steichen, who
was his brother-in-law, made six images showing
the writer's mood. "Carl sat at the breakfast
table," Steichen wrote, with "a look that brought
to mind Gardner's beautiful photographs of Lincoln
made the day after the Civil War surrender."

In Athens where he was photographing Isadora ▶
Duncan and her troupe, Steichen made this
picture of the great dancer's pupil and adopted
daughter, Thérèse. "The wind pressed the
garments tight to her body and the ends were left
flapping and fluttering," he wrote. "They actually
crackled. This gave the effect of fire — 'Wind Fire.' "

Wind Fire: Thérèse Duncan on the Acropolis, Athens, 1921

Paul Strand

New York, c. 1915

In 1907 Paul Strand—who, as the 17-year-old son of a middle-class New York family, might have been expected to go into business—encountered two of the masters of American photography. His life was never again the same. The two photographers who so affected him were Lewis Hine *(pages 98-101),* who taught Paul in his photography course, and Alfred Stieglitz *(pages 108-111),* to whom Hine introduced Strand.

Eight years later, Strand walked into Stieglitz' studio carrying a portfolio crammed with studies of the people on New York's streets. Stieglitz gave him a one-man show and hailed his work as "brutally direct."

Strand spent the following 15 years in close association with the eminent Stieglitz. Meanwhile he made a living as a freelance motion-picture camera-man. In 1926, when he could afford a vacation, he went West to photograph the Rockies; the following year, vacationing in Maine, he made close-ups of lichens and ferns; then a series on the Gaspé Peninsula, others on New England, Egypt, the Hebrides and Mexico.

Wherever Strand went and whatever he photographed, he made compositions by associating different textures—a technique that turned many of his portraits *(page 129)* into still lifes.

Two elements that are repeatedly visible in Strand's photography are seen in this early street scene: sympathetic treatment of working-class conditions and delight in composition—in this case a study in verticals and horizontals.

Geometric composition is a feature in another ▶ *Strand photograph, this one of a fellah operating an ancient water wheel in Egypt. The texture of the tilled earth contrasts with that of the stone walls, and the composition is enhanced by the angular branches on which the birds roost.*

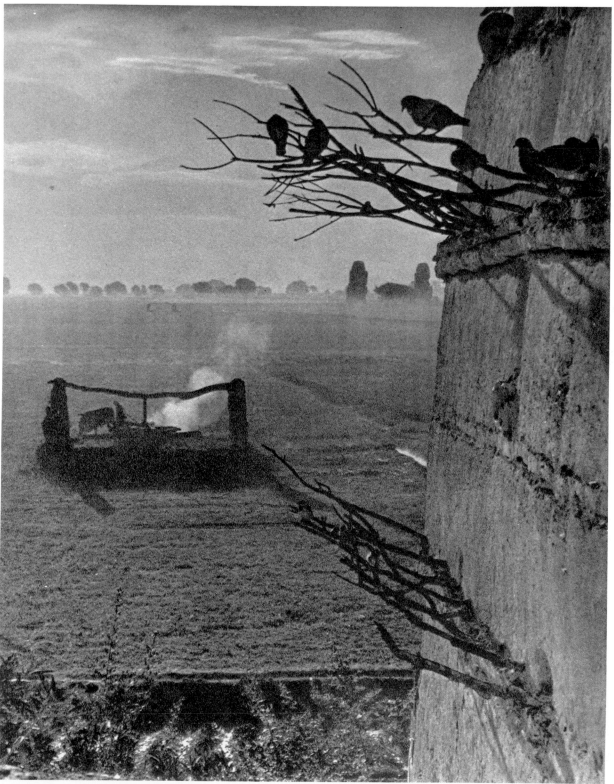

Water Wheel and Colossi, Gurna, Upper Egypt, 1956

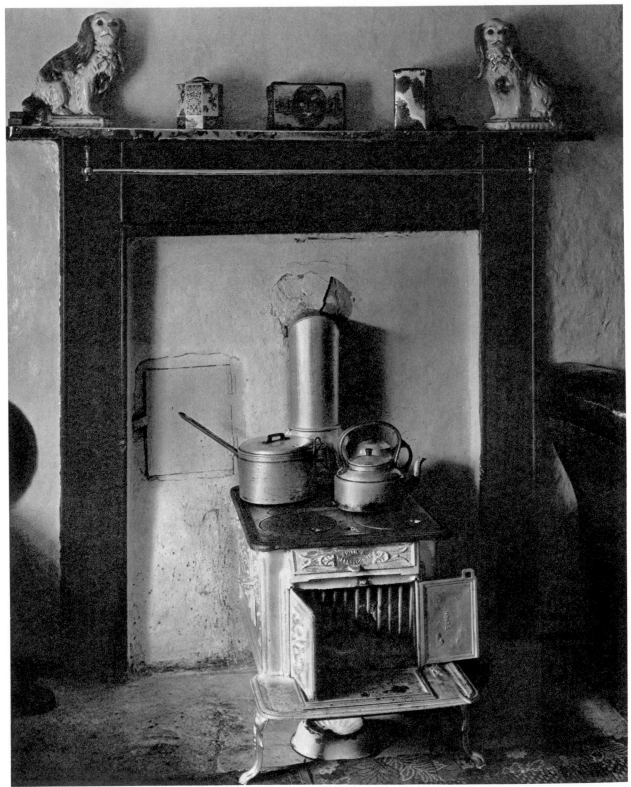

Kitchen, Loch Eynort, 1954

128

◄ For three months Strand wandered through the Hebrides off Scotland, photographing the working people and their setting. In the still life at left he lovingly caught the simple textures of the kettle, the flue, the Victorian stove, the walls, the mantel —and suggested the rough hands that lit the fire.

In the Hebridean face at right Strand captured the ideal proletarian look —the brawny cheeks, the beetling brow, the clear, honest gaze. The picture is almost as much still life as portrait, for the variations around the face —the heavy duck cap with braid, the fraying shirt collar, the thick woolen jacket and, in the back, weathered wood —are themselves a study in differing textures.

Piermaster MacEachen, 1954

129

Man Ray

Man Ray spent most of his life flouting convention. He made up a new name and a new identity while he was in school. "My first name was Emmanuel and I changed it into 'Man,'" he has said. "My second name is nobody's business." He began to paint before World War I in the styles then just sweeping the art world, took up the camera to reproduce his own paintings for a catalogue and, on going to Paris, sold the same service to fellow artists.

Most of Ray's first photographs were straightforwardly realistic, totally unlike the wild fancies of his artwork—an inconsistency he explained on the ground that he had to make a living. He made himself fashionable compiling a portrait record of Paris intellectuals. "I worked fast. As soon as they walked in the door the camera would start clicking," he wrote. "No one knew how I did it. When they asked me I gave them wrong information."

Soon Man Ray introduced the startling ideas of Dadaism and Surrealism to his photographs. He developed a technique of cameraless photography, putting objects directly onto photographic printing paper, then turning on the light. The results he called Rayographs *(right)*. He also exploited the process of solarization *(far right)*. He would try anything for a special effect, as these pictures demonstrate.

Dada artists combined all sorts of ideas and materials—the more absurd the better—and Man Ray was the most innovative practitioner of the same idea in photography. This example is a shadow image, or Rayograph, made by placing objects on photographic paper and exposing it. The objects—string, a toy gyroscope, the end of a strip of movie film—were things he happened to have on hand in his studio.

Rayograph, 1924

The strangely altered tones of a solarized nude give it a haunting quality. It looks almost like a drawing until the appearance of some areas — the eyes, the hair — is noticed. The effect was produced at the time the negative was being developed; a light was briefly switched on, altering the chemical reactions so that in the final print the highlights became gray, shadows became darker and a stronger outline formed where dark and light areas came together.

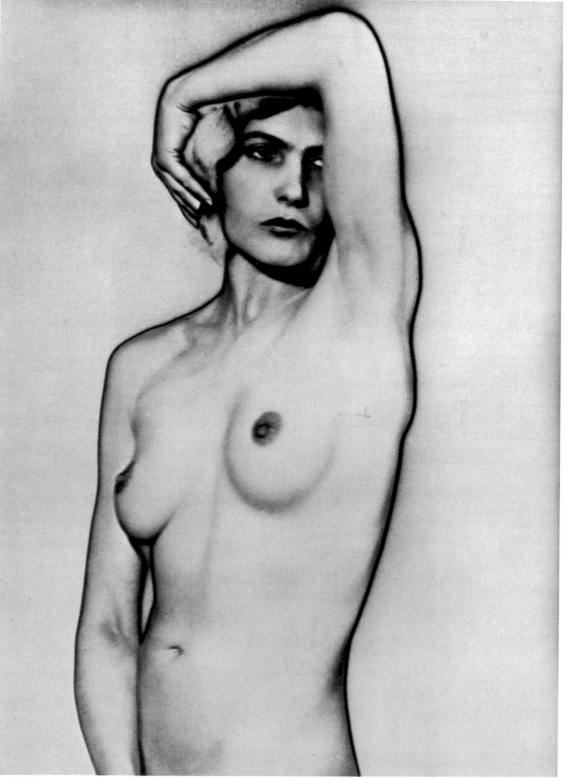

Nude, 1929

László Moholy-Nagy

László Moholy-Nagy was a young student at Budapest University, reading law and writing articles for magazines, when World War I detoured him into the army, gave him shell shock and cost him his left thumb. Afterward he went back for his law degree but found himself increasingly attracted to avantgarde art. By 1920 he was in Berlin and hobnobbing with the Dadaists, the iconoclasts who ridiculed traditional art and sported with the new and experimental. In 1923 he became a member of the Weimar Bauhaus, that seminal academy of radical art, design and social thinking that was shaking the art world.

Here Moholy-Nagy took his essential form as an artist and photographer. An exuberant experimenter, he turned to the plastics and the new materials, to the machine shop and the science laboratory as the new source for art, and plunged fearlessly into light and color, murals, photography, furniture design, layout, even ballet. When the Nazi regime set the Bauhaus to flight, Moholy-Nagy wandered to Amsterdam and to London and finally to Chicago, where he rerooted himself and founded his own school of design.

Ever curious, ever innovative, in his photography Moholy-Nagy worked with and without a camera. He experimented in negative printing, double exposure, double printing and photomicrography, and with photomontage *(opposite)*. He also pioneered such fragmented views as the one at right.

Moholy courted the outrageously controversial. He made the provocative photograph at left with a steep angle of vision, sharp diagonals, and four disembodied legs that are cut off arbitrarily.

The Diving Board, 1931

In this ambiguous photomontage Moholy used the negative of a self-portrait for the figure that is uppermost, then repeated the figure in a white silhouette. The figure within the silhouette is firing a rifle, the trajectory of which goes through the black silhouette (third from left) and into the girl's breast. Moholy defined photomontage as "a tumultuous collision of whimsical detail from which hidden meanings flash," a definition that fits this strange image.

Jealousy, 1927

André Kertész

In 1912 an 18-year-old Budapest book-keeper named André Kertész spent his first savings on a small camera and began photographing human vignettes. When World War I broke out and he was drafted into the Austro-Hungarian army, he put his camera and a supply of heavy little glass plates into his knapsack, and during spare moments made a photographic diary of war: troops moving up, a soldier parting from his wife. "His child's eyes see each thing for the first time," said a friend.

That bright-eyed curiosity and wonder never left him. In Paris in the 1920s, when his pictures had attracted sufficient attention to merit a one-man show, his subjects were so varied as to defy classification, and so, it would seem, was his style; critics compared him with painters as far apart as Gustave Courbet and Maurice Utrillo. Yet nearly all his pictures were linked by a common idea: They portrayed the "found scene," lovers in a Budapest park *(opposite)* or hobos snoozing on a Paris *quai (right)*. Then and in his later pictures *(following pages)*, he juxtaposed human figures with nature and with man-made artifacts, paradoxically contrasting elements of formal design with the casual air of a snapshot.

The Paris hobos who bedded down beside the Seine saw Kertész with his camera so often that they made free to give him advice. Here he caught them, human beings at rest with their thoughts, joined by the strong linear design of tree trunks, masonry and the men's own bodies.

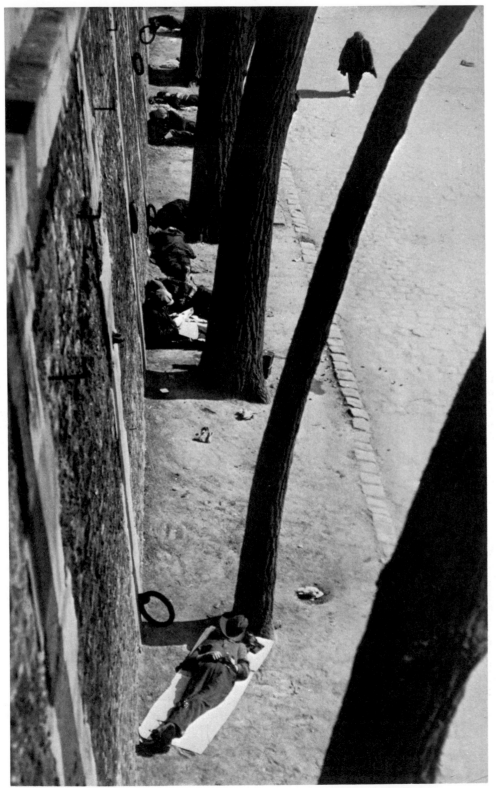

Sur le Quai de la Seine, 1926

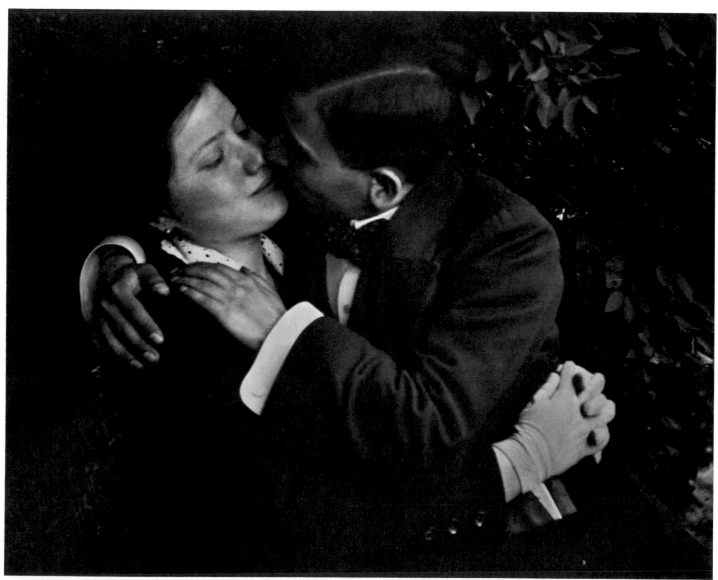

Couple in the Park, 1915

Kertész was walking in a Budapest park one afternoon early in World War I when the young man and woman with him stopped. They kissed, and Kertész caught the sensuality and tenderness of the moment with his camera.

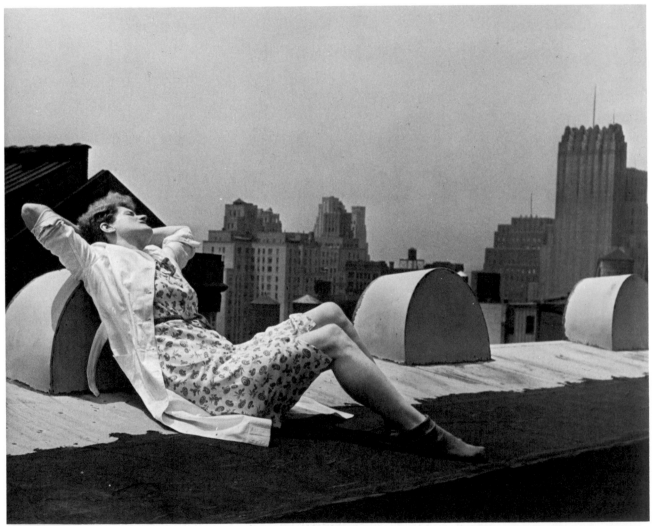

Relaxation, 1943

Kertész caught this woman sunbathing on a
rooftop during a lunchtime break in New York City.
But there is much more to the picture: This is a
very natural woman, in a pose made all the more so
by the rhythmic rounded shapes alongside her
and the contrast of the angular skyline behind her.

Visiting a friend in Manhattan, Kertész was struck ▶
by the angled planes of an air shaft in a tenement
across the street. He returned several times with
a camera, but saw no sign of the life that would give
a human touch to the bricks and mortar. It was not
until he had been trying for the picture for a year
that a woman finally appeared at one of the topmost
windows, and Kertész got his photograph.

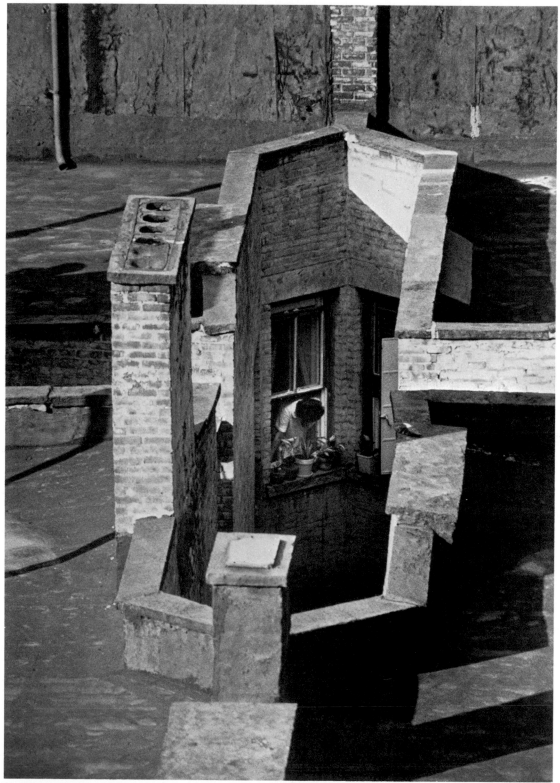

West 23rd Street, 1970

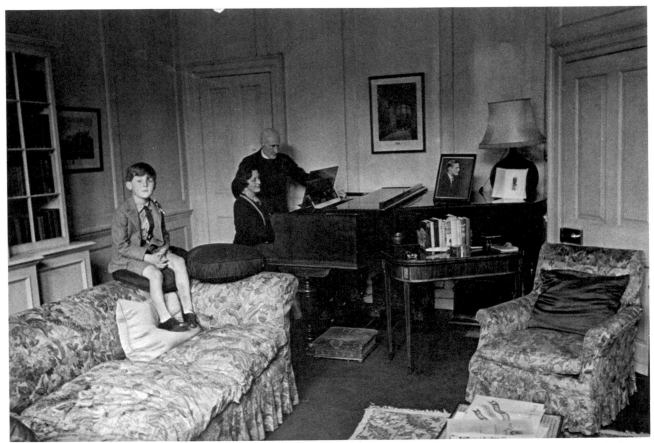

The Cloisters, St. George Chapel, Windsor, 1935

One day in 1930 at an international peace conference, Aristide Briand, the French Minister of Foreign Affairs, advised his colleagues to wait for Erich Salomon before getting down to the business at hand. "What's a meeting that isn't photographed by Salomon?" Briand asked. "People won't believe it's important at all," he said.

He was only half joking. His observation pointed up the weight attached not only to the profession of photojournalism but personally to Erich Salomon, who had made candid revelation into an art. What Salomon strove for and got was a record of the human aspects of great people at work—not the stiff formal portraits of dignitaries standing in a row after their disputes had been settled, but the human efforts by which historic moments are reached. In fact, the phrase "candid camera" had to be coined by the London *Graphic* to describe Salomon's exciting work.

But there was another, lesser-known side to Salomon that expressed itself in photographs of not-so-public scenes recorded with wry but subtle symbolism. These comments on his era made their points every bit as effectively as his candids of Pierre Laval and Benito Mussolini. It is from this category that the pictures on these pages are taken.

Round Tower at Windsor Castle, 1935

◄ On a visit to England, Salomon photographed an austere clergyman, Arthur Stafford Crawley, Reverend Canon of Windsor's St. George Chapel, and his wife in their formal drawing room, as their grandson perched on a sofa, more absorbed in the photographer than in his august grandfather—a perfect picture of upper-class British propriety and informality.

During the visit to Windsor on which he took the picture opposite, Salomon found still another opportunity for satiric comment. Looking at Windsor Castle from the rear window of his rented Rolls-Royce, he photographed this view of the symbol of England's Establishment as it would be seen by a member of the Establishment— slyly suggesting that it is a limited view.

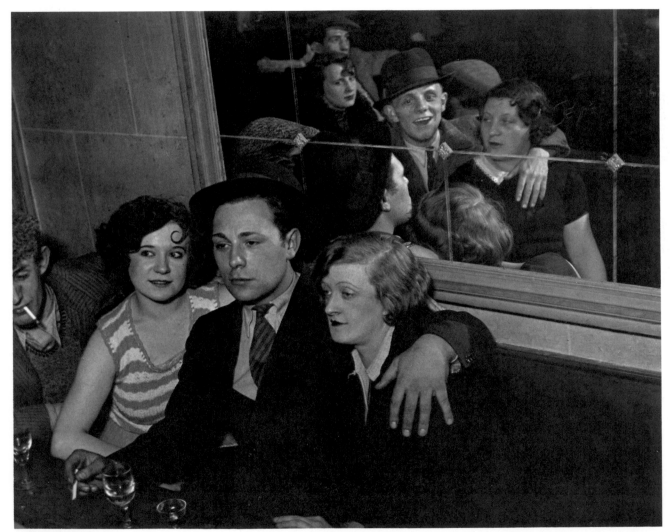

Au Bal-Musette, Paris, 1932

*In this dance hall Brassaï found prostitutes,
pimps and delinquents in mixed moods of ennui
and merrymaking. Part of the group faces
the camera; the others are reflected in the mirror.
The mirror served two purposes. Technically
it helped reflect the light available in the hall;
artistically it gives the viewer the sense of looking
at two levels of reality, as in a Cubist painting.
The scoring of the mirror adds to the effect.*

The first time Brassaï saw Paris, he was a 4-year-old boy from Hungary on a trip with his father. The boy stayed a year and never forgot the city. Twenty-one years later, in 1924, Brassaï returned as a working journalist and became obsessed with Paris at night—the immense panorama of drifters, lost old people, concierges, impassive prostitutes, gangsters, lighted fountains, unexpected parks and dingy cafés. Soon, he wrote, "I had a whole profusion of images to bring to light which, during the long years I lived walking through the night, never ceased to lure me, pursue me, even to haunt me."

An accomplished artist, Brassaï had previously looked down on the medium of photography, but now he bought a camera. Night after night he roamed Montparnasse, becoming so much part of the scene that people went about their lives oblivious of the clicking shutter—though taking pictures at night was a novel practice at the time. One day in 1933 when he had the photographs for his first book, *Paris de Nuit*, laid out on his bed, author Henry Miller happened in and saw the prints. To Miller, whose love of Paris is literary legend, Brassaï's pictures seemed "the illustrations to my books. I beheld to my astonishment a thousand replicas of all the scenes, all the streets, all the walls, all the fragments of that Paris wherein I died and was born again."

Like exotic flowers in a jungle, the angular headdresses of two nuns sparkle amidst the cactus plants lining a path in a garden in Monaco. The picture is unplanned and unposed; the photographer was walking through the gardens with only three unexposed frames remaining on his roll of film when he spied the nuns, strolling from the nearby convent of St. Vincent de Paul.

The Exotic Gardens of Monaco, 1946

August Sander

SS-Man, Cologne, 1938

Farm Girls, Westerwald, 1927

The four Sander photographs on this page and at right have in common the static quality the photographer meant them to have—they are pictures of social types rather than psychological delineations of individuals. Above, at the left, is a young storm trooper, a properly uniformed martinet who serves a dictatorial state. The two sisters on the right are graceless and plain; they are farm girls, used to hard work from childhood.

August Sander is preeminently the camera eye of pre-World War II Germany. He was a photographer from the time that, as a teenager, he set up a studio in a hut outside his parents' house, to which he repaired after work in the family-owned mine. Later he published two portfolios—*Portrait of An Era* and *German Looking-Glass*—filled with posed pictures that precisely delineated a time and a people. The pictures were not meant solely to reveal personal character, but to show classes that made up German society —the provincial families, the small-business men, the professionals—all dressed up in their Sunday best and staring straight ahead. Looking at their

Student, Cologne, 1926

Widower with His Sons, Cologne, 1925

pictures, one critic wrote: "We have the feeling of having lived through enormous changes in the last 50 years." And indeed the changes had been vast, for Sander's pictures span the period from the heyday of the bourgeois German of Kaiser Wilhelm's era to the rise of the storm troopers in the Hitler years.

Partly because Sander's first portfo-

lio reflected a down-to-earth view of ordinary German folk with no idealization, and partly because it included Jews among its portraits, Hitler's Gestapo confiscated the book in 1934. But Sander hid the negatives for more than a decade, until after the War ended and his historic photography could once more be publicly shown.

Two more of Sander's social types are the youth at left and the middle-class man at right above. The youth is a student from a well-to-do family, but there is nothing in the spare background or in his bloodless demeanor to indicate specifics of his personality. The widower and his two sons represent a passionless, colorless family —another of the types Sander saw in the socially stratified culture of pre-World War II Germany.

143

Josef Sudek

To the people of Prague, Josef Sudek, a gray and disheveled man born near the turn of the century, was long a familiar figure. From his little wooden workshop at Újezd 28, he peered through his studio windows, which were often crusted with ice *(right)* or misted with rain. There and on excursions through town, Sudek humanized Franz Kafka's city. Americans hardly know him; the standard *History of Photography* does not even list him in its index.

Sudek lost his right arm in World War I, but he never let that handicap seriously hinder him. For years he plodded around Prague, a bowed figure carrying an old wooden view camera and its tripod over his armless shoulder. He wore no tie but kept a scarf circled loosely around his neck. His equipment was as unassuming as his appearance. He cared nothing for gadgetry; his favorite camera was a Kodak Panoramic more than 50 years old. He claimed not to know what a light meter was.

But in his studio and away from it, when something arrested his attention Sudek stopped, framed his tired eye within two circled fingers, waited patiently for the light he wanted—and caught pictures like the ones on these pages, which made the citizens of Prague call him their poet with a lens.

Looking out and looking in were two of Josef Sudek's preoccupations. Peering through the frosted glass of his studio window (right), he found a bird perched in a tree while winter seems to melt away in a pattern both leafy and feathered.

Through the Studio Window, date unknown

In a Public Garden, 1954

Gardens also fascinated Sudek. In the picture above, taken in a park in Prague, Sudek brought ghostly life to an unpeopled scene: The chairs are arranged as if they were meant for conversation, and the flagstones suggest wraithlike footprints.

Pankrác, on the Outskirts of Prague, 1959

Using a Panoramic camera with a special lens, Sudek made the most of a prosaic setting at the city's edge. He created a design out of overhead wires, trolley tracks and the curb underfoot, exaggerating the emptiness of the street and sky.

Edward Weston

"Dear Papa," wrote Edward Weston in 1902, when he was 16 years old. "Received camera in good shape. It's a dandy. . . . I think I can make it work all right." He made it work so well that by the time he was 31 he had won international fame. In his studio in California he took romantic portraits of Hollywood starlets, dancers and babies (usually in soft focus). His pictures were shown in salons in London, New York, Boston, Toronto and Philadelphia.

Weston's acclaim and the realistic style he later developed earned him a $2,000 Guggenheim Fellowship—the first awarded to a photographer—in 1937. With it he traveled 35,000 miles photographing the American West. On that and other tours across the United States he took pictures that were not so much regional as they were archetypal America, pictures of the natural flora and man-made constructions that occur nowhere else in the world.

Those scenes and the way he chose to render them marked Weston's distinctive style. He used a minimum of equipment, usually shot with the smallest aperture on the camera, and he almost never retouched or cropped his negatives. His images are realistic, sharp and beautiful. In Weston's own words, he tried to get the quality of his subject matter "rendered with the utmost exactness: stone is hard, bark is rough, flesh is alive." But that exactness, when rendered by Weston, surpasses documentary realism, for it is united with a special eye for design.

Mammy—U.S. 61, Mississippi, 1941

Spying this combination eatery and filling station in Mississippi, Weston photographed a uniquely American still life. He took the picture while on a trip in search of illustrations for a special edition of Whitman's classic Leaves of Grass.

By keeping his aperture at the smallest setting, Weston got the fine subtleties of design in the rough bark of the tree and its swirling trunk — and with equal clarity caught the foliage on the distant slope and the clouds beyond. The photograph is a realistic picture of part of a tree; more than that, it is a study in varying shapes, textures and forms.

Juniper, Lake Tenaya, Yosemite National Park, 1938

Nude, 1920

Weston's name is almost synonymous with
sharply focused pictures that render every detail
precisely (preceding pages); but this softly
diffused nude, which he made early in his career,
demonstrates his deft use of a different approach.
Detail is submerged, while attention is drawn
to shapes created by shadows and bright
background, for an impersonal study of pattern.

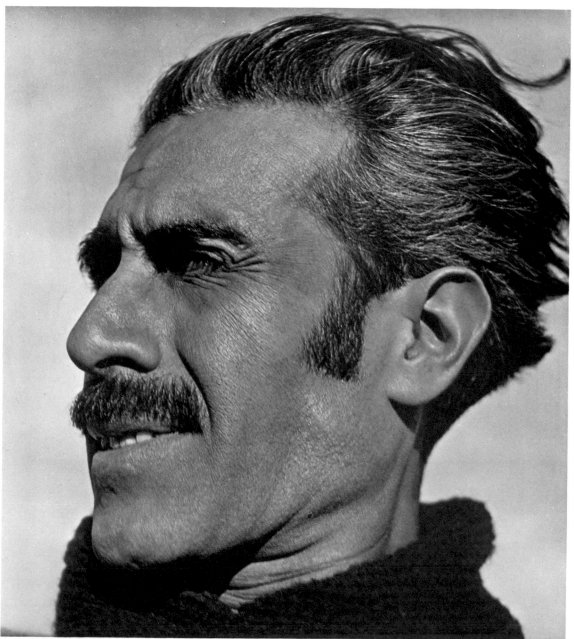

An unstudied portrait of Mexican Senator Manuel Hernández Galván was taken on an outing at the moment he fired his pistol at a peso tossed into the air. The weapon and the target do not show; only loose strands of hair and the taut facial muscles suggest action — but the result is a spontaneous portrait of a tough and energetic man.

Senator Manuel Hernández Galván, Mexico, 1924

Manuel Alvarez Bravo

Good Reputation Sleeping, Mexico City, 1938

In 1914, when Manuel Alvarez Bravo was a schoolboy in Mexico City, the sight of cannon and cadavers was a familiar one in the streets there, for the country was in the process of revolution. The recollections of the uncertain life around him stayed with him long af-ter nominal peace arrived. He took up photography and became part of the art colony of the capital, where he came under the influence of artists José Clemente Orozco, David Alfaro Siqueiros and Diego Rivera, revolutionaries who were bent on combining the innova-tions of modern art with the symbols of Mexican folk mythology. Alvarez Bravo used his camera as his artist friends used their palettes, telling a somber and sometimes an anguished story of grimness and oppression—never, how-ever, polemically, but with quiet irony.

Mr. Municipal President, Sierra de Michoacán, Mexico, 1947

◀ A nude originally commissioned as the cover for a catalogue of surrealist art is an exercise in the contradictions that the photographer felt characterized life in general, and his homeland in particular. The woman seems both sacred and profane. She is secluded by an adobe wall yet threatened by cactus barbs, and the coarseness of those seemingly ritual bandages (borrowed from a medical student) contrasts with her soft flesh.

The mayor of a provincial town peers glumly at the camera, surrounded by the paraphernalia of his office and the symbols of success: portraits, a calendar, architectural plans, an oversized desk with papers and ink. But he looks frightened, and what seem to be bullet holes riddle the wall, as if his days are numbered. This is no official portrait of a minor dignitary; it is a compassionate study of man struggling with human destiny.

Albert Renger-Patzsch

In the long-continuing battle between straight, realistic photography and romanticized photography, one of the staunch sentinels of realism was Albert Renger-Patzsch of Germany. Opposed to the avant-garde double exposures and photomontages of Moholy-Nagy *(pages 132-133)* and Man Ray *(page 130)* and to the Victorian poses beloved by Britain's Royal Photographic Society, Renger-Patzsch produced austere, eloquent photographs of landscapes, forests and industrial artifacts. His volume entitled *The World Is Beautiful* (1928) was to become the manifesto of a renewed realism called "The New Objectivity," and the photographer expressed his creed in these words: "Let us leave art to the artists and let us try by means of photography to create photographs which can stand alone . . . without borrowing from art."

But straightforward as his pictures were, they went far beyond the realism of mere documentation. Whether photographing close-ups of nature *(near right)* or man-made objects such as rope *(far right)* or architecture (which he caught from strange angles, looking up at spires and down on parapets), he was able to find design in everything he looked at during his long career, which lasted into the 1960s.

So clear and unornamented is Renger-Patzsch's photograph of the tree at right that the initials carved just above the first branches are readable, yet the intricacy of the gnarled tree itself makes its own design. Such twisted and snakelike trees, growing in the Süntel mountains of north Germany, were favorite subjects of Renger-Patzsch's. He delighted in showing the mystery and fascination to be found in realism.

Süntelbeech between Hanover and the Weser, 1960

Hallig Man in His Boat, 1927

Renger-Patzsch's evocation of detail and design is
repeated in his loving attention to the coiled
rope, whitened by sun and sea and handsomely
textured, lying in the cockpit of this boat from
the Halligen Islands along the Frisian coast.

Alexander Rodchenko

Artists in Russia anticipated the 1917 Bolshevik Revolution by joining in revolts of their own kind: Cubism, Futurism and other avant-garde movements all made an appearance there before World War I. Soon after the Communists took power, fine art of all kinds was declared out of style, and artists either took their art underground or went along with the new philosophy called Constructivism. This view hailed the machine as a liberating force and stipulated that art be socially relevant, not merely an empty diversion.

One who embraced the new order as an acceptable environment for artists to work in and ultimately made an artistic contribution by any standards was the avant-garde painter Alexander Rodchenko. He was the son of landless peasants and therefore, by Communist standards, of impeccable social origin. In 1918 he became an official in the Soviets' ambitious Constructivist art program; in 1922 he abandoned painting and turned to the camera, which he considered more relevant to the new technological society.

Rodchenko made some memorable photomontages to illustrate poetry, and many fine full-face portraits. His most interesting works, however, were photographs like the ones shown here, shot from overhead and from underneath his subjects, and reflecting ideas carried over from his Constructivist painting. Rodchenko sought to glorify all things technological by expressing fundamental geometric forms, particularly the circle and the axis line, and his oblique angles of perspective brought real objects to the verge of abstraction. In a sense, he came back to where the pre-Communist Rodchenko had started.

At the Telephone, Moscow, 1928

Circus Wheel, U.S.S.R., 1940

◀ *Rodchenko delighted in viewing subjects from above and below, a perspective he first used in painting and carried over into photography. The steepness of angle made familiar scenes bizarre, sometimes abstract, as in this photograph of a woman standing at a wall telephone.*

To get this strange picture of an acrobat in a revolving circus wheel, Rodchenko took advantage of the spotlighting at the center of the arena. The shape of the wheel, the lights within it and the angle from which the performer is seen show the beauty in both human and machine.

Dorothea Lange

One day in 1932, the bleakest year of the Depression, Dorothea Lange looked out the window of her San Francisco portrait studio and found herself staring at a bread line. She walked outdoors to photograph it, and thus launched a new career—and a towering reputation. She spent much of the rest of those troubled times working under the auspices of the Farm Security Administration, which employed photographers to publicize the plight of the poor. She proved to have a unique capacity to make explicit the human toll of the Depression. She achieved impact not because she used tricks or unusual techniques but, rather, because the depth of her compassion guided her camera. She got people at moments that told about their lives and their feelings.

When the Depression was over and times changed, so did her subjects. But in all her work Miss Lange lived up to the ideal articulated three centuries ago by Francis Bacon, whose words were posted on the door of her darkroom: "The contemplation of things as they are, without error or confusion, without substitution or imposture, is in itself a nobler thing than a whole harvest of invention."

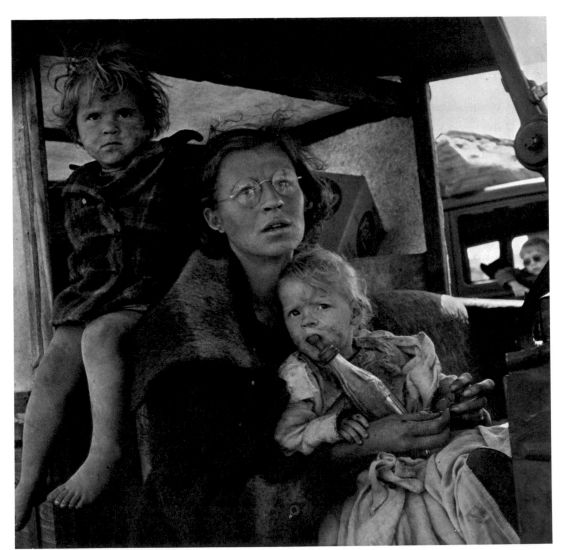

Heading West, Tulare Lake, California, 1939

A mother and her two children stare into a bleak future in a photograph made after the natural disaster of drought had combined with the economic Depression to uproot families all over the United States. The truck in which they sit is almost irrelevant; the gaunt eyes and clutching hands tell the tale of misery and hunger.

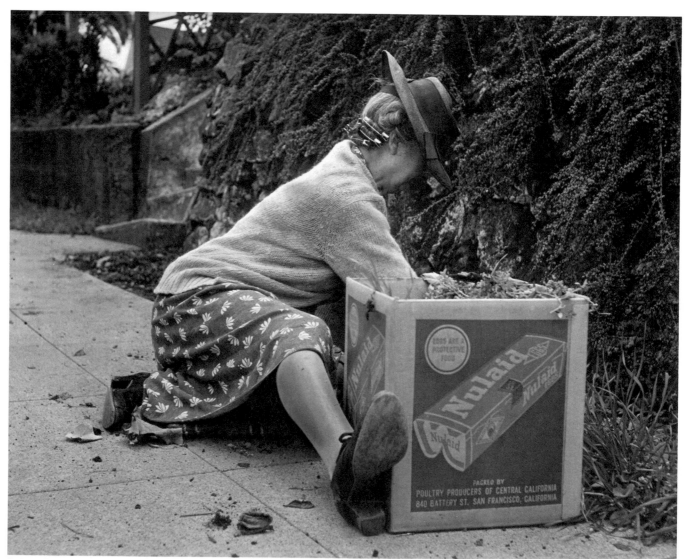

Spring in Berkeley, 1951

Gentle humor suffuses this photograph of a prosperous suburban gardener. Although there is one prop — the egg box filled with plant clippings — the message and the laugh spring from the woman's ungainly pose and the incongruity of her hatted and curler-decked head, as well as her total absorption in her work.

Walker Evans

Walker Evans was an upper-middle-class youth living in the genteel poverty of reduced circumstances when, in 1928, he decided to take up photography. That was after a trip to Paris, where he sat in on occasional courses at the Sorbonne and haunted the famous Sylvia Beach bookshop, peering from a distance at such celebrities as James Joyce, his hero, and vicariously gratifying his taste for the literary.

He quickly developed a distinctive photographic style and made himself a master of it. He addressed himself to the artifacts of life rather than to people. One critic has called Evans the "world's greatest expert at photographing empty rooms in houses and making them echo with the people who live there." Some of his street scenes, too, lack people, and many of his pictures memorialize—with a precision rarely matched—storefronts, billboards and backyards. Many of these pictures have the ghostly suggestion that the people who belong there have died or fled, leaving the places to atrophy. When humans do appear, they are, like the woman shown at right, isolated from social goings-on. Yet peopled or not, Evans' photographs speak of life, providing some of the camera's most trenchant comments on the quality of American society.

What might have been a snapshot of an afternoon at the beach becomes a comment on life. The girl in her Sunday finery, noting the scene below her, is observed by the camera—and poses the question: Who sees the cameraman?

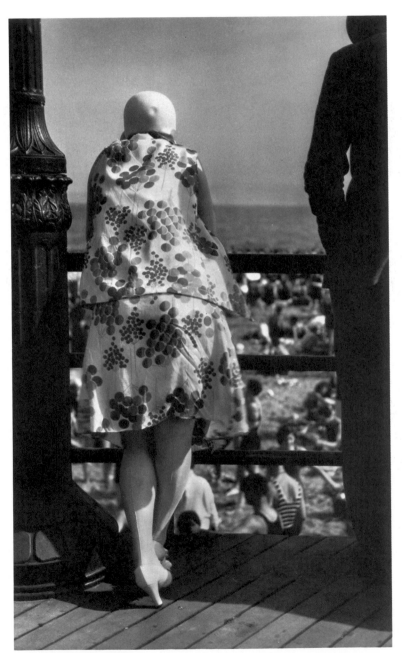

Coney Island Boardwalk, 1929

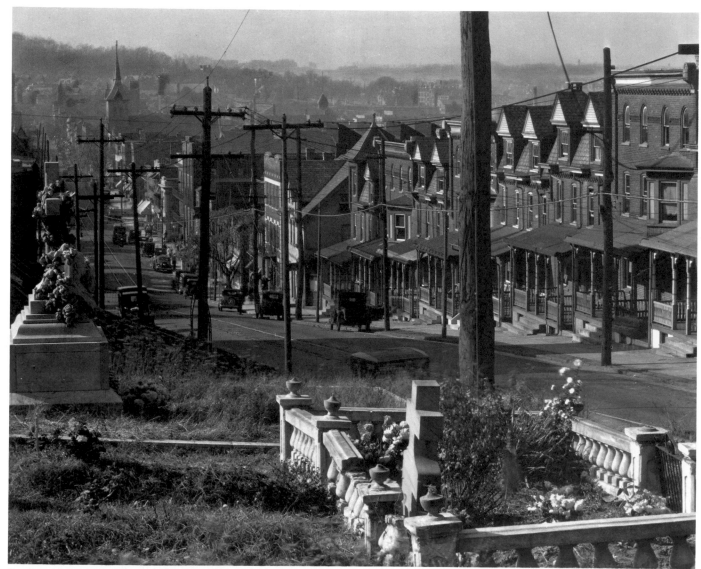

Street and Graveyard in Bethlehem, Pennsylvania, 1936

This picture, taken during the Depression, has some poignant symbolism no town planner ever put there: The graveyard suggests the plight of the steel-mill city and the telephone poles form crosses, repeating those in the cemetery.

159

The mirror, the floorboards, the diminishing door frames, all lead the viewer's eye from room to room — examples of a familiar artistic device expertly handled. But as Evans used them they are more: They reveal the personality of unseen residents and symbolize the durability, austerity and rectitude of the New England character.

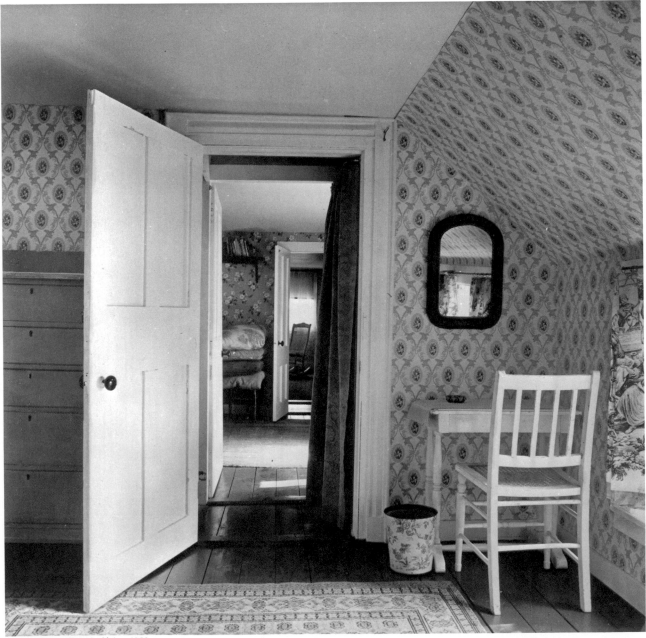

Upstairs Room, Walpole, Maine, 1962

Refining the Photographer's Own Vision 164

Bill Brandt 166

Lisette Model 168

Henri Cartier-Bresson 170

W. Eugene Smith 176

Robert Frank 180

Ansel Adams 182

Minor White 184

Harry Callahan 186

Aaron Siskind 188

Yousuf Karsh 190

Philippe Halsman 192

Arnold Newman 194

Irving Penn 196

Ernst Haas 200

Photographers represented in this chapter include: ▶
Bill Brandt 1
Henri Cartier-Bresson 2
W. Eugene Smith 3
Robert Frank 4
Ansel Adams 5
Minor White 6
Harry Callahan 7
Aaron Siskind 8
Yousuf Karsh 9
Philippe Halsman 10
Arnold Newman 11
Irving Penn 12
Ernst Haas 13
Lisette Model 14

Refining the Photographer's Own Vision

A century after Louis Daguerre announced his discovery to the world, it was almost impossible to get through the day without looking at a photograph. Pictures were everywhere—on the pages of magazines, newspapers and books, on the walls of museums, the sides of buses and the faces of billboards, often larger than life and in colors far more brilliant. By midcentury, in the boom that followed World War II, camera companies were turning out billions of dollars' worth of cameras, film, light meters, strobe units and other increasingly sophisticated picture-taking gear each year. There were 17,293 professional photographic studios in the United States by 1954. In that same year amateurs snapped two billion pictures.

Where, amid this torrent of celluloid, was the art of photography? What were the masters doing?

Nothing radically new, it sometimes seemed. No icons were smashed, and no new deities erected. For the main themes had already been set, and now began a time of refining and developing, of perfecting techniques already pioneered and exploiting the discoveries of earlier decades. Yet some of this period's photographers were among the greatest ever. No photojournalist has captured the storytelling moment so magnificently as Henri Cartier-Bresson, though he was quarrying a vein earlier tapped by Erich Salomon and André Kertész. Studio portraitists such as Arnold Newman and Philippe Halsman continued a tradition as old as the daguerreotype, yet they brought to it new psychological depth and technical proficiency.

Nevertheless, new things were beginning to happen. One was a rich cross-fertilization of ideas between the various branches of photography. Photojournalism, flourishing in the pages of mass-circulation picture magazines, increasingly influenced the approach of portrait photographers, who often depicted their subjects in storytelling settings that helped describe their personalities. Newman might pose an artist with his paintings or a musician with his piano; and even Yousuf Karsh, a master of the classic head-and-shoulders studio portrait, bundled Nikita Khrushchev into a massive fur coat to reveal the Soviet leader as a personification of the eternal Russian peasant. Another photographer, Lisette Model, blurred the line between photojournalist and portraitist still further. Model—an admirer of August Sander *(pages 171-172)* and his gallery of German "social types"—gathered her own varied collection of anonymous yet strikingly individual portraits on the streets and within the salons and saloons where her subjects passed their lives. In her work, the photojournalistic story and the portrait are one.

A strong surrealistic flavor—a legacy from the photographic experiments of Man Ray and Moholy-Nagy—occasionally tinged the work of the portraitists and the photojournalists alike. Halsman's numerous portraits of Salvador Dali, himself the grand old man of surrealistic art, frequently showed the painter in

164

fantastic, otherworldly poses—suspended eerily in midair, or contemplating such nightmarish phenomena as skulls that were made of living bodies. And Bill Brandt, a photojournalist, produced a series of nudes so visually distorted that they seem to flow across the print like strange rivers of flesh.

Another, even deeper impulse began to pervade the work of many photographers. More consciously and outspokenly than they had for decades, photographers now were imposing their own feelings on the subjects in front of their cameras. The artist's personal vision, of course, has always been the leaven that makes great pictures. But during the vogue for straightforward photography in the 1930s, photographers generally had expressed their vision in the selection of subject matter—an impressive landscape, a tender moment between lovers, a migrant worker whose face reflected the hardship of economic depression. With the choice once made, the photographer had used the camera to report the scene, in much the way a journalist produces an objective news report. But now some photographers, like first-person columnists, were beginning to offer extremely subjective, personal interpretations. A darkly introspective quality fills Brandt's documentary pictures, turning them into an intensely personal visual poetry. W. Eugene Smith, another reporter with a camera, felt compelled to record events in a way that showed his own compassion for the joys and sufferings of humanity.

The turn toward the first-person statement shows up most dramatically in photographic progeny spawned by the f/64 Group, the school of photography that had been founded in the 1930s by Edward Weston and Ansel Adams. Its goal, technically perfect renditions of the world as it is seen in the camera's eye, seemed the antithesis of the introspective photograph. But soon its members began to talk in strangely nonobjective, almost mystical terms. A photograph is "an instrument of love and revelation," proclaimed Adams in 1948, that must "see beneath the surfaces and record the qualities of nature and humanity which live . . . in all things." Adams' leading disciple, Minor White, went even further: His precisely detailed close-ups of rocks, icicles, driftwood and other objects were, he felt, "inner landscapes" discovered on a metaphysical voyage of "self-discovery through a camera." But perhaps the innermost limits were reached by another photographer of the period, Aaron Siskind. Asked to comment on some close-up pictures of nature taken in the summer of 1952, he declared, "I'm really not interested in rocks. I'm really interested in myself." It was a statement that no photographer, a few decades earlier, would have thought of making—but that no serious photographer in the 1970s would consider at all strange.

Bill Brandt

When the young British photographer Bill Brandt began taking documentary pictures of English life in 1931, at the age of 26, he was one of his country's few serious camera freelancers. He had just returned home from Paris, where he had studied photography under Man Ray, the American surrealist *(pages 130-131)*. But now he had to make a living, and he resolved to build a career in photojournalism, a profession that was still in its infancy.

But Brandt was a photojournalist with a difference. For under Man Ray's tutelage, he had developed a moody, surreal style of his own. It was later to show up most clearly in the way he printed: on high-contrast paper that intensified shadows into ebony blacks, charged highlights with unnatural brilliance, and cast a veil of graininess over familiar objects, turning them into eerie, unsettling presences.

When Brandt started making portraits, he infused them with this same shadowy, brooding quality. A series of nudes that he made in the 1950s are photographed from such odd perspectives that the figures seem violently distorted. Indeed, every Brandt picture displays a slightly unworldly, dream-ridden quality that the photographer himself called "the spell that charged the commonplace with beauty . . . a combination of elements which reveals the subject as familiar yet strange."

Brandt took this black view of Newcastle during the Depression, when he traveled to the north of England to document the squalor of the coal-mining towns. Brandt's wife wrote that Newcastle's soot-darkened buildings "looked to him as if they might have been built of coal."

Train Leaving Newcastle, 1937

Brandt shot this nude with an ancient polished-mahogany Kodak that had no shutter, a fixed focus, a primitive wide-angle lens and an aperture as tiny as a pinhole. In photographs like this, Brandt transforms the female figure into such strange, surrealistic shapes that the novelist Lawrence Durrell called them "a prolonged meditation on the mystery of forms."

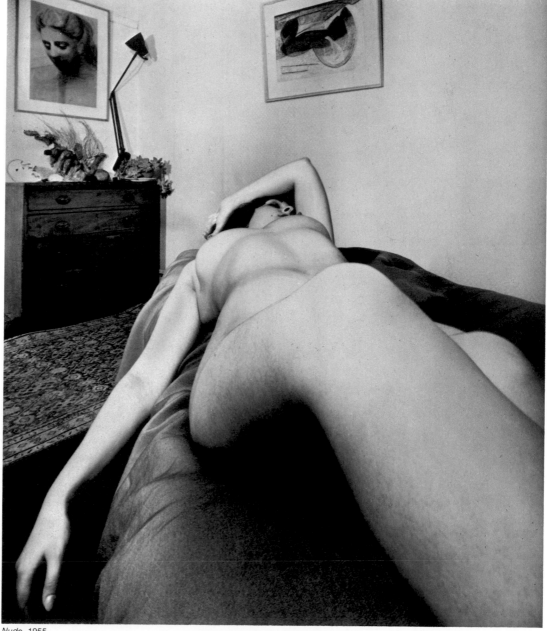

Nude, 1955

Lisette Model

In 1940, a recent immigrant from Europe named Lisette Model applied for a job as a darkroom worker at a New York magazine. As proof of her skills, she showed photographs she had developed (and, incidentally, taken) of vacationers on the Riviera. The picture editor looked at her pictures and said: "You must be crazy. You are one of the greatest photographers in the world."

That reply left Model "aghast," and unemployed: The magazine published her photographs but gave the darkroom job to someone else. "Never could I understand why the photographs were good," she said 40 years later. "I always found that they were utterly banal. But people said they were original, and I couldn't see that, for years and years and years."

Something of that shocked and unsophisticated honesty has remained with Model throughout a career spent photographing everyone from barroom habitués to society matrons. She still chooses her subjects "by attraction"—an affinity she refuses either to figure out or to explain. ("Don't shoot," she has said, "till the subject hits you in the pit of the stomach.") Above all, she still has what her longtime friend and colleague Berenice Abbott calls her "fearless eye." "I know of no photographer who has photographed people as inwardly as Lisette Model," Abbott wrote. "She does not shrink from reality. She meets it head on. Concerned with art, the subject is lost. Concerned with the subject, art is found. This is Lisette Model."

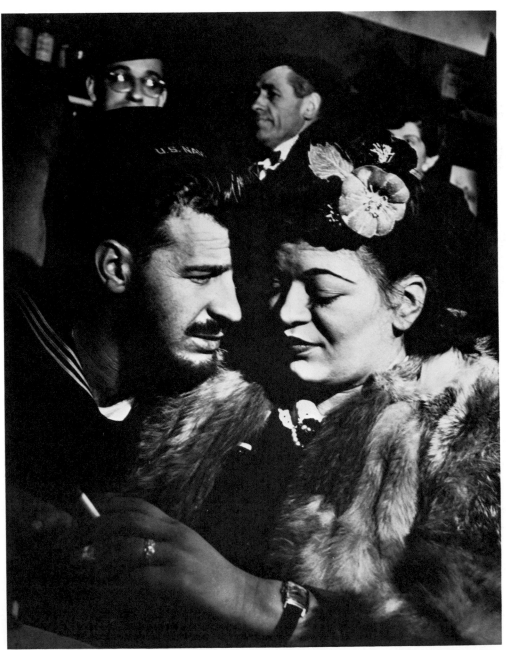

A U.S. Navy sailor and a woman in a fur piece enjoy a quiet moment in Sammy's Bar in New York City. Model's gift for photographic intimacy led Berenice Abbott to write that she "uses the camera with her entire body and as an extension of the eye itself."

Sailor and Girl, Sammy's Bar, New York City, c. 1940

So tanned he looks almost like cast bronze, a man in a three-piece suit sits in a deck chair on the Promenade des Anglais in Nice, France, in 1937. One old friend admitted that he "didn't know how to take" Model's pictures when he first saw them in the early 1940s. "They were like nothing I'd seen: strong and ugly. Later I acquired the taste."

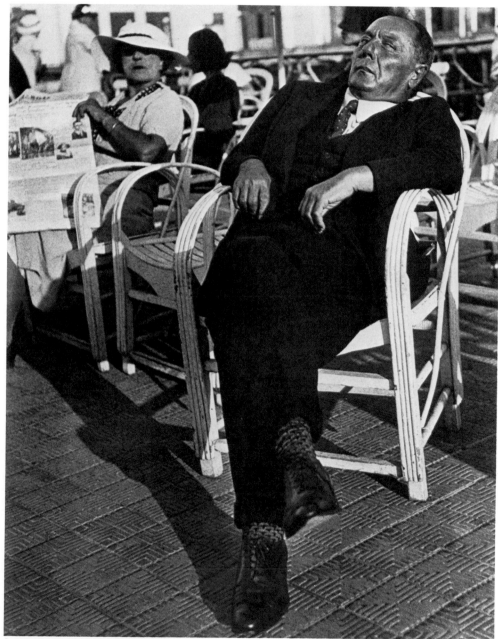

Promenade des Anglais, Nice, France, 1937

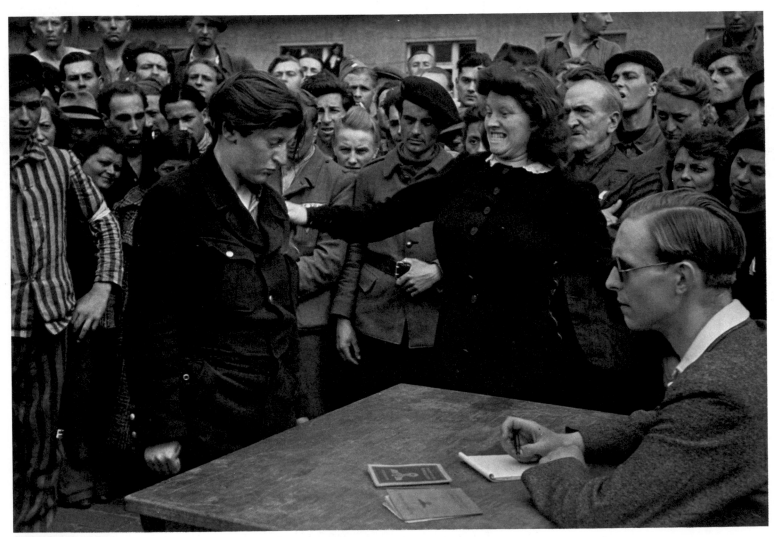

Dessau, Germany, 1945

In a camp for displaced persons at the end of World War II, a war refugee exposes an informer for the Gestapo. Cartier-Bresson, who had himself spent 36 months in a German prison camp before escaping to join the French underground movement, caught the episode at the precise moment when all the refugee's pent-up rage and resentment exploded across her face.

One of photography's legends is Henri Cartier-Bresson. An unobtrusive man in banker's shoes, with glasses and quick gray eyes, he is probably the most influential photographer of his generation. His working methods and abilities are part of photographic lore: an uncanny talent for remaining invisible to the people he photographs (he covers the metal parts of his camera with black tape so they will not shine); an insistence on creating a complete picture on the spot (he never alters or crops a print); an instinct for extracting the most telling moment from the scene before him. Often the scene is quite ordinary—a woman eating in a café, children playing, lovers kissing. But in Cartier-Bresson's pictures, it takes on a significance that touches everyone.

What is the secret? Essentially timing. When a photographer raises his camera at something that is taking place in front of him, says Cartier-Bresson, "there is one moment at which the elements in motion are in balance. Photography must seize upon this moment." Suddenly the shapes in the viewfinder capture the essence of what is happening—a sneer that shows hatred *(left),* two leaning torsos that convey the warmth of lovers *(right).* It is this instinct for the "decisive moment," combined with a deep understanding of and compassion for human nature, that is Cartier-Bresson's greatest contribution to photography.

The scene is slight—a couple kissing across a table—but the photographer has rendered it with a simple warmth that makes it memorable. And with humor: Even the dog seems intent on the goings-on. The composition enhances the intimacy, for the eye travels full circle—down the curve of the young man's arm to the dog, from there to the girl, and so back to the kiss itself.

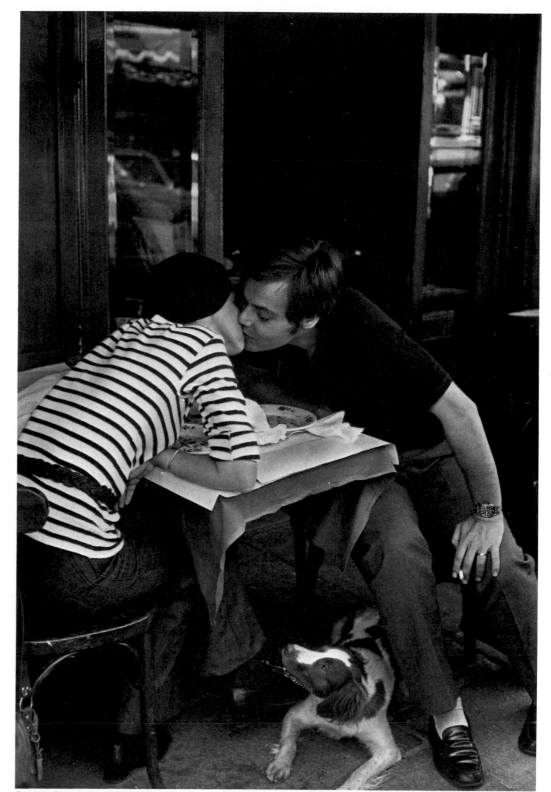

Outside a Bistro, France, 1968-1969

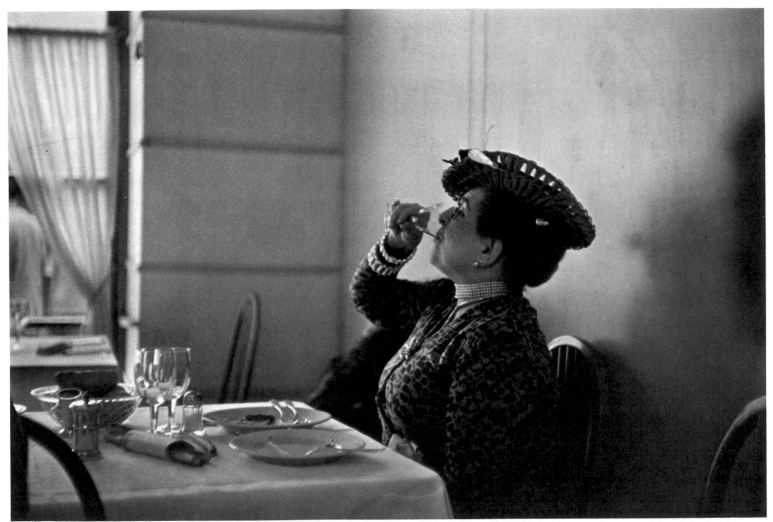

An Old Customer, San Remo, Italy, 1953

Cartier-Bresson has an infallible talent for
seizing upon the one gesture or expression that
conveys the essence of a person's character.
What could be more revealing than the prim
finality with which this rather starchy matron in an
Italian trattoria downs her solitary apéritif?

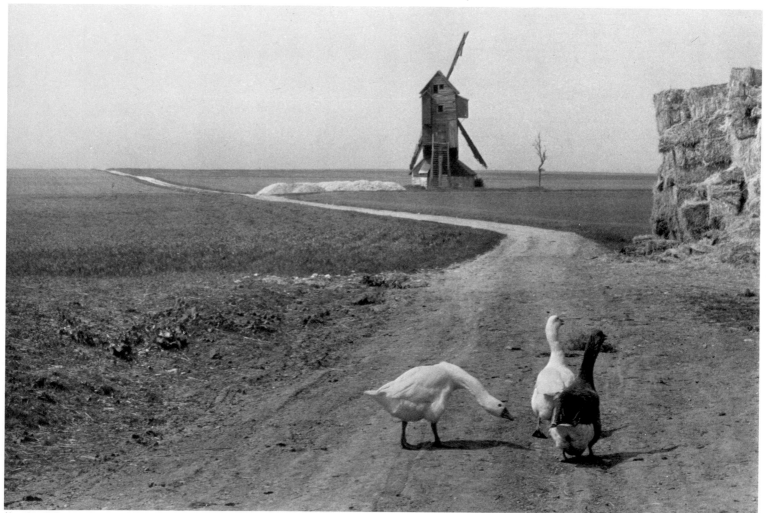

Abandoned Windmill, Beauce, France, date unknown

To lead the eye into this simple rural landscape of
the French countryside, Cartier-Bresson used a
compositional device employed by romantic
landscape painters from van Ruisdael to Corot — a
winding road that disappears into the distance.
But the photographer added a characteristic
down-to-earth touch, for the picture's focal point
is a gaggle of raucous, rather comic geese.

Castle St. George, Lisbon, Portugal, 1955

"We must respect the atmosphere which surrounds the human being," maintains Cartier-Bresson. And it is atmosphere that tells the story of this picture, taken on a parapet of an ancient fortress in Lisbon. The rusting cannon, the eroding stones, the city far beneath, the sun so hot that one man holds an umbrella against it, all seem like nostalgic evocations from an earlier day that echo the pensive looks of the old men.

These two girls, turned out in Sunday best, are too young to have been born when the graves behind them were dug, soon after the Normandy invasion. But Cartier-Bresson has tied the girls and the graves together: The children's similar postures and identical white outfits correspond visually with the rigid pattern of white crosses, while their serious gazes, intent on something not shown the viewer, seem appropriate to a cemetery.

American War Cemetery, Saint-Laurent, Normandy, 1968-1969

W. Eugene Smith

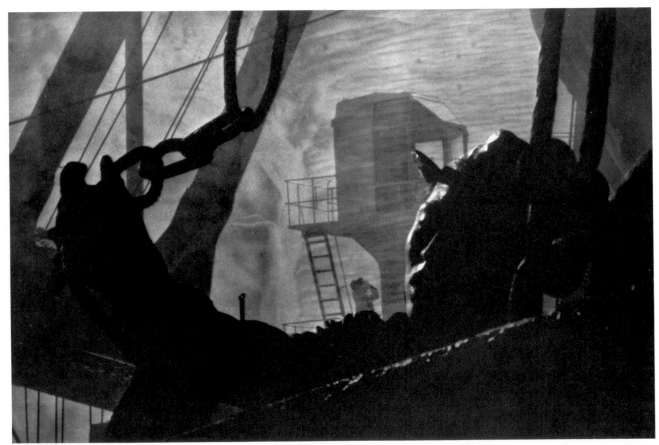

Japan, 1962

W. Eugene Smith was a photojournalist with a profound sense of mission. Each picture, he hoped, would somehow help to increase people's sympathy for their fellow human beings.

Smith first turned his compassionate eye on the human condition during the Depression, when, still a teenager, he began taking pictures for local newspapers in his native Kansas. During World War II, as a combat photographer fol-

lowing American forces through the Pacific, he reported the heroism of the foot soldier in pictures that seemed to capture all the horror of modern warfare. "Each time I pressed the shutter release it was a shouted condemnation," he said, and he harbored an idealistic hope that his pictures would help prevent future wars.

Once, believing his early pictures were not strong enough, Smith de-

stroyed them all; he explained afterward that they had "great depth of field, very little depth of feeling." And feeling, for Smith, was all important. It gives nobility to his photographs of ordinary men, whether a Caribbean fisherman *(right)* or a Japanese construction worker *(above)*. Occasionally it takes an ominous turn, as in the disquieting glimpse of a dead friend's apartment shown on a following page.

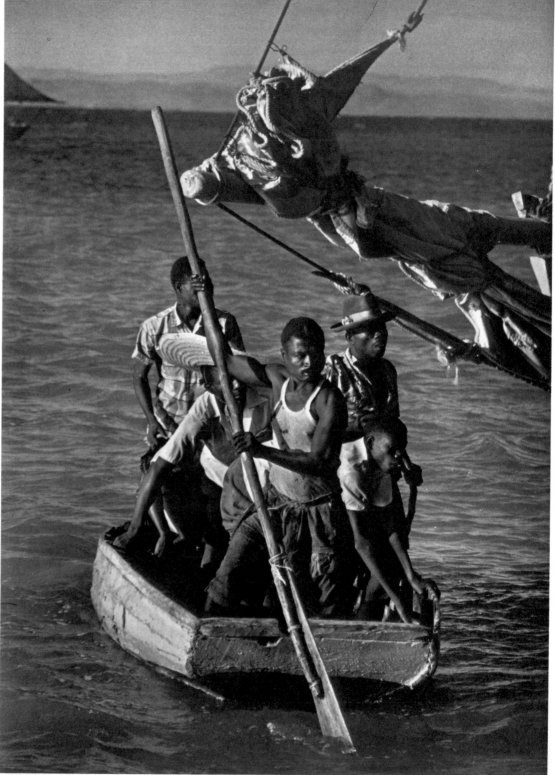

All the industrial muscle of modern Japan seems present in a powerful rendition of a single laborer in a giant manufacturing yard. Although Smith spent a year in Japan photographing for a book on the nation's industries, he considered himself "a tourist who often finds he is homesick for that remarkable country and its people."

A Haitian boatman ferrying passengers to a schooner is one in a sequence titled "Haiti, a barren, starving, beautiful land." And indeed the boatman reveals a dignified and powerful beauty that transcends the obvious poverty of his ragged clothing and primitive dory.

Isle of Tortuga, off Haiti, 1958

177

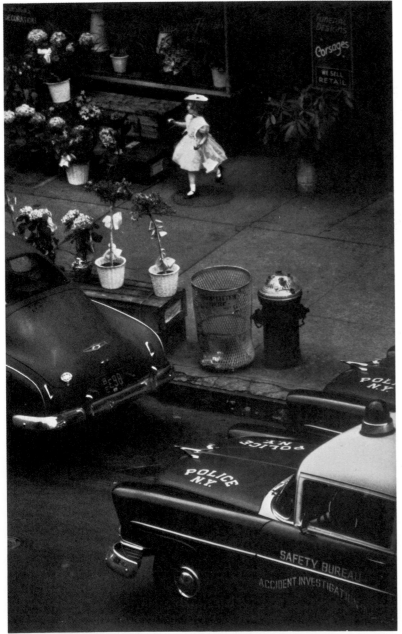

Smith often recorded the changing moods of New York City as he saw them from his loft studio overlooking Manhattan's wholesale flower market. "With my window as the proscenium arch," he wrote, "the street is staged with all the humors of man." Sometimes the humors are ominous, as in this glimpse of a little girl running from a flower shop. Where is she running, and why is she all dressed up? Why are police cars waiting at curbside? What unseen drama is taking place?

From My Window, New York, 1958

A disquieting photograph of lifelike figures is a tribute to the memory of their creator, Elie Nadelman, who had just died. Pictured exactly as they were found by the photographer, they became ghostly presences in the mortuary half-light of the sculptor's New York City town house.

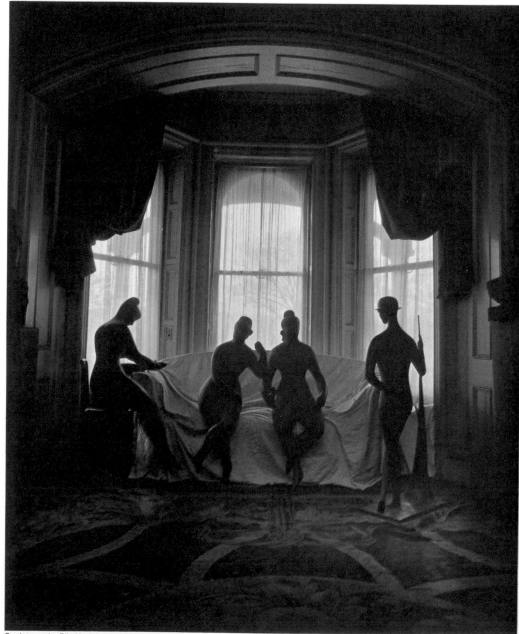

Sculptures by Elie Nadelman, 1949

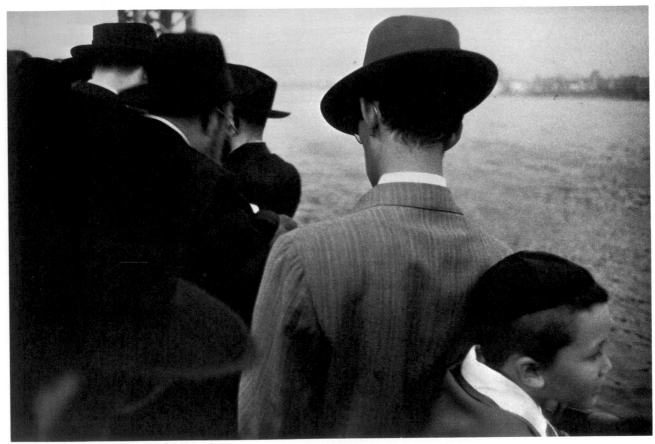

Rosh Hashanah—East River, New York City, date unknown

The United States got a fresh view of itself in 1959 with the publication of *The Americans,* a book of photographs by Swiss-born Robert Frank. With powerful restraint Frank revealed scenes of life most Americans either took for granted, ignored or never even noticed. To him, America was a land of isolated individuals, often uneasy with one another and their surroundings, lost in their private worlds *(above)* or else in an impersonal world, harassed by sup-

posed miracles of technology *(right).*

Frank's work is deceptive because of its apparent haphazardness. He was one of those who in the 1950s chose to abandon the theory of the "decisive moment" espoused by Henri Cartier-Bresson *(pages 170-175).* Instead, he photographed ordinary scenes at random moments, not necessarily when the action was at its peak or the mood at its most intense. His pictures seem to be crude snapshots, but it is this very

unplanned appearance that fills them with the forlorn and ironic quality true to the situations he set out to record.

A reticent, soft-spoken man, Frank first came to the United States in 1947 when he was 23. In New York City he photographed fashion for *Harper's Bazaar,* became a freelancer, won a Guggenheim Fellowship in 1955 and toured the United States. His trip produced *The Americans,* from which the pictures shown here have been taken.

Restaurant—U.S. 1, Leaving Columbia, South Carolina, 1955

◄ The photograph at left happened to be a scene of Orthodox Jews performing an ancient ritual on the banks of New York City's East River on Rosh Hashanah, the Jewish New Year. The men traditionally go to a body of water to scatter crumbs from their pockets as a purification ceremony. But the picture tells more of American life and character than it does of religious rites. Frank chose not to photograph the crumbs in the turned-out pockets, or even the human gestures of ritual. The men all have their backs to the camera and, like the little boy who looks into the distance, appear preoccupied with thoughts of their own.

The very ordinariness of this scene—a television set no one is watching, unoccupied tables and chairs in a customerless café—is what makes this photograph such an unsettling comment on the emptiness of modern society. The picture disturbs the viewer even more if he recognizes the face on the screen: Oral Roberts, evangelical minister and faith healer, preaching to a nonexistent flock. The harsh sunlight from the unshaded window, the barren interior of the roadside restaurant and even the glare of the television screen itself all add to the air of desolation—as if human life had disappeared from the earth.

Ansel Adams

Courthouse, Mariposa, California, 1934

Clarity and precision, as in this straightforward study of a country courthouse, are Adams hallmarks. In 1932, with six other photographers, among them Edward Weston (pages 146-149), he founded a photography group called f/64, which referred to the sharp focus and great depth of field that can be obtained with small apertures. One of its goals was to make just such meticulously detailed pictures as the one at left.

This panorama of storm clouds breaking over Wyoming's Teton mountains, with the Snake River winding into the foreground, has the grandiose sweep that led one critic to describe Adams' landscapes as "intense, extroverted and heroic" —words more commonly applied to Wagnerian opera than to straight landscape photography.

"Big country—space for heart and imagination." Thus does Ansel Adams describe his first love, the majestic landscapes he photographs so beautifully. His first pictures, taken with a box Brownie at the age of 14, were inspired by the mountain vistas of the Yosemite Valley, which he once called "the great earth-gesture of the Sierra." He has since become the foremost portrayer of the American land, particularly the West.

In the tradition of such great early landscapists as William Henry Jackson *(pages 80-81),* he packs view cameras and tripods into a station wagon and sets out in quest of the panoramas that express his almost mystic reverence for natural beauty. He looks for a quality of light—dawn rising over the desert, or sun breaking through clouds—that will give drama to his scene.

Adams approaches his huge theme with a meticulous respect for things as they are. Scorning tricky camera angles, he tries to render each scene as clearly and accurately as possible. As a youth he studied to be a concert pianist, and now, with his camera, he has a musician's instinct for precise technique. But technique, in photography as in music, is only a tool for conveying emotion, Adams asserts. "A great photograph," he says, "is a full expression of what one feels."

The Tetons and Snake River, Wyoming, 1941

Minor White

Many a photographer has been called a poet with a camera; Minor White was literally that, for he often accompanied his photographs with blank verse. His book *mirrors messages manifestations*, in which the two pictures that are shown here were published, was introduced by the following lines: "Fire burns on the lintels of doors/Flames burn across the ridge poles." This metaphysical thought conveys the intensity of White's photographic vision.

White's photographs are, in fact, visual poems. He worked in the sharply detailed style of Ansel Adams *(pages 182-183)* and Edward Weston *(pages 146-149),* his close friends and artistic comrades. But he had a different vision of what lies beyond the clear images and perfect prints. The goal of the serious photographer, as White saw it, was "to get from the tangible to the intangible," to render a view of a building or a close-up of a rock in such a way that it becomes a metaphor for something else—usually the photographer's own state of mind.

"A conversation with light"—a phrase White used to describe the work of Alfred Stieglitz (pages 128-131)—might also characterize White's own approach to this closely felt study of morning sunlight flooding through a kitchen window (right).

Windowsill Daydreaming, 1958

Temperature so cold that it froze the shutter open
led to the black sun in the picture below, for the
open shutter caused such severe overexposure
that some parts of the scene reversed their tones.
"I accepted the symbolism with joy," White said;
and — taking a poet's license with astronomy —
he added, "The sun is not fiery after all,
but a dead planet. We on earth give it its light."

Black Sun, 1955

Harry Callahan

New York, 1968

Since the 1930s, Harry Callahan has added a quiet, lyrical and original voice to photography. In quality, his work has been compared with the best of Edward Steichen *(pages 122-125),* and Steichen himself placed Callahan among the few who have lifted photography "into the realm of the arts."

Callahan began taking pictures seriously after hearing a series of lectures by Ansel Adams *(pages 182-183).* With Adams' precisely rendered landscapes as a starting point, Callahan developed a style entirely his own, characterized by rich, dark tones and clear shades of white that turn many of his pictures, like the landscape opposite, into designs in black and white. This precise use of the extremes of the tonal scale also can be found in his pictures of people, such as the street scene above, its dark shadows and bright walls reflecting the emptiness of a city where humans pass one another without noticing.

Each in his own world, pedestrians seem frozen in an urban landscape filled with looming, impersonal buildings. Callahan explains that he likes to photograph people in the street "because when they are walking they are lost in thought."

Stark black trees silhouetted against snow and ▶ winter sky are typical of this photographer's best landscapes — delicate black-and-white near-abstractions that are also perceptive studies of nature. "Nothing is more wonderfully quiet than Callahan's trees, those stately presences abiding winter," exclaimed one admirer.

Chicago, 1950

Aaron Siskind

In Gloucester, Massachusetts, in the summer of 1944, Aaron Siskind experienced what can only be described as a change of vision. He had been producing still lifes—"a discarded glove, two fish heads and other commonplace objects which I found kicking around on the wharves," he recalls. But now he looked at these items in a completely new way. "For the first time in my life," he said, "subject matter as such had ceased to be of primary importance."

It was a total about-face for Siskind. Since the 1930s he had been photographing such documentary themes as Harlem tenements and Bowery bums. Subject matter had been the whole point. Now the subject was all but unrecognizable. His close-ups of stone walls and peeling posters *(far right)* are all surface and design, like canvases by a nonrepresentational painter. The picture itself, not the scene it shows, has become Siskind's vehicle for conveying impact and emotion.

Indeed, Siskind's new-found vision is the inevitable step after the "equivalents" of Alfred Stieglitz *(pages 110-111),* in which forms found in nature, rendered precisely and directly with the camera, are offered as expressions of the photographer's own state of mind. "I'm not interested in nature," Siskind says, "I'm interested in *my own* nature."

These tumbling figures are part of a sequence the photographer made of boys diving into Lake Michigan. But he has photographed them in such a way, without background or normal perspective, that they become studies of pure form. Where are they in relation to the viewer? Are they rising or falling or simply suspended in space?

From *Pleasures and Terrors of Levitation,* 1954

Rome, 1963

Joan Miró, 1965

"The perfect photographic portrait has still to be made," the Canadian photographer Yousuf Karsh once said. But if anyone does finally make one, it quite possibly will be Karsh himself, for his specialty has been flawless portraits of the famous—rich likenesses that reveal every pore of the subject's face.

Karsh began his lifelong commitment to making fine portraits when he went to work at a photography studio in Canada. By 1932 he owned his own studio in Ottawa, and had begun building an international reputation for dignified, faultlessly detailed likenesses of the world's great men and women.

Part of the Karsh technique is total control over his sitter. Once, when Winston Churchill refused to remove his cigar for a portrait, the photographer plucked the offending cigar from the Prime Minister's lips. For an effect he wanted, Karsh made painter Joan Miró change clothes, and put Nikita Khrushchev into an immense fur coat. For Karsh insists on revealing one quality: an "inner power" that shows the source of his sitter's greatness. "It is the mind and soul of the personality before my camera that interests me most," he says, "and the greater the mind and soul, the greater my interest."

Karsh arrived at Miró's studio to make this portrait only to find the great Spanish painter waiting uncomfortably in his fanciest suit. Persuaded to change into everyday working clothes, Miró relaxed with an ingenuous expression that reflects the mischievousness of his own paintings.

When Nikita Khrushchev, then Soviet Premier, was ▶ *asked to put on the voluminous fur, he obliged with a characteristic twinkle in his eye. "You must take the picture quickly," he said, "or this snow leopard will devour me!" The result, Karsh believes, "is the face of the eternal peasant, perhaps the collective portrait of a great people."*

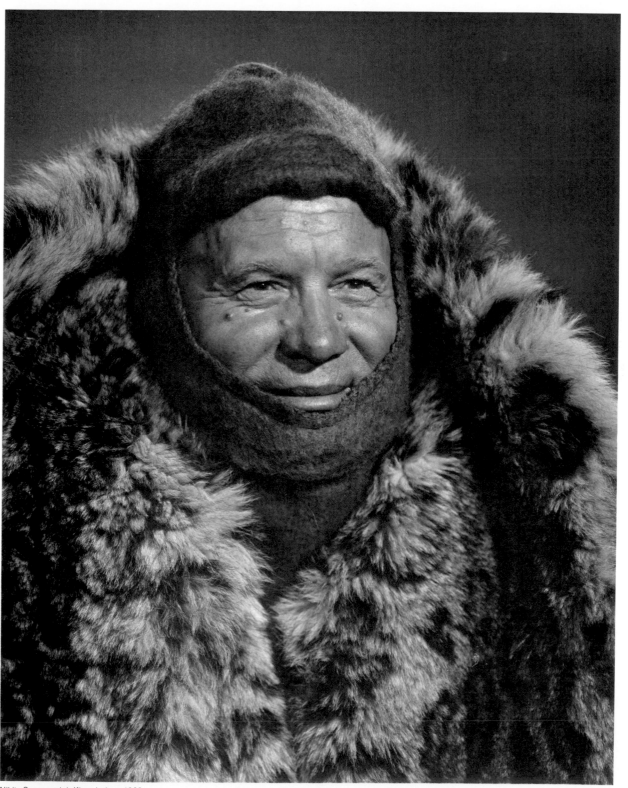

Nikita Sergeyevich Khrushchev, 1963

191

Philippe Halsman

Most photographers try to perfect a single style that is uniquely their own. Not so Philippe Halsman, a marvelously imaginative portrait photographer who had a chameleon-like talent for shifting styles and evoking new responses. He could move, at the click of a shutter or the whim of a picture editor, from high seriousness *(far right)* to puckish humor, from careful realism to the wildest surrealism *(right)*. "My specialty," he proudly maintained, "is versatility."

Halsman's many-faceted skills came to light in 1940, when he arrived in the United States from Paris and began making imaginative portraits of celebrities. His likenesses of Albert Einstein and Adlai Stevenson have been turned into postage stamps, and Richard Nixon adopted a Halsman photograph as his official presidential portrait.

One of Halsman's most imaginative —and outrageously funny—strokes is a book with portraits of 178 public figures, all shown leaping into the air with undignified abandon. Another irreverent Halsman work consists of 36 totally different views of Salvador Dali's mustache. But for all his humor, Halsman had a serious view. Each of his portraits, he said, is an effort "to capture the essence of the human being—his personality, soul, character."

In a surrealistic tour de force of his own, Halsman portrayed the surrealist painter Salvador Dali beside a death's head simulated out of living flesh. It took Halsman three hours to arrange the seven nude models in their macabre pose, which follows a sketch created by Dali himself.

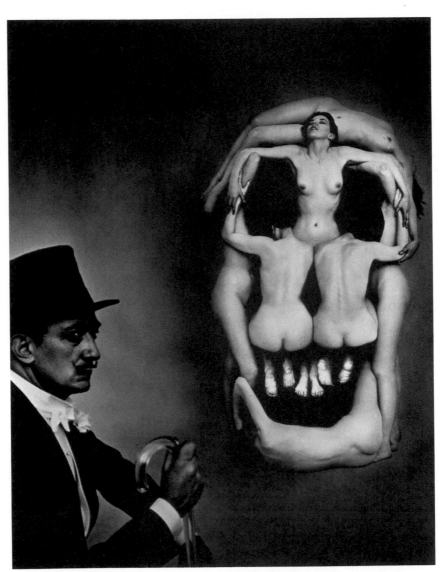

Dali and the Skull, 1951

When J. Robert Oppenheimer, the scientist who piloted A-bomb development during World War II, lost his security clearance in 1954 for "poor judgment," the blow nearly shattered him. This portrait captures the bewilderment that remained in the great physicist's tormented face.

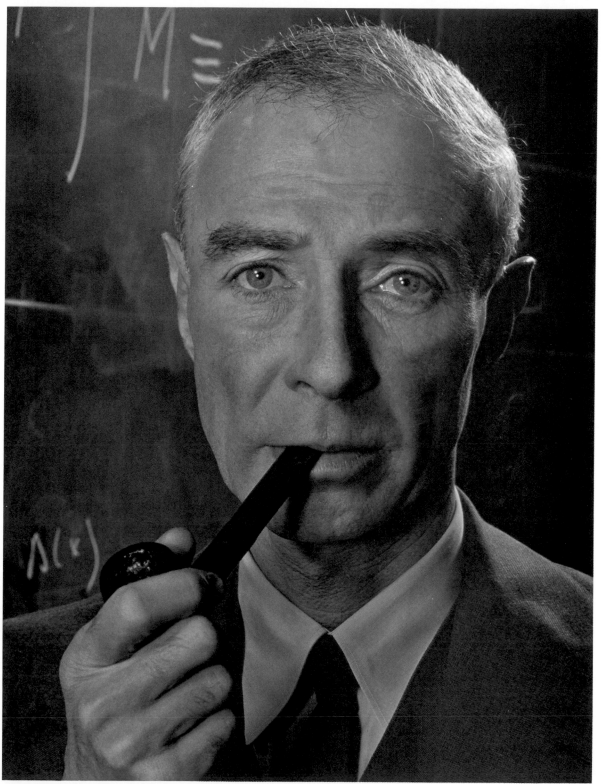

J. Robert Oppenheimer, 1958

Arnold Newman

Arnold Newman is master of a variety of photographic forms and subjects, but he is best known for his portraits of fellow artists. Beginning in 1941, when he was 23, Newman has photographed the creative minds of the day, often posing them in their own studios and work rooms, where their surroundings could suggest their personal styles.

Newman was raised in Atlantic City and Miami Beach, where his father ran hotels. Growing up in the hotel business, Newman said, made him adept at dealing with many different kinds of people. He intended to be a painter and studied art at Miami University, but lack of money forced him to drop out and take a job for $16 a week as an apprentice in a portrait studio. The work made him a convert from art to photography.

Newman, often irascible when not working, becomes the voice of authority when manipulating his camera and his sitters. He believes that photography "is a matter of controlling what's in front of you to make it do your will." Thus he deals firmly with his subjects —no matter how high their stations— posing them until he has the expression he wants. "Limited to one visual image," Newman has written of his work with a sitter, "I wish to tell the most about him in the world in which he lives We want to show him in his world fused with a creative visual idea."

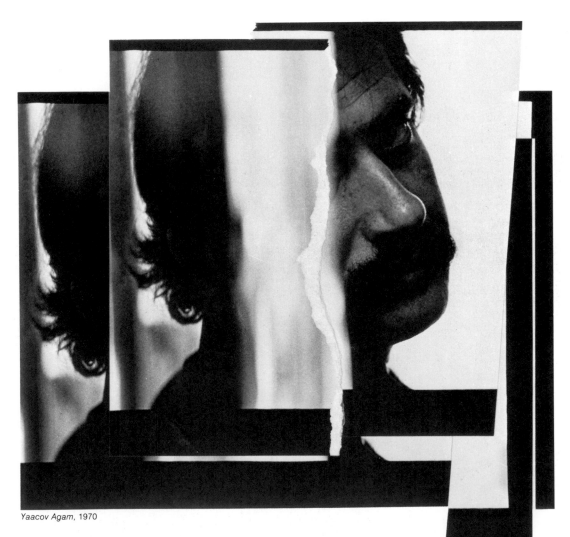

Yaacov Agam, 1970

Newman shot the negative for this unusual portrait of his friend Yaacov Agam, the Israeli painter and sculptor, while walking around New York with Agam in 1966. Some four years later he used the portrait to make a multiple-layer photograph, a combination of several prints—some of them torn —that were rephotographed. The overlaid images catch the spirit of Agam's kinetic works of art.

Two giants in their fields, Alfred Stieglitz, master ▶ photographer and high priest of modern art, and his wife, the abstract painter Georgia O'Keeffe, appear before a blank wall in the dark capes they habitually wore. The almost bleak simplicity of every element in the picture—settings, arrangement of sitters, facial expressions, body posture—is reminiscent of the couple's own art.

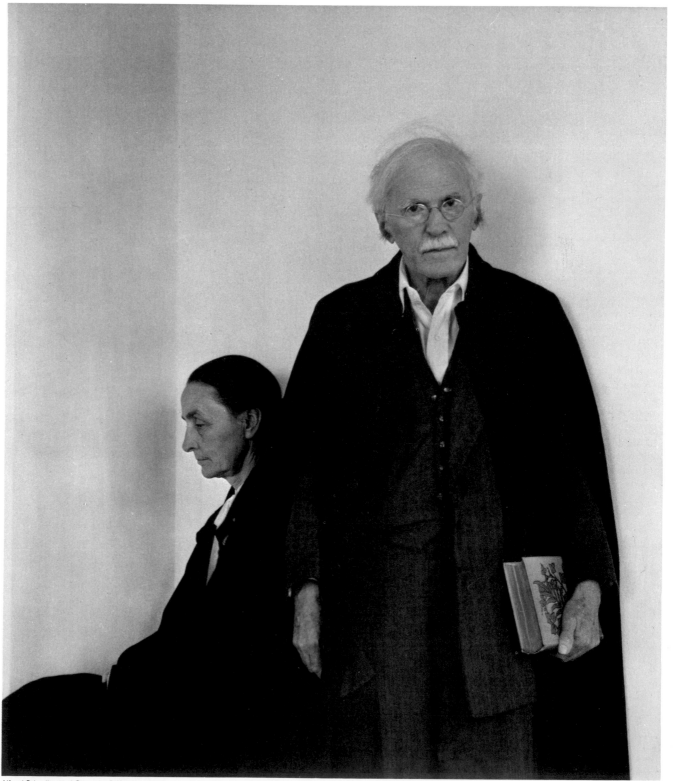

Alfred Stieglitz and Georgia O'Keeffe, 1944

Colette, 1951

There is a special elegance, both austere and startling, to a photograph by Irving Penn. Elegance is manifest in the severe poses of the fashion models that he began photographing in the early 1940s. It illuminates his advertising pictures, the economically rendered still lifes of cornflakes boxes, automobiles, diamonds and dinner plates. It distinguishes his portraits, whether of famous faces or of unknowns, shown forthrightly against the spartan background of a studio wall.

Part of Penn's sophistication comes from a paradoxical sense of reality. The picture that launched his career as America's foremost fashion photographer was a 1943 *Vogue* cover, the first of more than 150; it showed the incongruous items a woman might collect in her handbag: scarf, gloves, a huge topaz—plus several oranges and lemons.

Another facet of Penn's artistry is the intense concentration with which he works. He takes firm control of each portrait sitting, gently probing and cajoling until his subject reveals himself with a telling gesture or expression. As *Vogue's* Diana Vreeland described his technique, "There is never a moment when his mind is, so to speak, in space and taking it easy."

◀ *Making portraits of famous people, Penn says, is "a kind of surgery; you cut an incision into their lives." And in this penetrating likeness he has stripped away the defenses of one of France's most sophisticated novelists to reveal the essential Colette—part whimsy, part steel, a keen but tolerant observer of humanity's foibles.*

This surprising tulip, displayed on its side in close-up, provides a flamboyant splash of strong color and graceful shape. It fulfills one of Penn's stated principles—that a good photograph should startle the eye of the beholder.

Tulip, 1967

New Guinea Highlander, 1970

Herring, Sweden, 1963

◀ *A savage elegance distinguishes this portrait of a Chimbu tribesman decked out in the ceremonial finery of clay mask, grass wig and leaf cloak. Though taken on a field trip to the primitive jungles of New Guinea, it is essentially a fashion photograph — it proclaims the photographer's keen delight in the brilliant colors and imaginative materials of the tribesman's regalia.*

Cool, delicate color harmonies give beauty to this still life of herring, dill and potatoes, taken to illustrate a magazine article on the pleasures, both visual and culinary, of life in Sweden. With a sophisticated eye for detail and an unfailing instinct for well-balanced composition, the photographer makes each of these simple ingredients look like something special.

Ernst Haas

New York City Reflections, 1960s

Photography, Ernst Haas once declared, "is a transformation, not a reproduction." He should know. There are few photographers who have so successfully transformed the objects we see and know into shapes, and shapes into their constituent colors. Massive city buildings *(above),* which were photographed through a revolving door, appear to break, rearranging themselves in almost cubistic fashion; a beachscape *(right)* is repeatedly mirrored in small puddles; an opening rose *(page 202)* becomes a study in red, and in the wonder of life. "The smallest cells are reflections of the largest," Haas wrote. "And in photography, through an interplay of scales, a whole universe within a universe can be revealed."

Water Drops, 1963

◄ Reflected New York City buildings create a dizzying sense of city life in this photograph taken through a revolving door. "Reflections constantly appear as one walks through the cities," Haas wrote of this picture, "images creating the spirit of a city within a city, within yet another city. Only as a photographer can one preserve this perfection of overlaying images in compositions that hold together."

Little puddles deposited by a breaking wave fill the crevices in a piece of coral. Most of the puddles show blue or tan, reflecting the element—sky or land—nearest to them. But some half dozen or so contain full miniature versions of the entire scene, with sky, ocean, breakers and sandy beach all caught as though by a wide-angle lens.

Rosebud, 1970

A half-bloomed rose opens petal by petal, the blur of the background—and of the edges of the unfolding petals—imparting a mysterious sense of real motion to this still photograph. Haas shot the rose every half hour or so to record each stage of its progress from "egglike bud" to full flower—and to celebrate what he called "the miracle of creation."

An Explosion of Styles and Techniques 206

William A. Garnett 208

Marie Cosindas 210

Paul Caponigro 212

Jerry N. Uelsmann 216

Duane Michals 218

Robert Heinecken 220

Diane Arbus 222

Garry Winogrand 226

Lee Friedlander 230

Josef Koudelka 232

Donald McCullin 236

William Eggleston 238

Stephen Shore 239

Joel Meyerowitz 240

Photographers represented in this chapter include: ▶
William A. Garnett 1
Marie Cosindas 2
Paul Caponigro 3
Jerry N. Uelsmann 4
Robert Heinecken 5
Diane Arbus 6
Duane Michals 7
Garry Winogrand 8
Lee Friedlander 9
Josef Koudelka 10
Donald McCullin 11
William Eggleston 12
Stephen Shore 13
Joel Meyerowitz 14

An Explosion of Styles and Techniques

In the turbulent 1960s and their afterglow, the 1970s, photography underwent changes as dramatic and far-reaching as those that swept through politics, society and the world at large. They were, in a favorite word of the period, *radical* changes, going "to the root issue of the photographer's definition of his function," as critic and curator John Szarkowski put it. At times there seemed to be no consensus on whether the photographer even had a function, much less on what it was. Everywhere there was a turn (some would say a retreat) to private concerns—to personal preoccupations and esthetic enthusiasms. The documentary impulse itself seemed to go private. Two of the best documentarians, Josef Koudelka and Donald McCullin, spent most of the period photographing gypsies and wars, their respective obsessions. Other photographers created dreamscapes, photosculptures and formal essays in color that chiefly revealed how they felt about the world.

In this, of course, they were following trends already prominent in the 1950s—trends that could be traced back, for that matter, to Alfred Stieglitz and before. But their approaches were more daring, more innovative, more blatantly idiosyncratic, more private. And they led to pictures that were often paradoxical and puzzling. A public that had grown more knowledgeable about photographic styles and techniques found itself increasingly unsure of what it was seeing—or why it was so moved by a photograph on a museum wall.

That the image was in a museum at all speaks volumes. The picture magazines that had shaped many earlier photographers and had given them a large public purpose—a large public, period—were on the wane; some ceased publication altogether, others shrank in size, circulation or frequency. Yet, at the same time, photography was winning broader recognition as an art form. Museum after museum opened new photography collections or expanded existing ones. One survey of four major U.S. museums showed a more than threefold increase in the number of prints acquired between 1965 and 1975. Private purchases also grew. Though a few New York art galleries had sold photographs in the past, it was not until 1969 that New York City got its first successful commercial photography gallery; a decade later it had more than 20. By that time, too, the city was able to boast eight museums that routinely exhibited photographs.

New York was perhaps exceptional, but it was far from unique. In 1978, for example, there were more than 50 photography exhibits in Washington, D.C., alone. And more and more lavishly printed photography books rolled off the presses of publishers who used to laugh at such long shots. Most important of all, the number of colleges and universities that taught photography expanded dramatically throughout the 1960s. This had a twofold effect: It provided jobs for many established photographers (who now enjoyed the same security their novelist colleagues in the English department had), and it produced thou-

sands of skilled and informed graduates, many with high photographic and academic ambitions of their own.

This triumph of photography as an artistic discipline, the acknowledged equal of painting and sculpture, signaled the inevitable eclipse of the crisply detailed, beautifully finished black-and-white print. It survived, but much as representational painting survived: as just one among a dazzling array of styles and techniques. Yet, for all their differences, many of the 14 new masters considered in this chapter can be grouped together, at least roughly and approximately, by common goals, methods or influences. Jerry N. Uelsmann combines many negatives into single surrealistic prints, jarring our mental expectations of order while satisfying a visual interest in form. Duane Michals works a similar magic in his dream sequences — short picture stories in which people walk out of the waking world and into some very strange places indeed. Robert Heinecken uses magazine clippings as well as his own photographs to build collages and photosculptures that shock by a calculated blend of political, social and sexual imagery.

Others manage to suggest mysteries without resorting to darkroom sorcery. William A. Garnett flies high over the American landscape, shooting the familiar countryside as spectacular and exotic patterns of line and color. Fellow landscapist Paul Caponigro stays flat on the ground. But he too punctures the known landscape, "making visible the constant flow" of nature and suggesting, as Minor White did earlier, a mystical inner landscape where seen and seer merge. And Marie Cosindas, a master of instant Polaroid film, employs her modern resource to craft still lifes and portraits that charm the eye by their flawless formal elegance and ethereal, almost antique mood. Another portraitist, Diane Arbus, worked in the more acid vein of Robert Frank, eschewing elegance for searing insight. Garry Winogrand and Lee Friedlander — themselves spiritually descended from Frank — perfected the art of the apparently haphazard street scene, taking "snapshots" full of unexpected humor, meaning and mystery. Three others helped transform color photography. William Eggleston, Stephen Shore and Joel Meyerowitz advanced a profound revolution simply by accepting color as a natural part of human vision. No longer did color have to be boldly graphic or otherwise attention-getting to be considered photographically legitimate; it had only to be there, ready for use, like volume and texture and focus. The photographer's language (already overflowing the photographer's dictionary) was thus immensely and wonderfully expanded.

William A. Garnett

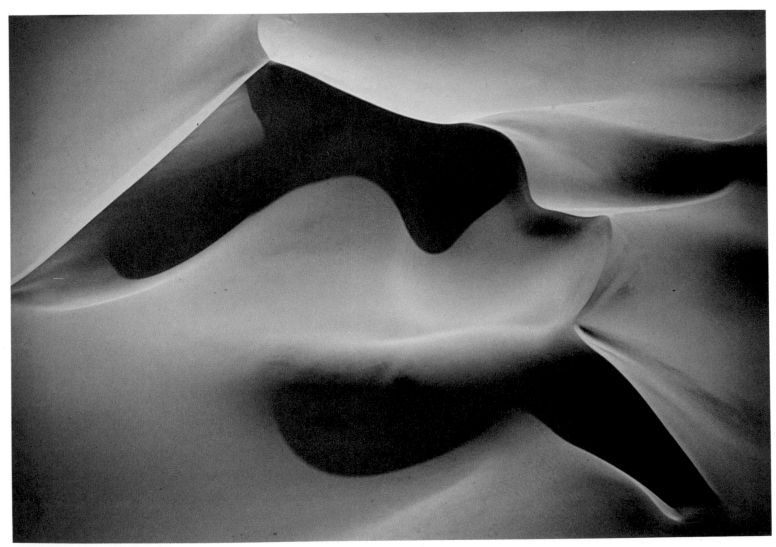

Sand Dune, Death Valley, California, 1967

Aerial photography is usually thought of as a tool for weather forecasting, mineral exploration, military reconnaissance and other nonesthetic pursuits. But in William A. Garnett's expert hands it becomes an art of spectacular grandeur. Garnett flies hawklike over the United States, photographing underwater sandbars off Cape Cod, the graceful abstract patterns of heartland farms, and the exotic vistas of the Southwest. He aims not to wrest secrets from the landscape but simply to celebrate and preserve its diverse glory. Angered by human violence against the land, the pilot-photographer has logged nearly a million air miles since 1947 on his mission to record for future generations a beauty he fears may soon be lost.

Sunlight falls across the wind-sculpted sands of Death Valley (left), shaping its own patterns, in gold and black, to complement the desert's contours. Garnett has learned to steer his plane with one elbow as he aims his camera out the window, to be ready for that fleeting moment when shifting sand, changing light and moving plane combine to create the desired photograph.

Much praised and photographed by the earthbound, Arizona's Painted Desert (right) is a marvel of pure form and resplendent color from one thousand feet. This seemingly abstract composition is testimony to a natural process that particularly fascinates Garnett: the inexorable wind and water erosion by which the planet slowly reshapes itself over the eons.

Painted Desert, Arizona, 1975

Marie Cosindas

Like countless amateurs who are intent on nothing more artistic than souvenir snapshots, Marie Cosindas shoots with self-developing Polaroid film. Yet there is nothing casual about her work. In fact, it is hard to imagine photographs that look less like snapshots or have had more artistry lavished upon them.

Cosindas sometimes spends days assembling her densely cluttered still lifes: first getting together the articles themselves (everything from dolls to asparagus stalks is fair game), then arranging and rearranging them until she is satisfied. Her portraits are equally meticulous constructions, with both the background and the subject's clothing and pose frequently determined by the photographer. The shooting itself is a labor of constant refinement. She may take hours and dozens of Polaroid pictures to create the one print with the desired color and expression that becomes the finished portrait.

Instant film, with its muted contrasts, helps Cosindas achieve the subtle and suggestive colors she loves. It makes up for the lack of a negative (each Polaroid print, like a painting or daguerreotype, is unique) by encouraging her to test the effects of different filters, exposures, even room temperatures. "To be able to see the results immediately," Cosindas recalled of her first experiments, "was like a little miracle. I could hold an entire darkroom in the palm of my hand."

American poet Ezra Pound stares intently from this portrait, taken in a dark hotel lobby in Spoleto, Italy, in 1967. Cosindas saw Pound often during a summer spent exhibiting at the Spoleto Festival. She recalls that the laconic 82-year-old expatriate never spoke to her until the end of this portrait session, when he said one word: "enough."

Ezra Pound, Spoleto, Italy, 1967

Asparagus Still Life I, 1967

Wax fruit, ribbon-tied asparagus, a replica of an old painting, a single rose—and much else—fill this vibrant composition by Marie Cosindas. The feathery colors and odd objects used in such still lifes make them seem almost otherworldly. "They are like something remembered," noted one critic, "an experience of the eye softened by time."

Paul Caponigro

Paul Caponigro sees his photography as an exploration into three distinct landscapes. First—and his own first love—is the scene itself, creation in all its splendid and wondrous variety. Then there is the print, "a landscape of discovery and delight" in which tones replace objects and all storms are caused by chemical emulsions. Finally comes an almost mystical realm that Caponigro calls "the landscape behind the landscape." Here nature or photography, or both, subtly take control, "offering back," he says, "what I *sensed* as well as what I saw."

Caponigro has spent his professional life working to capture—to inhabit—that third landscape. His meticulously crafted prints evoke the actual scene in front of his lens with exquisite precision. But his primary interest is in that other terrain —magical and poetic—where imagination and photochemistry meld with nature to "express the quiet forces moving in nature" and to create "a landscape of reflection, of introspection."

A process of "discovery" guides him. "I feel my way," explains Caponigro. "I know and direct up to a point and only so far as nature cooperates." Beyond that point lies the "mystery" that turns his best photographs into "dreams locked in silver"—permanent images distilled from his own fleeting sense of "the thread which holds all things together."

Sunlight plays like quicksilver on a waterfall in County Sligo, Ireland, turning its cascading spray into white filigree. "The ratio of light to dark in each photograph creates a different effect in each viewer," says Caponigro. But he adds: "When I'm photographing, I don't think about the proportions of light and darkness. My hands and eyes organize the image into existence on the ground glass."

Sligo Waterfall, Ireland, 1967

Badlands, South Dakota, 1959

A clump of hardy flowers sits in a rock-strewn basin
in the Badlands of South Dakota. The merciless sun
has not only cracked the otherwise barren earth but
also made it almost impossible to tell the flowers'
stalks from their shadows. "Most of us tend to take
things too literally," Caponigro says. "I want to get at
another aspect of experiencing, to see beyond the
image, behind appearance. Taking things too
literally stands in the way of this — like a veil."

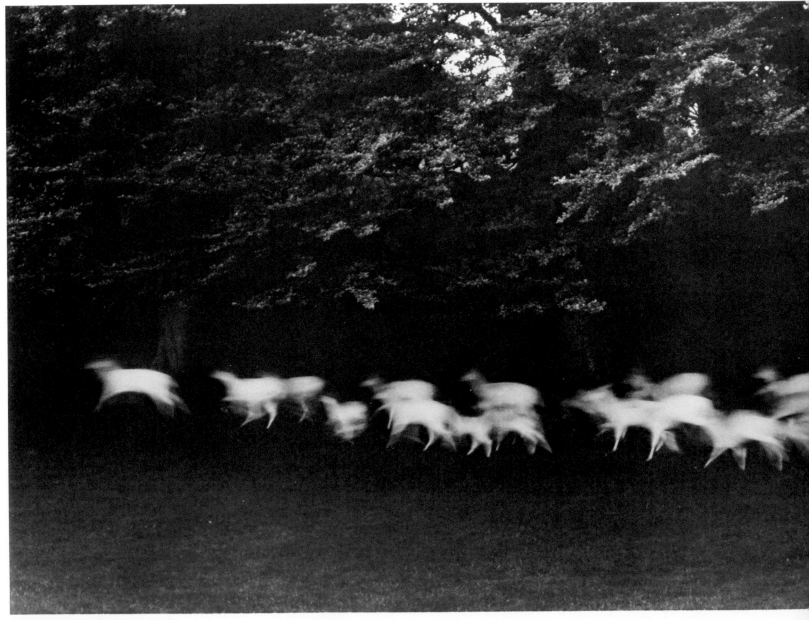

Running Deer, County Wicklow, Ireland, 1967

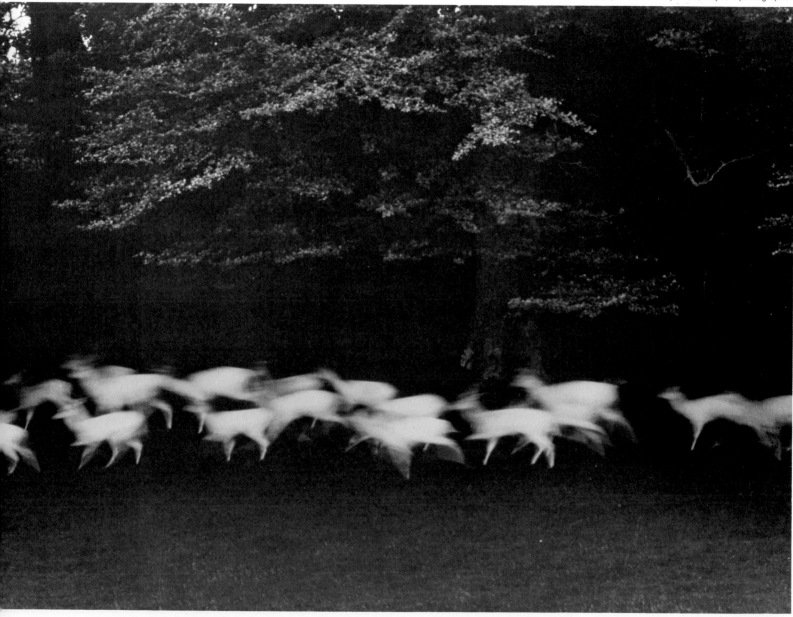

A herd of white deer scatters across a meadow on an estate in Ireland. Caponigro had stalked the herd, arranging his equipment (long lens, slow shutter speed) on the far side of the field. Then the deer ran past, faster than expected, leaving this blurred image — "a ghostly effect more wonderful than the sharper focus I'd hoped for," says the photographer.

Jerry N. Uelsmann

Of the photo-surrealists who flourished in the 1960s, Jerry N. Uelsmann did most to revive and advance the art of composite photography. His incongruous juxtapositions and eerie dreamscapes once again demonstrated that the artist with a camera, like the artist with a brush, need not be concerned exclusively with the faithful reproduction of things as they are.

There are certain elements recurring in Uelsmann's photomontages that recall the paintings of Salvador Dali and René Magritte: Human limbs stand disembodied, while whole trees float in midair, their roots exposed; up and down, in and out, are confused, reversed or merged. But Uelsmann also uses some purely photographic tricks, playing positive images against negatives and reproducing the same object at different sizes within a single photograph.

Uelsmann takes photographs without any preconceived notion of how they will ultimately be used: He simply collects images, confident, as he says, that "an old Uelsmann negative gathers no moss." The vision of what he wants comes later, often in the darkroom, where he builds his intricate constructions from the negatives in his image bank. Once printed, these montages have the seamless unity of ordinary photographs—a quality that only heightens their bizarre effects.

An open archway beckons us into a realm of clouds, while a lopped-off arm stands like a piece of statuary in the dark alcove next to it. These assembled images, like fragments of a dream, tease the mind with promises of revelation but stop just short of yielding up their hidden message. They challenge the imagination to impose on them a unity of rational meaning to equal the unified look created by Uelsmann's skillful printing.

Untitled, 1974

A misty otherworldliness seems to shroud a
landscape in which a pair of trees—actually one tree,
reproduced twice—are suspended in midair,
feather light in root and crown. Yet where exactly is
"midair," given the disconcerting inversion that
places the sky at the bottom of the picture?

Untitled, 1969

217

1

2

5

Duane Michals carries the camera into a world of his own devising, bringing back snapshots of dreams, even whole narrative sequences apparently shot on location in the subconscious. Like the comic books of his youth, these sequences tell their stories simply, frame by frame. However, the stories are unique: A naked man mounts a narrow staircase, merging with the light at top, in "A Man Going to Heaven"; two soberly dressed apartment dwellers gradually turn into Adam and Eve, their home into the Garden of Eden, in "Paradise Regained"; a dead man literally gives up the ghost in "The Spirit Leaves the Body" *(above and right).*

Double exposures, sandwiched negatives and deliberately blurred prints help Michals get beyond what he calls "the transient phenomena that constitute the things of our lives." He declares: "I believe in the invisible. I'm for photographs that make us question everything, that do not give answers, that make you wonder what the hell is happening."

The Spirit Leaves the Body, 1968

"This is literally what I think happens when you die," Michals says of this photo sequence. A corpse lies unmoved throughout the seven frames. But the dead man's spirit, created through double exposure, sits up alertly, as though waking from a dream, then stands and walks away from the body —and into the camera. "The body is just a vehicle for the spirit," Michals explains.

Robert Heinecken

Robert Heinecken makes art out of an endlessly beguiling variety of fragments. His images seem to explode at the viewer. Visual morsels are racked on swivel blocks, inviting rearrangement *(right),* or splashed across a woman's torso like tattoos of anguish *(opposite).*

Technique, to Heinecken, is a playground without rules. He layers transparencies, one over another, on sheets of clear acrylic, and cuts and reassembles prints like puzzles. He uses photographic emulsion directly on canvas, then enhances the image with pastel chalk. One print was not only drawn upon but also bleached, stained and redeveloped.

The intent of all this experimentation is to "bring together disparate images or ideas so as to form new meanings," Heinecken explains. "It is the incongruous, the ironic and the satirical that interest me, particularly in socio-political and sexual-erotic contexts. I sometimes visualize myself as a bizarre guerrilla, investing in a kind of humorous warfare."

That is an appropriate view for a former Marine fighter pilot. But Heinecken is also a teacher; and in his work, as in the classroom, one of his chief aims is to change the way people see. To that end, he shuffles his trick deck of images with a joyful abandon. "It's almost like you can't miss by doing it," he exults. "It's like opening Christmas presents."

Heinecken believes the power of his art derives from "the tensions between a beautifully constructed image/object and the sense that you are in the presence of a mild perversity—a kind of balancing act." Comments Heinecken with guileful simplicity: "Pictures can function by simply bringing things together that were not together before, causing us to wonder what they are now."

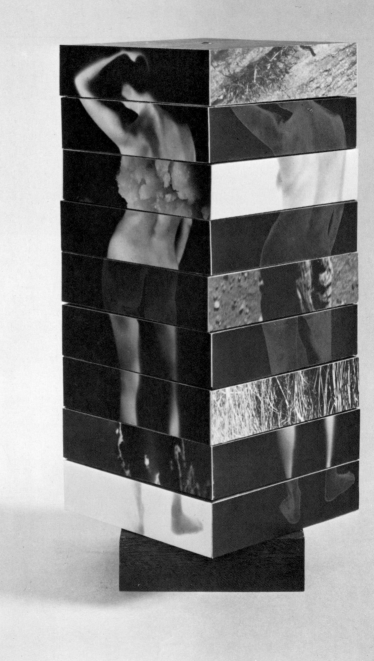

Figure Sections/Beach, 1966

Heinecken attached portions of photographs to the sides of nine walnut blocks one inch high and then stacked the blocks on a central spindle to create the movable photosculpture shown at left. The shape and appearance of the object can be varied at random. "It can be read," says Heinecken, "as saying that if you make a picture that has eight million combinations, there's no decision made about what the right one is."

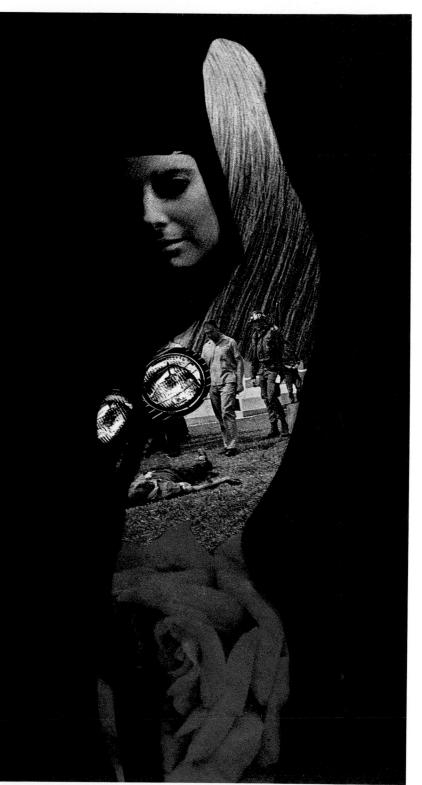

A sweep of blond hair, headlights, death in Vietnam and a red rose fill the soft outline of a young woman's body in Heinecken's "Costume for Feb. '68" — the month in which the North Vietnamese Army and the Viet-Cong launched the all-out Tet offensive against the South. The "costume" is a collage of clippings overlaid with a black-and-white transparency. The combinations and tensions in such works, says Heinecken, often result in "people wanting to laugh and wanting to cry" at the same time.

Costume for Feb. '68, 1968

Diane Arbus

"There's a kind of power thing about the camera," Diane Arbus once said. "Everyone knows you've got some edge. You're carrying some slight magic which does something to them. It fixes them in a way." She used that magic on everyone from society matrons to strippers, from twin girls to young men in hair curlers. And she used it to not only fix but also reveal identity—"what's left," she said, "when you take everything else away."

Arbus was relentlessly intense, direct, unsentimental—a surgeon who probed the disjuncture "between what you want people to know about you and what you can't help people knowing about you." Yet each of her subjects remains an irreducible individual. "What I'm trying to describe," she said, "is that it's impossible to get out of your skin into somebody else's. And that's what all this is a little bit about. That somebody else's tragedy is not your own."

Her method was a kind of aggressive diffidence. "The thing that's important to know," she commented, "is that you never know. You're always sort of feeling your way." Yet Arbus also sensed her own particular genius—that she owned "some slight corner on something about the quality of things. . . . I really believe that there are things which nobody would see unless I photographed them." Writing in 1972, a year after Diane Arbus died, critic Robert Hughes agreed: "Arbus did what hardly seemed possible for a still photographer," he wrote. "She altered our experience of the face."

Lady at a Masked Ball with Two Roses on Her Dress, New York City, 1967

A socialite at a formal ball smiles confidently from behind her mask. Arbus was fascinated by disguises of all kinds. "You see someone," she said, "and essentially what you notice about them is the flaw. It's extraordinary that we should have been given these peculiarities. And, not content with what we were given, we create a whole other set."

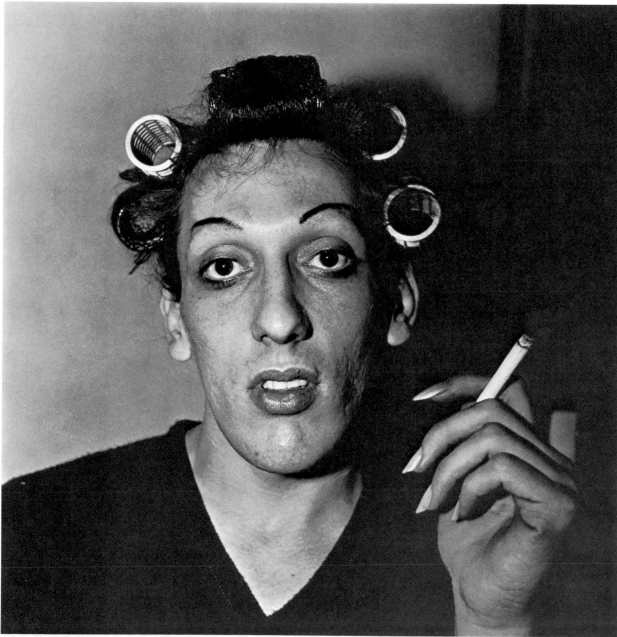

A Young Man in Curlers at Home on West 20th Street, New York City, 1966

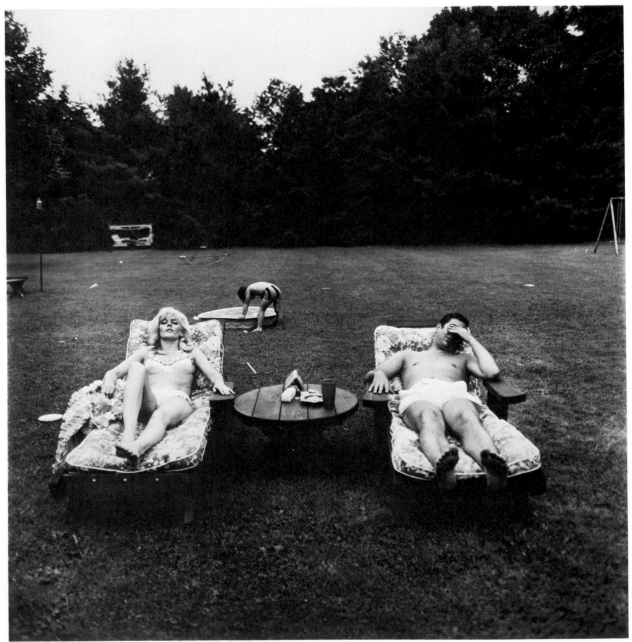

A Family on Their Lawn One Sunday in Westchester, New York, 1968

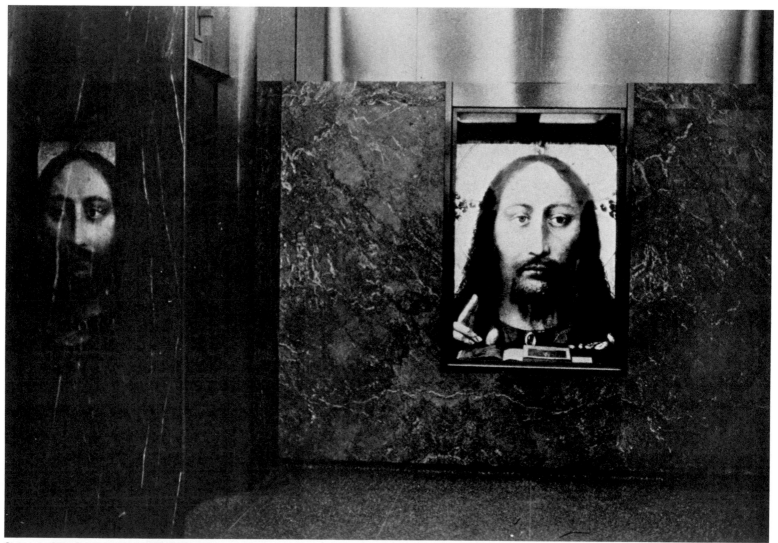

Christ in an Office Building Lobby, New York City, 1963

◄ *As their son amuses himself at his plastic pool, a couple in an affluent suburb of New York City sunbathe in their yard on a summer weekend. "Here, if anywhere, was normality triumphant," wrote critic Gene Thornton of this picture. "Yet of all the portraits Diane Arbus took, this is one of the few in which the sitters do not look you in the eye."*

A picture of Christ casts its ghostly reflection onto the gleaming marble wall (left) of a New York City office building. This photograph is a rare Arbus — one without living people in it. But it is very much an Arbus nonetheless: The subject (though not its reflection) seems to stare straight into the camera, every detail revealed by the pitiless lighting.

Garry Winogrand

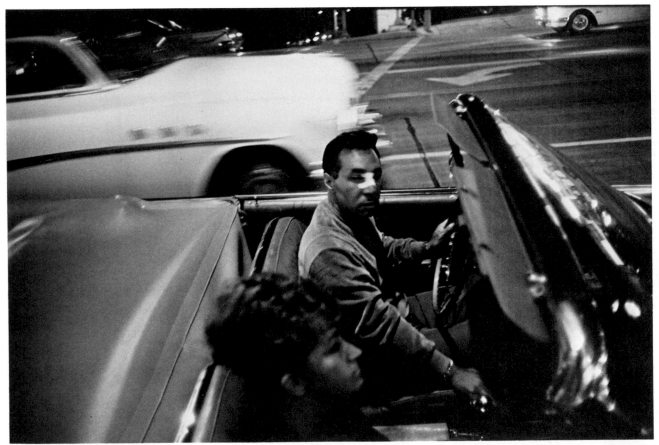

Los Angeles, 1964

As an art student at Columbia University, Garry Winogrand found that brushing oils onto canvas was a painfully slow and tedious task. Then he discovered the free darkroom at the school. Soon he was roaming the streets of New York City, 35mm rangefinder camera in his hand, greedily collecting images in a quick, almost journalistic fashion.

Even in this more flexible medium, Winogrand has not been satisfied to work within traditional bounds. He has turned what appear to be offhand street candids and flash-flattened shots of public functions into a wryly ironic and individual inventory of life in America. His style is so innovative and has been so influential that John Szarkowski, photography curator at The Museum of Modern Art, calls him simply "the central photographer of his generation."

At first glance, Winogrand's pictures sometimes strike the eye as unplanned, random. One critic has compared his photographs to "the fast, jostling, indiscriminate visual hodge-podge of television spot news coverage." But a second look usually reveals just how careful a craftsman Winogrand is. He stops time and freezes action to afford us glimpses—complex and complete—of the relationships between people and their surroundings, between people themselves, even between people and animals. And Winogrand's precise, split-second timing includes only the necessary elements: those things that, when isolated together, when framed by the camera, resonate with meaning and often with humor.

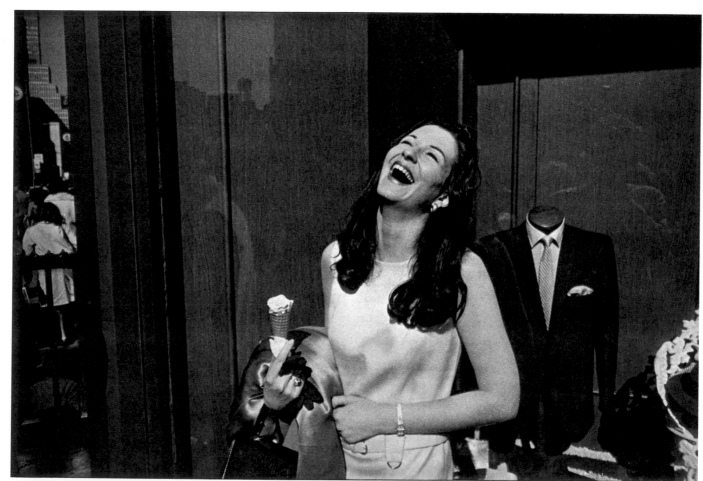

New York City, c. 1963

◄ *A man and a woman sit in an open convertible on a
Los Angeles street as a car passes in a blur. The
image is basically ambiguous and "problematic," a
condition that Winogrand says makes a photograph
live. Questions abound: Is the car moving? How
did the man hurt his nose? Why is he staring at
the woman? Why is she ignoring him?*

*A young woman juggles an ice-cream cone, her
coat, gloves and purse —and bursts beautifully into
laughter on a bright sunny day in New York City.
The man's jacket in the window display stands
beside the woman as a sort of comic escort,
seemingly ready to step through the glass, take her
free arm and join the throng around the corner.
Winogrand, with his camera at his eye, appears
above the jacket, reflected in the windowpane.*

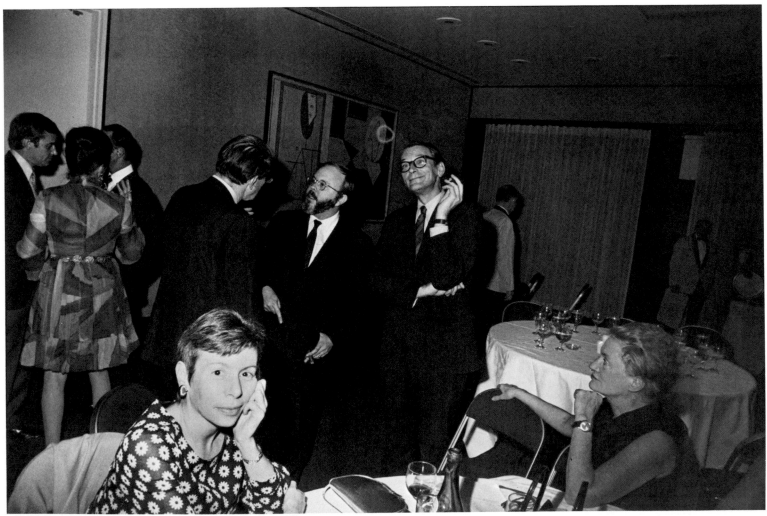

Opening, Frank Stella Exhibition, The Museum of Modern Art, New York, 1970

At the opening of a New York art exhibit,
guests' reactions range from the boredom of the
seated women to the intent involvement of the
groups conversing at left. The most intriguing figure
in this flash-washed scene, however, is the
man delightedly watching the smoke ring he has
created—a white circle seen by the camera as
part of the abstract painting in the background.

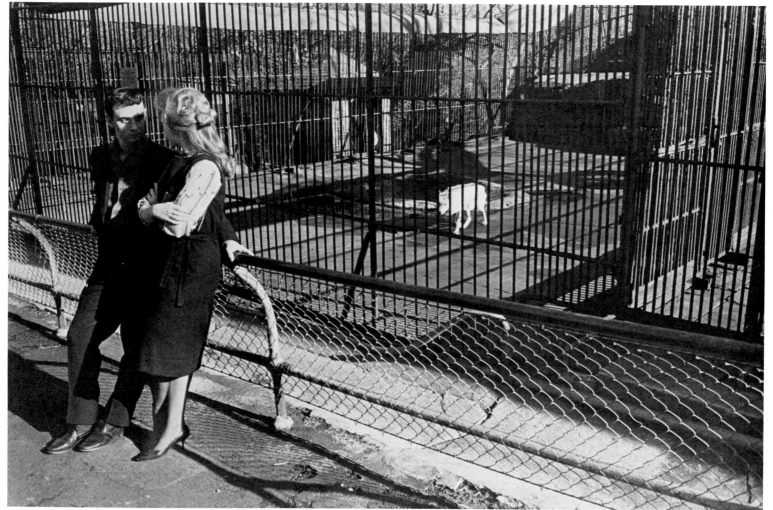

Bronx Zoo, c. 1969

In this amusing vignette, an American white wolf at the Bronx Zoo appears to stalk a couple casually propped against the guard rail in front of the animal's cage. Winogrand—who grew up near the zoo and often makes it and its inhabitants his subjects—is not tempted to interpret either his work or his motives. "I photograph," he once said, "to find out what something will look like photographed."

Atlantic City, New Jersey, 1969

Ordinary objects, such as street signs, telephone poles and store windows, fill Lee Friedlander's pictures of roadside America. But by taking them from expected context and recombining them in the camera, he turns their ordinariness into mosaics of texture and information.

Friedlander says he hunts "that moment when the landscape speaks to the observer." Often it speaks in a strange tongue. The things most people emphasize when negotiating the same territory appear reduced or queerly juxtaposed: Humans are seen through windows; such monuments as Mount Rushmore are reflected in one pane of a glass building.

Distractions that observers usually edit out Friedlander puts back in—not timidly, but as central elements. The result is a new look at familiar sights that can leave the viewer just this side of vertigo.

230

New York City, 1964

◄ Trailing a flag, a man and a woman ride a
motorcycle in a parade through the streets of Atlantic
City, New Jersey, in 1969. Another woman—
framed by the windows of the shop at left—watches
the parade from a bench in front of her house.
The clutter of wires, signs and buildings forms an
almost perfectly rectangular pattern within which
the people and their activities seem distinctly
secondary, yet all the more intriguing.

With his glasses off and the phone silent, a
businessman lays his head upon his desk in a
streetfront office in New York City. The man is
spied through a hole in the cardboard that otherwise
blocks all view of his office—a hole probably cut
so he could see out, used here by Friedlander to see
in. The cityscape reflected above the cardboard
appears almost clear enough to be not in front of the
window but, rather, behind it, like the man.

Josef Koudelka

Jarabina, 1963

Josef Koudelka was first drawn to gypsies by their exotic beauty, gestures and ornaments. Before long he was charmed by their communal ceremonies and festivals. "In the end," a friend wrote, "he was completely absorbed by his subject."

That is no exaggeration. Koudelka has been photographing gypsies since 1961, and almost nothing but gypsies for the last 15 years. In the process he has practically become one himself. Since leaving Czechoslovakia in 1970, he has been a stateless, homeless wanderer—an "unencumbered man," as his French editor expressed it, whose "talent is for living with less than nothing."

Koudelka is as obsessive about his work as he is about gypsies. He once went four years without printing a single image, then gathered up his accumulated negatives and turned out 6,000 prints in a few months. "The most important thing for me is to keep on working," he declares. "I am afraid to stop."

Strážnĭcě, 1965

◄ His face numb with introspection, a young Czech
gypsy in handcuffs climbs a rutted path to the
gallows to be hanged for murder in the village of
Jarabina in 1963. Townspeople and policemen
(including a soldier at left with a camera) watch
his lonely walk. Koudelka's pictures, wrote one critic,
"form the silent equivalent of an epic drama,"
complete with "theater, large gesture, brave style,
precious camaraderie and bitter loneliness."

Gypsy musicians play to a mixed crowd of gypsies
and Czechs at a street festival in Strážnĭcě in 1965.
"I keep covering festivities and other events that
reoccur year after year," says Koudelka, who began
as a theater photographer in Prague. "I know the
stage, I know the play and I know the actors.
Sometimes they have an off-day, sometimes they are
at their best. The same holds true of me. What
interests me is when we are all at our best."

233

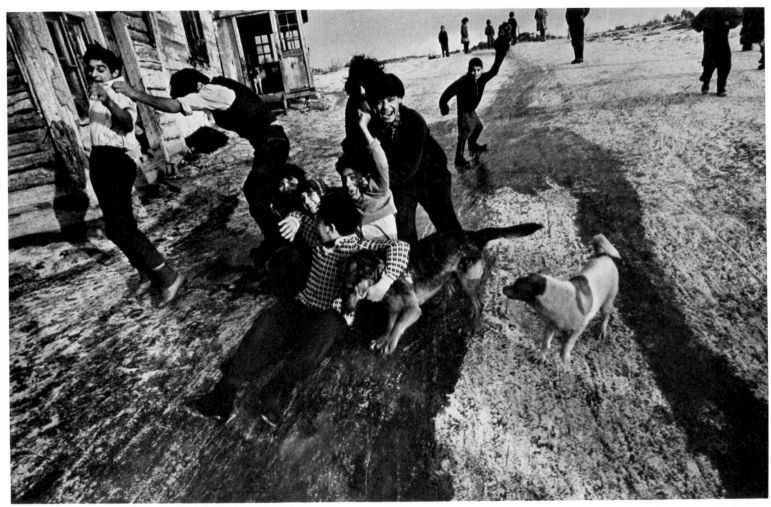

Rakúsy, 1964

All smiles and mock terror, gypsy children — and one
reluctant dog — slide down an icy hill next to some
weathered houses in a village in northeastern
Czechoslovakia in 1964. "Josef's rage is to see," a
friend notes, "but not to see without being seen. He
has a way of getting down to things eye to eye —
without arrogance or condescension — of offering
himself to whomever he's chosen, man for man."

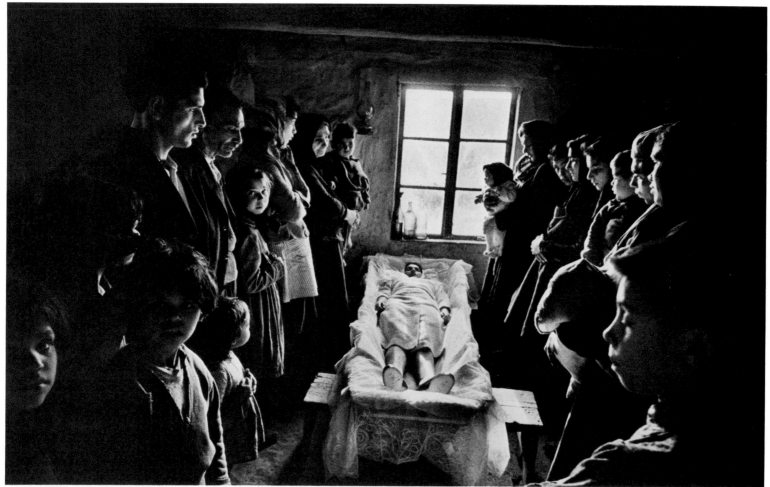

Jarabina, 1963

Her rough casket lined with lace, a dead young woman lies in burial white, surrounded by mourning relatives, at a wake in Jarabina in 1963. Since leaving Czechoslovakia, Josef Koudelka has resolutely refused all magazine or commercial assignments, keeping himself free to track the gypsies of France, Spain, Portugal, England and Ireland. "I do not need any outside pressure to work," he says. "It is very important for me to feel that I am free. I make photographs for myself."

Donald McCullin

For more than two decades Londoner Donald McCullin has borne outraged witness against what he describes as "the destruction business"—terror, revolution and warfare—from the Congo to Cyprus to Cambodia. At times he has been less a witness than a sufferer. He was imprisoned and savagely beaten in Idi Amin's Uganda, and caught shrapnel in both legs in Cambodia. Fellow journalists and combatants alike have marveled at his courage—some would say madness—under fire. "Don played right in on the horns, like a great bullfighter," said one reporter who saw him in action in Southeast Asia. Others have expressed astonishment at his coolheaded attention to technical concerns, such as light readings, in the midst of battle. He explains simply that he refuses to risk his life for unusable negatives.

McCullin is anxious to be known as more than a chronicler of wars. But author John Le Carré rightly calls his photographs of British life (industrial blight, urban down-and-outs, Ulster violence are typical subjects) "war pictures taken in peacetime." They bear the stamp of his almost unbearable fascination with danger, degradation, death. "I don't believe you can see what's beyond the edge unless you put your head over it," McCullin says. "That's the only place to be if you're going to see and show what suffering really means."

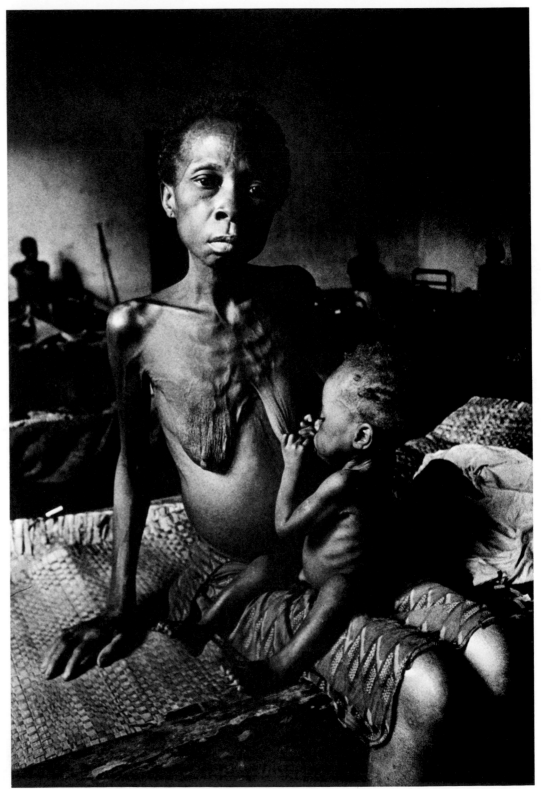

A Biafran mother, prematurely old at 24, suckles her baby at her empty breast. In this typically disturbing image from the Nigeria civil war of 1967 through 1970, McCullin portrays the misery inflicted upon civilians with the same outraged compassion that informs his pictures of battlefield carnage. He sees his task as "searching out the really bad scenes to make people aware of them."

Biafra, 1970

236

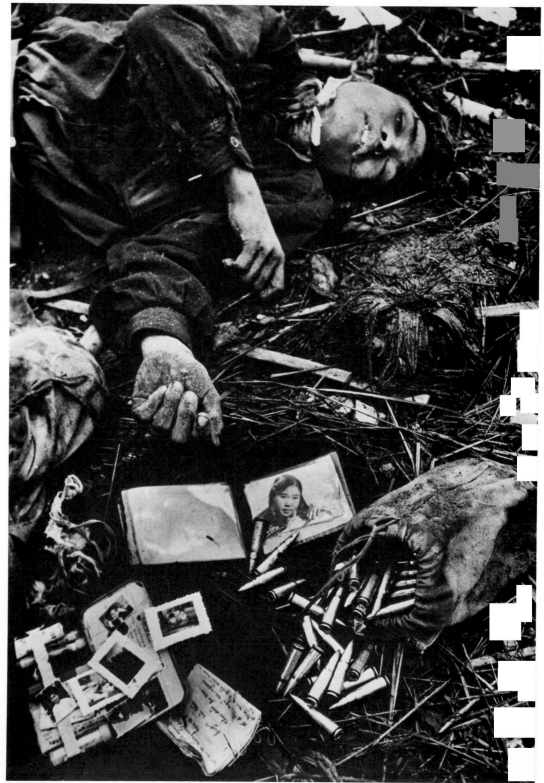

A North Vietnamese soldier lies dead on a battlefield in South Vietnam during the bloody Tet offensive in 1968. The soldier's belongings — a tin of letters and snapshots, a wallet, a bag of ammunition — are scattered about him after being searched for plunder. McCullin regards photography as an applied science, not an art, and his camera as merely a tool. "I only use the camera like I use a toothbrush," he says. "It does the job."

Vietnam, 1968

William Eggleston

The complex harmonies of natural color that mark the work of William Eggleston are typical of the new school of color photography that emerged in the 1970s. Unlike an older generation of studio and magazine photographers, Eggleston and such others as Stephen Shore *(far right)* and Joel Meyerowitz *(page 240)* seek no help from studio props and lights and are little inclined to alter natural color with filters. They are looking for color combinations that are odd, interesting, beautiful, and already in existence, awaiting only discovery.

Most of Eggleston's photographs are taken in and around his home town of Memphis, Tennessee. Even his most formal compositions—such as the photograph at right—read like quick entries in a visual diary of the life of one man in one place. But their chief concern, Eggleston insists, is with the values and tensions of color itself. If seen in black and white, many of them would appear dull and leaden—mere snapshots. In color they move subtly from shade to shade or jump with sudden explosions of intensity.

A mudhole, some automobile tire tracks and a box full of empty motor-oil cans are transformed by William Eggleston into a subdued symphony of blues and browns. From the rich chocolate of the late-afternoon shadows to the pale blue-gray of the sky reflected in the upper tracks, the colors move and change across the surfaces of a subject whose very banality focuses attention on them.

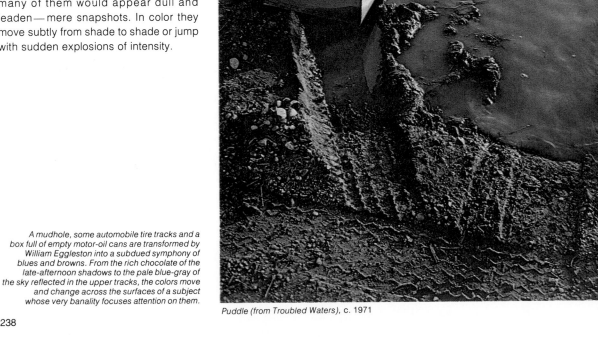

Puddle (from Troubled Waters), c. 1971

An empty downtown street opens onto a line of gently rolling hills in a small city in northwestern Massachusetts. Bright sunlight and deep shadows fall on the walls, pavement and lampposts, creating a strong composition of horizontals and verticals and imparting a special clarity and glow to the muted colors of everyday life.

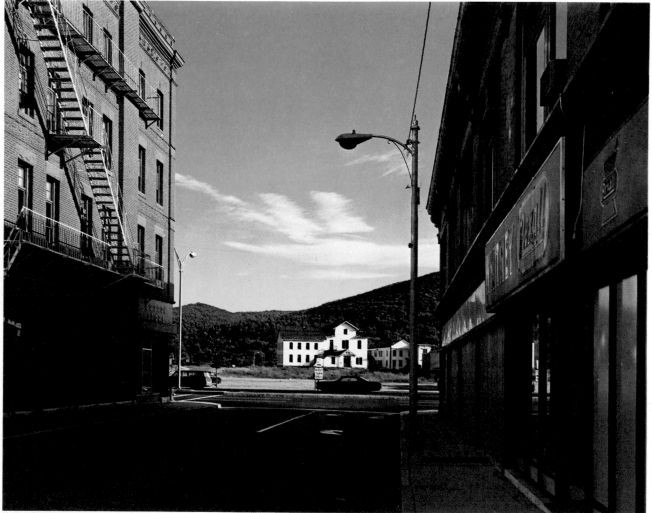

Holden Street, North Adams, Massachusetts, 1974

Stephen Shore's color photographs of American cities seem at first glance to be as simple and artless as postcards: The light is bright, the subject clear, the color true. Only the picturesque "sights," the *raison d'être* of postcards, are missing. Their absence is deliberate. Shore concentrates not on proud monuments but on street lamps, roads and old buildings—material he can shape into strong, abstract designs, using color to create visual poetry from bald fact.

Shore sometimes waits hours for the light to bring the shapes and colors into the relationships he seeks. Patience and a kind of indirection are essential to his work. "By dwelling on the spaces between things," wrote one critic, "Shore reveals the character of a place quietly and without rhetoric, like the well-timed pause of a skilled actor."

239

Joel Meyerowitz

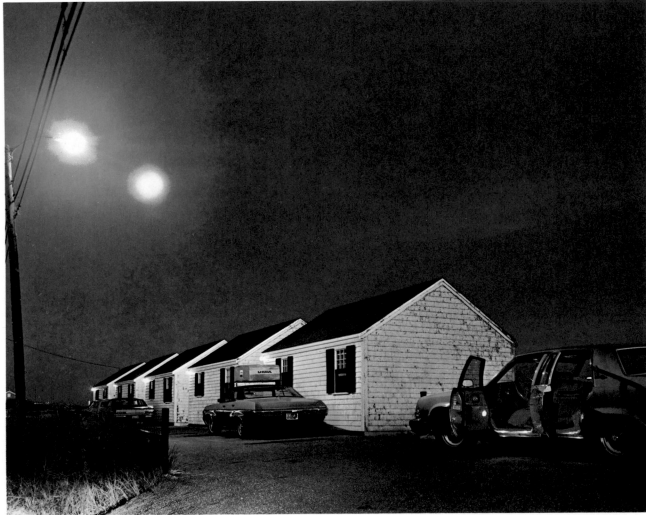

At dusk on Cape Cod, a row of small summer cottages stretches away under a luminous blue-violet sky. A rose-ringed full moon and a lone street lamp mix their lights to cast an eerie glow (now lavender, now aquamarine) over the buildings and automobiles. No one is in sight —just an empty car, its open doors revealing a red interior and suggesting a recent arrival or imminent departure.

Red Interior, Provincetown, 1977

Twilight, moonlight and unshaded neon mingle and clash in Joel Meyerowitz' urban and Cape Cod landscapes. His atmospheric, often moodily romantic use of color reveals surprising depths of feeling in unlikely subjects such as roadside diners and jerry-built cottages.

Meyerowitz began his career working as a street photographer—a rapid-fire virtuoso who stalked city neighborhoods with a 35mm camera. Then, in 1976, he turned to a vintage 8 x 10 Deardorff view camera and a very different type of photography. The big Deardorff takes time to set up and needs long exposures. But it catches the slightest changes in what a critic, writing of Meyerowitz, called ''the color of light itself.'' And that—''something simple and visible,'' says Meyerowitz, ''but filled with mystery and promise''—is his essential subject. □

Bibliography

General

Adams, Robert, *Landscape: Theory*. Lustrum Press, 1980.

Andrews, Ralph W., *Picture Gallery Pioneers*. Bonanza Books, 1964.

Brassaï, *Brassaï Présente Images de Camera*. Hachette, 1964.

Campbell, Bryn, ed., *World Photography*. Ziff-Davis Books, 1981.

Capa, Cornell, ed., *The Concerned Photographer*. Grossman Publishers, 1972.

†Diamonstein, Barbaralee, *Visions and Images: American Photographers on Photography*. Rizzoli, 1982.

Doty, Robert, *Photo-Secession*. George Eastman House, 1960.

†Eauclaire, Sally, *The New Color Photography*. Abbeville Press, 1981.

Five Photographers. University of Nebraska, 1968.

Gernsheim, Helmut, *Creative Photography: Aesthetic Trends 1839-1960*. Faber & Faber, 1962.

Gernsheim, Helmut and Alison:
The History of Photography from the Camera Obscura to the Beginning of the Modern Era. McGraw-Hill, 1969.
L.J.M. Daguerre: The History of the Diorama and the Daguerreotype. Dover, 1968.

Gruber, Fritz L., ed., *Grosse Photographen Unseres Jahrhunderts*. Econ Verlag, Düsseldorf, 1964.

Lewis, Steven, James McQuaid, and David Tait, *Photography: Source & Resource*. Turnip Press, 1973.

Lyons, Nathan, *Photographers on Photography*. Prentice-Hall, 1966.

Newhall, Beaumont:
The Daguerreotype in America. Duell, Sloan, and Pearce, 1961.
Latent Image: The Discovery of Photography. Doubleday, 1967.

Newhall, Beaumont and Nancy, *Masters of Photography*. Harry N. Abrams, 1969.

Not Man Apart. Sierra Club, San Francisco, 1964.

Photography 64. George Eastman House, 1964.

Ray, Man, *Un Siècle de Photographie de Niépce*. Musée des Arts Décoratifs, Paris, 1965.

Rudisill, Richard, *Mirror Image: The Influence of the Daguerreotype on American Society*. University Microfilms, Ann Arbor, 1967.

Smith Schuneman, R., ed., *Photographic Communication: Principles, Problems and Challenges of Photojournalism*. Hastings House, 1972.

Szarkowski, John:
†*Mirrors and Windows: American Photography Since 1960*. The Museum of Modern Art, 1978.
The Photographer and the American Landscape. The Museum of Modern Art, 1963.

*Taft, Robert, *Photography and the American Scene*. Dover, 1964.

Thomas, D. B., *The First Negatives*. A Science Museum Monograph, London, 1964.

Victoria's World. The Art Museum of The University of Texas at Austin, 1968.

Wise, Kelly, ed., *The Photographers' Choice: A Book of Portfolios and Critical Opinion*. Addison House, 1975.

†Witkin, Lee D., and Barbara London, *The Photograph Collector's Guide*. New York Graphic Society, 1979.

Great Photographers

Adams, Ansel:
†Adams, Ansel, and Nancy Newhall, *This is the American Earth*. Sierra Club, San Francisco, 1960.
Newhall, Nancy, *The Eloquent Light*. Sierra Club, San Francisco, 1963.

Alvarez Bravo, Manuel:
Manuel Alvarez Bravo: Photographs 1928-1968. Mexico 68 Programa Cultural de la XIX Olimpiada, 1968.
*Parker, Fred R., *Manuel Alvarez Bravo*. Pasadena Art Museum, 1971.

Atget, Eugène:
Abbott, Berenice, *The World of Atget*. Horizon Press, 1964.
Atget, Eugène, and Marcel Proust, *A Vision of Paris*. Macmillan, 1963.

Arbus, Diane:
Diane Arbus: An Aperture Monograph. Aperture, Inc., 1972.

Bayard, Hippolyte:
Bayard XXV Calotypes 1842-1850. Société Française de Photographie, Paris, 1965.
Jeanloup Sieff-Hippolyte Bayard. Éditions la Demeure, Paris, 1968.

Brady, Mathew B.:
Horan, James D., *Mathew Brady: Historian with a Camera*. Crown Publishers, 1955.
Meredith, Roy, *Mr. Lincoln's Contemporaries: An Album of Portraits by Mathew B. Brady*. Charles Scribner's Sons, 1951.

Brandt, Bill:
Brandt, Bill:
Camera in London. Focal Press, 1948.
The English at Home. B. T. Batsford, London, 1936.
Literary Britain. Cassell and Company, London, 1951.
A Night in London. Charles Scribner's Sons, 1938.
Perspective of Nudes. Amphoto, 1961.
Shadow of Light. Viking, 1966.

Brassaï:
Brassaï. Bibliothèque Nationale, Paris, 1963.
Brassaï, *Camera in Paris*. Focal Press, 1949.
Brassaï. Éditions Neuf, Paris, 1952.
†*Brassaï*. The Museum of Modern Art, 1968.
*Morand, Paul, *Paris de Nuit*. Arts et Métiers Graphiques, Paris, 1933.

Callahan, Harry:
Callahan, Harry, *Photographs*. Van Riper & Thompson, 1964.
Harry Callahan. The Museum of Modern Art, 1967.

Cameron, Julia Margaret:
Gernsheim, Helmut, *Julia Margaret Cameron*. The Fountain Press, 1948.

Caponigro, Paul:
*Caponigro, Paul, *Landscape*. Aperture, Inc., 1975.
Paul Caponigro: An Aperture Monograph. Aperture, Inc., 1967.

Cartier-Bresson, Henri:
Cartier-Bresson, Henri:
Cartier-Bresson's France. Viking, 1971.
The Decisive Moment. Simon & Schuster, 1952.
The Europeans. Simon & Schuster, 1955.
Man and Machine. IBM, 1969.
†*The World of Henri Cartier-Bresson*. Viking, 1968.
†Kirstein, Lincoln, and Beaumont Newhall, *Photographs by Cartier-Bresson*. Grossman,

1963.

Coburn, Alvin Langdon:
Gernsheim, Helmut and Alison, eds., *Alvin Langdon Coburn Photographer: An Autobiography*. Frederick A. Praeger, 1966.

Cosindas, Marie:
Marie Cosindas: Color Photographs. New York Graphic Society, 1978.

Eggleston, William:
William Eggleston's Guide. The Museum of Modern Art, 1976.

Emerson, Peter Henry:
Emerson, Peter Henry:
Naturalistic Photography. Sampson Low, Marston, Searle & Rivington, London, 1889.
Pictures of East Anglian Life. Sampson Low, Marston, Searle & Rivington, London, 1888.
Emerson, P. H., and T. F. Goodall, *Life and Landscape on the Norfolk Broads*. Sampson Low, Marston, Searle & Rivington, London, 1886.

Evans, Walker:
Evans, Walker:
American Photographs. Doubleday, 1938.
Many are Called. Houghton Mifflin, 1966.
Message from the Interior. Eakins Press, 1966.
Evans, Walker, and James Agee, *Let Us Now Praise Famous Men*. Houghton Mifflin, 1966.
†*Walker Evans*. New York Graphic Society, 1971.

Fenton, Roger:
Gernsheim, Helmut and Alison, *Roger Fenton: Photographer of The Crimean War*. Secker & Warburg, 1954.

Frank, Robert:
†Frank, Robert, *The Americans*. Grossman, 1969.

Friedlander, Lee:
Horizon. Horizon Publishers, Inc., July 1978.
Positive. Creative Photography Laboratory, M.I.T., 1980-81.

Frith, Francis:
Frith, Francis, *Cairo, Sinai, Jerusalem and the Pyramids of Egypt: A Series of Sixty Photographic Views*. James S. Virtue, 1860.

Gardner, Alexander:
Gardner, Alexander, *Gardner's Photographic Sketchbook of the Civil War*. Dover Publications, 1959.

Garnett, William A.:
Garnett, William, *The Extraordinary Landscape: Aerial Photographs of America*. Little, Brown and Company, 1982.

Haas, Ernst:
Haas, Ernst:
†*The Creation*. Michael Joseph Ltd., 1971.
In America. Viking, 1975.

Halsman, Philippe:
Halsman, Philippe:
Halsman on the Creation of Photographic Ideas. Ziff-Davis, 1961.
Jump Book. Simon & Schuster, 1959.

Heinecken, Robert:
Enyeart, James, ed., *Heinecken*. The Friends of Photography, Light Gallery, 1980.

Hill, David Octavius and Robert Adamson:
David Octavius Hill, Robert Adamson: Inkunabein der Photographie. Museum Folkwang, Essen, 1963.
*Eliot, Andrew, *Calotypes by D. O. Hill and R. Adamson*. Private Printing, Edinburgh, 1928.
*Michaelson, Katherine, *A Centenary Exhibition of the Work of David Octavius Hill and Robert Adamson*. The Scottish Arts Council, 1970.

Hine, Lewis W.:
Gutman, Judith Mara, *Lewis W. Hine and the American Social Conscience*. Walker and Company, 1967.
Hine, Lewis W., *Men at Work*. Macmillan, 1932.
Jackson, William Henry:
Jackson, Clarence S., *Picture Maker of the Old West: William H. Jackson*. Charles Scribner's Sons, 1947.
Jackson, William H., *Time Exposure: The Autobiography of William Henry Jackson*. G. P. Putnam's Sons, 1940.
Jackson, William H., and Howard R. Driggs, *The Pioneer Photographer: Rocky Mountain Adventures with a Camera*. World Book Company, 1929.
Karsh, Yousuf:
Karsh, Yousuf:
Faces of Destiny. Ziff-Davis, 1946.
†*In Search of Greatness*. Knopf, 1962.
Karsh Portfolio. University of Toronto Press, 1967.
Kertész, André:
André Kertész Paragraphic. Grossman, 1966.
André Kertész: Photographer. The Museum of Modern Art, 1964.
Davis, George, ed., *Day in Paris: Photographs by André Kertész*. J. J. Augustin, 1945.
Paris vu par André Kertész. Librairie Plon, Paris, 1934.
Keith, Thomas:
Thomas Keith. Corporation of the City of Edinburgh, Libraries and Museum Committee, 1966.
Koudelka, Josef:
Art in America. Art in America, Inc., Nov.-Dec. 1975.
Camera. C. J. Bucher Ltd., Lucerne, Switzerland, December 1975.
Camera. C. J. Bucher Ltd., Lucerne, Switzerland, August 1979.
Koudelka, Josef, *Gypsies*. Aperture, Inc., 1975.
Lange, Dorothea:
†*Dorothea Lange*. The Museum of Modern Art, Doubleday, 1966.
Lange, Dorothea, *Dorothea Lange Looks at the American Country Woman*. Ward Ritchie Press, 1967.
Lange, Dorothea, and Paul S. Taylor, *An American Exodus*. Renal & Hitchcock, 1939.
McCullin, Donald:
American Photographer. Gary A. Fisher, May 1981.
McCullin, Don, *Hearts of Darkness*. Alfred A. Knopf, 1981.
Homecoming. St. Martin's Press Inc., 1979.
Martin, Paul:
Martin, Paul, *Victorian Snapshots*. Country Life Limited, London, 1939.
Meyerowitz, Joel:
Aperture. Aperture, Inc., 1977.
Meyerowitz, Joel, *Cape Light*. New York Graphic Society, 1978.
Michals, Duane:
Bailey, Ronald H., and The Editors of Alskog, Inc., *The Photographic Illusion: Duane Michals*. Alskog, Inc., 1975.
Michals, Duane, *Real Dreams*. Addison House, 1976.
Model, Lisette:
Lisette Model: An Aperture Monograph. Aperture, Inc., 1979.

Popular Photography. Ziff-Davis Publishing Co., May 1980.
Moholy-Nagy, László:
†*László Moholy-Nagy*. Museum of Contemporary Art, Chicago, 1969.
Moholy-Nagy, László:
Painting, Photography, Film. Lund Humphries, 1967.
Vision in Motion. Paul Theobald and Co., 1965.
†Moholy-Nagy, Sibyl, *Moholy-Nagy: Experiment in Totality*. M.I.T. Press, 1969.
Nègre, Charles:
Jammes, André, *Charles Nègre: Photographer 1820-1880*. Private Press, 1963.
Notman, William:
Greenhill, Ralph, *Early Photography in Canada*. Oxford University Press, 1965.
Harper, J., and Stanley Triggs, eds., *Portrait of a Period: A Collection of Notman Photographs 1856-1915*. McGill University Press, Montreal, 1967.
O'Sullivan, Timothy H.:
Horan, James D., *Timothy O'Sullivan: America's Forgotten Photographer*. Doubleday, 1966.
Penn, Irving:
Penn, Irving, *Moments Preserved*. Simon & Schuster, 1960.
Ray, Man:
Man Ray. Los Angeles County Museum of Art, Lytton Gallery, 1966.
Ray, Man:
Photographs 1920-1934 Paris. Random House, 1934.
Self Portrait. Little, Brown and Company, 1963.
Renger-Patzsch, Albert:
Albert Renger-Patzsch: Der Fotograf der Dinge. Ruhrland und Heimatmuseum, Essen, 1966.
Junger, Ernst, *Bäume*. C. H. Boehringer Sohn, Ingelheim, 1962.
Renger-Patzsch, Albert, *Gestein*. C. H. Boehringer Sohn, Ingelheim, 1966.
Rodchenko, Alexander:
*Linhart, Lobomir, *Alexander Rodchenko*. S.N.K.L.U., Prague, 1964.
Salomon, Erich:
Salomon, Erich:
Celebrated Contemporaries. J. Engelhorns Nachfolger, Stuttgart, 1931.
Portrait of an Age. Macmillan, 1967.
Sander, August:
Sander, August, *Deutschenspiegel*. Sigbert Mohn Verlag, Hamburg, 1962.
Siskind, Aaron:
Siskind, Aaron:
Aaron Siskind. Horizon Press, 1965.
Aaron Siskind Photographs. Horizon Press, 1959.
Smith, W. Eugene:
†*W. Eugene Smith: His Photographs and Notes*. Aperture Monograph, Aperture, Inc., 1969.
Steichen, Edward:
Sandburg, Carl, *Steichen the Photographer*. Harcourt Brace, 1929.
Steichen, Edward:
A Life in Photography. Doubleday, 1963.
†*Steichen the Photographer*. Doubleday, 1961.
Steichen, Edward, ed., *The Bitter Years: 1935-1941*. Doubleday, 1962.
Stieglitz, Alfred:
America and Alfred Stieglitz: A Collective Portrait. Doubleday, 1934.
Bry, Doris, *Alfred Stieglitz: Photographer*. Boston

Museum of Fine Arts, 1965.
Norman, Dorothy, *Alfred Stieglitz*. Duell, Sloan and Pearce, 1960.
Seligmann, Herbert J., *Alfred Stieglitz Talking*. Yale University, 1966.
Strand, Paul:
Newhall, Nancy, *Paul Strand: Photographs 1915-1945*. The Museum of Modern Art, 1945.
Strand, Paul:
Photographer of Mexico. Da Capo Press, 1967.
Un Paese. Giulio Einaudi editore S.p.A., 1954.
Strand, Paul, and James Aldridge, *Living Egypt*. Horizon Press, 1969.
Strand, Paul, and Basil Davidson, *Tir A'Mhurain*. Grossman, 1968.
Strand, Paul, and Nancy Newhall, *Time in New England*. Oxford University Press, 1950.
Sudek, Josef:
Linharta, Lobomira, *Josef Sudek Fotografie*. S.N.K.L.U., Prague, 1956.
Řezáč, Jan Sudek, Artia, Prague, 1964.
Sudek, Josef:
Praha. Svoboda V. Praze, Prague, 1948.
Praha Panoramatická. S.N.K.L.U., Prague, 1959.
Sudek, Josef, and Emanuel Piche, *Karlüv Most*. S.N.K.L.U., Prague, 1961.
Talbot, William Henry Fox:
Talbot, William H. F., *The Pencil of Nature*. Da Capo Press (facsimile edition), 1969.
Thomson, John:
Thomson, John:
Illustrations of China and Its People. Sampson Low, Marston, Low & Searle, London, 1873.
Street Life in London. Sampson Low, Marston, Searle & Rivington, London, 1877.
Uelsmann, Jerry N.:
*Uelsmann, Jerry, *Silver Meditations*. Morgan Publishing Co., 1976.
Vroman, Adam Clark:
†Mahood, Ruth I., *Photographer of the Southwest: Adam Clark Vroman 1856-1916*. Ward Ritchie, 1961.
Weston, Edward:
Newhall, Nancy, *Edward Weston*. The Museum of Modern Art, 1946.
Newhall, Nancy, ed.:
The Daybooks of Edward Weston: Vol. 1. Mexico. George Eastman House, 1961.
Vol. 2. California. Horizon Press, 1966.
Edward Weston: Photographer. Aperture Monograph, Aperture, Inc., 1965.
Weston, Charis Wilson and Edward, *California and the West*. Duell, Sloan and Pearce, 1940.
Weston, Edward:
Edward Weston. E. Weyhe, 1932.
My Camera on Point Lobos. Da Capo Press, 1968.
White, Clarence:
Photographs of Clarence H. White. University of Nebraska Art Galleries, 1968.
White, Minor:
White, Minor, *mirrors messages manifestations*. Aperture Monograph, Aperture, Inc., 1969.
Winogrand, Garry:
Public Relations. New York Graphic Society and The Museum of Modern Art, New York, 1977.
Women Are Beautiful. Farrar, Straus & Giroux, 1975.

*Available only in paperback
†Also available in paperback

Acknowledgments

The index for this book was prepared by Karla J. Knight. For help in the preparation of this volume, the editors wish to thank the following: Berenice Abbott, Abbot, Maine; Tamar Agus, Assistant Librarian of the French Institute in the United States, New York City; Clifford S. Ackley, Assistant Curator, Department of Prints and Drawings, Museum of Fine Arts, Boston; Archives of Pinacoteca Querini-Stampalia, Venice; Thomas Barrow, Assistant Director, George Eastman House, Rochester, New York; Bernard V. Bothmer, Curator of Ancient Art, Brooklyn Museum, Brooklyn, New York; Antonella Vigliani Bragaglia, Centro Studi Bragaglia, Rome; Sonja Bullaty, New York City; Peter C. Bunnell, McAlpin Professor of the History of Photography and Modern Art, Princeton University, Princeton, New Jersey; Lucia Casanova, Director, Biblioteca del Museo Correr, Venice; Camera di Commercio, Venice; Josephine Cobb, Specialist in Iconography, National Archives and Records Service, Washington, D.C.; Joe Coltharp, Curator of Photography Collection, Humanities Research Center, University of Texas at Austin; Arnold H. Crane, Chicago; Jean Demachy, Paris; Étienne Dennery, Administrateur Général de la Bibliothèque Nationale, Paris; Professor Giorgio Ferrari, Director, Biblioteca Marciana, Venice; Ando Gilardi, Director, Fototeca Storica Italiana, Milan; Susanne Goldstein, Rapho Guillumette, New York City; Professor L. Fritz Gruber, Cologne; Herbert G. Hamilton, Museum Photographer, Museum of Fine Arts, Boston; Pierre-Georges Harmant, Président de la Société pour l'Étude et la Documentation sur la Photographie Ancienne, Paris; Terese Heyman, Curator of Photography, Oakland Museum, Oakland, California; History Division, Natural History Museum of Los Angeles County; Michael Hoffman, Publisher, Aperture, Inc., Millerton, New York; Abigail Hourwich, Librarian of the French Institute in the United States, New York City; Caroline Huber, Middendorf Gallery, Washington, D.C.; André Jammes, Paris; Cécile de Jandin, Cabinet des Estampes, Bibliothèque Nationale, Paris; Bill Jay, Royal Photographic Society, London; Edgar Yoxall Jones, Kent, England; Jerry Kearns, Prints and Photographs Division, Library of Congress, Washington, D.C.; Fritz Kempe, Director, Staatliche Landesbildstelle, Hamburg; Carole Kismaric, Associate Editor, Aperture, New York City; Susan Kismaric, The Museum of Modern Art, New York City; Philip B. Kunhardt Jr., New York City; Jennifer Licht, Associate Curator of Painting and Sculpture, The Museum of Modern Art, New York City; Ing. Lubomir Linhart, Prague; Charles Lockey, Curatorial Assistant, Oakland Museum, Oakland, California; Angelo Lomeo, New York City; Tom Lovcik, Curatorial Assistant, Department of Photography, The Museum of Modern Art, New York City; Jerald C. Maddox, Curator for Photography, Prints and Photographs Division, Library of Congress, Washington, D.C.; Grace Mayer, Curator, Edward Steichen Collection, The Museum of Modern Art, New York City; Ann E. McCabe, Curatorial Assistant, George Eastman House, Rochester, New York; Katherine Michaelson, London; Bernard de Montgolfier, Premier Conservateur-Adjoint au Musée Carnavalet, Paris; William Nabors, Aperture, New York City; Weston J. Naef, Curatorial Assistant, Department of Prints and Photography, The Metropolitan Museum of Art, New York City; Dorothy Norman, New York City; Eugene Ostroff, Curator, Division of Photographic History, The National Museum of American History, Smithsonian Institution, Washington, D.C.; Fred R. Parker, Curator of Photography, Pasadena Art Museum, Pasadena, California; Tristram Powell, London; Man Ray, Paris; Mrs. Albert Renger-Patzsch, Wamel-Dorf; Christiane Roger, Société Française de Photographie, Paris; Richard Rudisill, Art Department, University of New Mexico, Albuquerque; Gerhard Sander, The Sander Gallery, Washington, D.C.; Robert Sobieszek, Assistant Curator, George Eastman House, Rochester, New York; Otto Steinert, Professor for Photography, Folkwangschule, Essen; John Barr Tompkins, Head, Public Services, The Bancroft Library, University of California at Berkeley; Margaret Toner, National Committee on Employment of Youth, New York City; Hélène Toussaint, Attachée au Département des Peintures du Musée du Louvre, Paris; Stanley G. Triggs, Notman Photographic Archives, McCord Museum, Montreal; Catherine Whitworth, Research Assistant in the Photography Collection, The Humanities Research Center, University of Texas at Austin; Tiana Wimmer, Daniel Wolf Gallery, New York City; Richard N. Wright, President of the Onondaga Historical Association, Syracuse, New York.

Picture Credits

Credits from left to right are separated by semicolons, from top to bottom by dashes.

Mathew B. Brady Gallery, courtesy Meserve Collection. 51: Mathew B. Brady Gallery, courtesy Arnold H. Crane, copied by Paulus Leeser. 52: Mathew B. Brady Gallery, courtesy National Archives. 53: Mathew B. Brady Gallery, from *Mr. Lincoln's Contemporaries*, by Roy Meredith, Charles Scribner's Sons, New York; Mathew B. Brady Gallery, courtesy National Archives. 54: Alexander Gardner, courtesy Library of Congress. 55: Alexander Gardner, courtesy The Metropolitan Museum of Art, New York. 56, 57: George N. Barnard, courtesy The Museum of Modern Art, New York (page 57 copied by Derek Bayes). 58: Timothy O'Sullivan, courtesy Library of Congress. 59: Timothy O'Sullivan, courtesy George Eastman House. 60, 61: Nadar, courtesy Archives Photographiques. 62: Étienne Carjat. 63: Étienne Carjat, courtesy Gernsheim Collection, Humanities Research Center, The University of Texas at Austin. 64, 65: Julia Margaret Cameron, courtesy Victoria and Albert Museum, London, copied by Derek Bayes. 66: H. P. Robinson, courtesy The Royal Photographic Society of Great Britain, copied by Derek Bayes. 67: H. P. Robinson, courtesy The Royal Photographic Society of Great Britain, and Science Museum, London. 68: O. G. Rejlander, courtesy The Royal Photographic Society of Great Britain, copied by Derek Bayes. 69, 70: O. G. Rejlander, courtesy George Eastman House. 71-74: William Notman Studio, courtesy Notman Photographic Archives, McCord Museum of McGill University.

Chapter 3: 77: The Denver Public Library, Western History Department; courtesy Bancroft Library, University of California at Berkeley—Frederick Kingsbury, courtesy Private Collection; courtesy The Royal Photographic Society of Great Britain; courtesy Los Angeles County Museum of Natural History. 80: William Henry Jackson, courtesy Arnold H. Crane, copied by Paulus Leeser. 81: William Henry Jackson, courtesy State Historical Society of Colorado. 82, 83: Carleton Eugene Watkins, courtesy Bancroft Library, University of California at Berkeley. 84, 85: Adam Clark Vroman, courtesy Los Angeles County Museum of Natural History. 86: Peter Henry Emerson, courtesy George Eastman House. 87: Peter Henry Emerson, courtesy Gernsheim Collection, Humanities Research Center, The University of Texas at Austin. 88: John Thomson, courtesy Arnold H. Crane, copied by Paulus Leeser. 89: John Thomson, courtesy George Eastman

House. 90-92: Paul Martin, courtesy Ernest Martin Collection, copied by Bill Jay.

Chapter 4: 95: Berenice Abbott; Edward Steichen, courtesy Jean Demachy; Alvin Langdon Coburn, Collection Peter C. Bunnell, New York—Alvin Langdon Coburn, courtesy George Eastman House—Alvin Langdon Coburn, courtesy George Eastman House; Berenice Abbott. 98, 99: Lewis W. Hine, courtesy National Child Labor Committee. 100, 101: Lewis W. Hine, courtesy George Eastman House. 102: Robert Demachy, courtesy The Museum of Modern Art, New York, copied by Paulus Leeser. 103: Robert Demachy, courtesy Gernsheim Collection, Humanities Research Center, The University of Texas at Austin. 104, 105: Alvin Langdon Coburn, courtesy George Eastman House. 106, 107: Clarence H. White, Collection Clarence H. White Jr., copied by The Museum of Modern Art, New York. 108-111: Alfred Stieglitz, Collection Dorothy Norman, copied by Paulus Leeser. 112: Eugène Atget, courtesy The Museum of Modern Art, New York, copied by Paulus Leeser. 113: Eugène Atget, courtesy George Eastman House. 114-116: Eugène Atget, courtesy The Museum of Modern Art, New York.

Chapter 5: 119: Henri Cartier-Bresson from Magnum for *Life*; Hazel Kingsbury; Man Ray, courtesy Gernsheim Collection, Humanities Research Center, The University of Texas at Austin; Charles T. Branford Co.—Dan Budnik; Dink Salomon; Photo Gilberte Halász—Imogen Cunningham; Sonja Bullaty; Cole Weston from Rapho Guillumette; courtesy Pasadena Art Museum—Sabine Renger; courtesy Alfred H. Barr Jr.; Paul Taylor, courtesy The Oakland Museum Collection; no credit. 122-125: Edward Steichen, courtesy The Museum of Modern Art, New York. 126: Paul Strand, courtesy The Museum of Modern Art, New York, copied by Paulus Leeser. 127-129: Paul Strand. 130: Man Ray, courtesy George Eastman House. 131: Man Ray, courtesy The Museum of Modern Art, New York, copied by Paulus Leeser. 132: László Moholy-Nagy, courtesy The Museum of Modern Art, New York. 133: László Moholy-Nagy, courtesy George Eastman House. 134-137: © André Kertész. 138, 139: Erich Salomon from Magnum. 140, 141: Brassaï from Rapho Guillumette. 142, 143: August Sander. 144, 145: Josef Sudek, courtesy Sonja Bullaty. 146-149: Edward Weston. 150, 151: Manuel Alvarez Bravo,

courtesy Pasadena Art Museum. 152, 153: Albert Renger-Patzsch. 154: Alexander Rodchenko, courtesy The Museum of Modern Art, New York. 155: Alexander Rodchenko, courtesy Ing. Lubomir Linhart. 156: Dorothea Lange, courtesy Library of Congress. 157: Dorothea Lange, courtesy The Oakland Museum Collection. 158: Walker Evans, courtesy The Museum of Modern Art, New York. 159: Walker Evans, courtesy Library of Congress. 160: Walker Evans.

Chapter 6: 163: David Bruxner from Rapho Guillumette; Jean Marquis from Magnum; no credit—© 1971 Fred W. McDarrah; Nancy Newhall; Gus Kayafas—Harry Callahan; Jerry Aaronson; Ivan Dimitri from Rapho Guillumette; Yvonne Halsman—© Arnold Newman; Bert Stern; Arthur Tcholakian; Paul Diamond. 166, 167: Bill Brandt from Rapho Guillumette. 168, 169: © Lisette Model, courtesy Sander Gallery. 170-175: Henri Cartier-Bresson from Magnum. 176-179: W. Eugene Smith. 180, 181: Robert Frank. 182, 183: Ansel Adams. 184, 185: Minor White. 186, 187: Harry Callahan. 188, 189: Aaron Siskind (page 188, top #474, #37; bottom #477, #481). 190, 191: © Karsh of Ottawa from Rapho Guillumette. 192, 193: © Philippe Halsman. 194, 195: © Arnold Newman. 196: Irving Penn, © 1954 The Condé Nast Publications Inc. 197: Irving Penn, © 1967 The Condé Nast Publications Inc. 198: Irving Penn, © 1970 The Condé Nast Publications Inc. 199: Irving Penn, © 1965 Cowles Communications Inc. 200-202: Ernst Haas.

Chapter 7: 205: Lee Boltin/Mavis Pudding Inc.; Marie Cosindas; Ted Orland—Diane Farris; Joyce Neimanas; © David Gahr; Charles O'Neal—Eileen Hale; Lee Friedlander; Henri Cartier-Bresson from Magnum, Paris—Donald McCullin, England; courtesy William Eggleston; Bart Paulding; Sasha Meyerowitz. 208, 209: © William A. Garnett. 210, 211: © Marie Cosindas. 212-215: Paul Caponigro. 216, 217: © Jerry Uelsmann. 218, 219: Duane Michals. 220, 221: Robert Heinecken. 222: © 1967 Estate of Diane Arbus. 223: © 1966 Estate of Diane Arbus. 224: © 1968 Estate of Diane Arbus. 225: © 1963 Estate of Diane Arbus. 226-229: Garry Winogrand. 230, 231: Lee Friedlander. 232-235: Josef Koudelka from Magnum, Paris. 236, 237: Donald McCullin, England. 238: William Eggleston, courtesy Middendorf Gallery. 239: Stephen Shore. 240: Joel Meyerowitz.

Index
Numerals in italics indicate a photograph, painting or drawing of the subject mentioned.

A

Abbott, Berenice, quoted, 168
"Abraham Lincoln: The War Years" (Sandburg), 124
Adams, Ansel, *163,* 165, 182-183, 186; photographs by, *182-183;* quoted, 165, 182
Adams, John Quincy, 14
Adamson, Robert, *11,* 22-23; photographs by, with David Octavius Hill, *22-23*
Aerial photography, *208-209*
Agam, Yaacov, *194*
Allegorical photography, 19th Century, 45, *64, 66-67,* 68, *69-70*
Americans, The (Frank), 180
Aperture, 121, 146, 147, 182
Arbus, Diane, *205,* 207, 222-225; photographs by, *222-225;* quoted, 222, 223
Archer, Frederick Scott, 13
Architectural photography: 1840-1860, 28, *30-35;* 1860-1880, 44, *47-49, 74;* 1880-1900, *83, 85;* 1900-1920, *109, 113;* 1920-1940, *139;* 1940-1960, *182*
Atget, Eugène, *cover, 4,* 95, 97, 112-116; photographs by, *112-116*
Atlanta, *56-57*

B

Bacon, Francis, quoted, 156
Barnard, George N., *43;* photographs by, *56-57*
Barnum, P. T., 50
Baudelaire, Charles, *63;* quoted, 12, 63
Bauhaus, 132
Bayard, Hippolyte, *cover, 4, 11,* 24-25; and invention of photographic process, 24; photographs by, *24-25*
Bernhardt, Sarah, *62*
Bisson, Auguste Rosalie and Louis Auguste, 10, 13, 28, 36; photograph by, *36-37*
Blur, deliberate use of, *202,* 218
Boston, *14*
Brady, Mathew B., *cover, 4, 43,* 44, 50-53, 54, *55,* 58; photographs by, *50-53;* photographs by crew of, *54-59*
Brandt, Bill, *163,* 165, 166-167; photographs by, *166-167;* quoted, 166, 167
Brassaï, *119,* 140-141; photographs by, *140-141;* quoted, 141
Bravo, Manuel Alvarez, *119,* 150-151; photographs by, *150-151*
Briand, Aristide, 138
Bridgman, Laura, *17*
Burns, John L., *58*

C

Callahan, Harry, *163,* 186-187; photographs by, *186-187;* quoted, 186
Calotypes, *20-25, 32-34;* by Hippolyte Bayard, *24-25;* characteristics of, 13, 20, 21; by Maxime Du Camp, *34;* exposures for, 20, 24; by Hill and Adamson, *22-23;* history of, 13, 20; by Thomas Keith, *32-33;* by William Henry Fox Talbot, *20-21*
Camera(s): 8 x 10 Deardorff view, 240; Panoramic, 144, 145
Camera Notes (magazine), 96
Camera Work (magazine), 96
Cameron, Julia Margaret, *cover, 4, 43,* 45, 64-65; photographs by, *64-65*
Canada, 71, *74*
Candid camera, 138
Caponigro, Paul, *205,* 207, 212-215; photographs by, *212-215;* quoted, 207, 212, 213, 215
Carjat, Étienne, *43,* 45, 62-63; photographs by, *62-63*
Carte-de-visite, 36
Cartier-Bresson, Henri, *cover, 4, 163,* 164, 170-175; photographs by, *170-175;* quoted, 171, 174
Child labor, *99-100*
China, *88*
Churchill, Winston, *190*
Cityscapes: 1840-1860, *25-27, 32-33;* 1860-1880, 44, *46-49;* 1880-1900, *82-83;* 1900-1920, 105, *106, 109, 113-115;* 1920-1940, *122, 126, 136-137, 159;* 1940-1960, *166, 186, 200;* 1960-1980, *230-231, 239*
Civil War, 44, 50, *51, 54-58,* 80
Coburn, Alvin Langdon, *95,* 96, 104-105; photographs by, *104-105;* quoted, 96, 105
Cody, Buffalo Bill, *71*
Colette, *196*
Collodion plates, *26-29, 35-37,* 60, 78; of Bisson brothers, *36-37;* characteristics of, 13, 26, 35, 44; exposures for, 26, 44; of Francis Frith, *35;* invention of, 13; of Gustave Le Gray, *28-29;* of Charles Nègre, *26-27*
Color photography, 1940-1960, *197-202;* 1960-1980, 207, *208-211, 220, 238-240*
Composites, 68, 86, *216-217*
Constructivism, 154
Copper plates, 12
Courbet, Gustave, 134
Crimean War, 38, *40*
Crystal Palace, Great Exhibition, London, *30-31*
Cubism, 105, 140, 154
Czechoslovakia, *232-235*

D

Dadaism, 130, 132
Daguerre, Louis, 12, 20, 24, 164
Daguerreotypes, *14-17,* 24, 82; characteristics of, 12; exposures for, 15, 16, 19, 44; history of, 12, 13; by Southworth and Hawes, *14-17;* by Carl Ferdinand Stelzner, *18-19*
Dali, Salvador, 164-165, *192,* 216
Degas, Edgar, 45
Delamotte, Philip Henry, *11,* 30-31; photographs by, *30-31*
Demachy, Robert, *95,* 97, 102-103; photographs by, *102-103;* quoted, 102

Depression, 97, 98, 120, 176; photography of, 121, *156, 159*
Depth of field, 182
Dignimont, André, 114
Documentary photography: 1840-1860, 13, 18, 26, *30-31;* 1860-1880, 44-45; 1880-1900, 84, 90; 1900-1920, 97, *98-101;* 1920-1940, 120, 138; 1940-1960, 165, 166, 176; 1960-1980, 236
Double exposures, 120, 132, 152, *218-219*
Double printing, 132
Du Camp, Maxime, *11,* 12, 28, 34-35; photograph by, *34*
Duncan, Isadora, 124
Duncan, Thérèse, *125*
Duse, Eleonora, 122

E

Eastman, George, 96
Eggleston, William, *205,* 207, 238; photograph by, *238*
Egypt, *34-35, 127*
Egypt, Nubia, Palestine and Syria (Du Camp), 34
8 x 10 Deardorff view camera, 240
Einstein, Albert, *192*
Emerson, Peter Henry, 77, 79, 86-87, 97; photographs by, *86-87;* quoted, 79, 86
Emulsions, photographic, 220; 1840-1860, 12-13; 1860-1880, 44. *See also* Calotypes; Collodion plates; Daguerreotypes
England, *86-87,* 88, *89-90, 139, 166*
Equipment, photographic: 1840-1860, 12-13, 18, 26, 35, 36; 1860-1880, 56; 1880-1900, 78, 80; 1900-1920, 96, 103, 105; 1920-1940, 120, 144, 146; 1940-1960, 164, 167, 182; 1960-1980, 215, 238, 240
Evans, Walker, *119,* 158-160; photographs by, *158-160*
Exposure(s): calotype, 20, 24; collodion-plate, 26, 44; daguerreotype, 15, 16, 19, 44

F

f-64 Group, 121, 165, 182
"Family of Man" (exhibit), 122
Farm Security Administration, 156
Fashion photography, 196
Fenton, Roger, *11,* 38-40; photographs by, *38-40*
Flaubert, Gustave, 34
Flower photography, 197
Frank, Robert, *163,* 180-181, 207; photographs by, *180-181*
Friedlander, Lee, *cover, 4, 205,* 207, 230-231; photographs by, *230-231;* quoted, 230
Frith, Francis, *11,* 35; photograph by, *35*
Futurism, 154

G

Galerie Contemporaine, 62
Galván, Manuel Hernández, *149*
Gardner, Alexander, *43,* 54-55, 58; photographs by, *54-55*
Garnett, William A., *205,* 207, 208-209; photographs by, *208-209*

Gelatin emulsion, 44
German Looking-Glass (Sander), 142
Germany, 142-143
Glass plates, 13, 26
Gone With the Wind (film), 57
Grant, Ulysses S., 52
Great Exhibition, London, *30-31*
Guggenheim Fellowship, 146, 180
Gum arabic, 103
Gypsies, *232-235*

H

Haas, Ernst, *163,* 200-202; photographs by, *200-202;* quoted, 200, 201, 202
Haiti, *177*
Halász, Gyula. *See* Brassaï
Halsman, Philippe, *163,* 164, 192-193; photographs by, *192-193;* quoted, 192
Hamburg Historical Society, 18
Harper's Bazaar (magazine), 121, 180
Haussmann, Baron Georges Eugène, 47
Hawes, Josiah J., *11,* 13, 14-17. *See also* Southworth and Hawes
Heinecken, Robert, *205,* 207, 220-221; photographs by, *220-221;* quoted, 220, 221
Hill, David Octavius, *11,* 22-23; photographs by, with Robert Adamson, *22-23*
Hine, Lewis W., *95,* 97, 98-101, 126; photographs by, *98-101;* quoted, 98
History of photography: 1840-1860, *11-40;* 1860-1880, *43-74;* 1880-1900, *77-92;* 1900-1920, *95-116;* 1920-1940, *119-160;* 1940-1960, *163-202;* 1960-1980, *205-240*
Hitler, Adolf, 143
Hughes, Robert, quoted, 222

I

Impressionism, 13, 102
Indians, 19th Century photography of, *71, 78-79, 81, 84-85*
Instant film, 207, 210
Ireland, *212, 214-215*
Isthmus of Darién, *59*

J

Jackson, Ella, *53*
Jackson, William Henry, *cover, 4,* 77, 78, 80-81, 182; photographs by, *80-81*
Japan, 176
Johnson, William, *51*
Joyce, James, 158

K

Karsh, Yousuf, *163,* 164, 190-191; photographs by, *190-191;* quoted, 190
Keith, Thomas, *11, 32-33;* photographs by, *32-33;* quoted, 32
Kertész, André, *119,* 121, 164; photographs by, *134-137*
Khrushchev, Nikita, 164, *191*
Koudelka, Josef, *205,* 206, 232-235; photographs by, *232-235;* quoted, 232, 233, 235

L

Landscape photography: 1840-1860, 13, *21, 28-29, 36-37, 39;* 1860-1880, 44; 1880-1900, 78, *80;* 1900-1920, *104, 110-112, 116;* 1920-1940, *147, 152;* 1940-1960, 165, *173, 182-183,* 186, *187;* 1960-1980, 207, *208-209, 212-215, 217,* 240
Lange, Dorothea, *119,* 156-157; photographs by, *156-157*
Laval, Pierre, 138
Lawrence, Abbott, 14
Le Carré, John, quoted, 236
Lee, Robert E., *52*
Le Gray, Gustave, *11,* 13, 28-29; photographs by, *28-29*
Lenin, Nikolai, 121
Lighting: 1840-1860, 15, 28, 32, 38; 1860-1880, 64, 66; 1900-1920, *98-101, 106-107,* 108; 1920-1940, *148, 155;* 1940-1960, 166, *181, 182, 184;* skylights, 15; Stieglitz on, 108, 111
Lincoln, Abraham, 50, 53
Liszt, Franz, *61*
Longfellow, Henry Wadsworth, 14

M

McCullin, Donald, *cover, 4, 205,* 206, 236-237; photographs by, *236-237;* quoted, 236, 237
Maddox, Richard Leach, 44
Magritte, René, 216
Martin, Paul, *77,* 79, 90-92; photographs by, *90-92;* quoted, 90
Marville, Charles, *43,* 47-49; photographs by, *47-49*
Matisse, Henri, 96
Meyerowitz, Joel, *205,* 207, 238, 240; photograph by, *240;* quoted, 240
Michals, Duane, *205,* 207, 218-219; photographs by, *218-219;* quoted, 218, 219
Miller, Henry, quoted, 141
Miró, Joan, *190*
mirrors messages manifestations (White), 184
Model, Lisette, *163,* 164, 168-169; photographs by, *168-169;* quoted, 168
Moholy-Nagy, László, *119,* 120, 152, 164; photographs by, *132-133;* quoted, 133
Montage. *See* Photomontage
Morgan, J. P., 122
Multiple-images, *105, 124, 133, 194*
Museum-exhibited photography, 1960-1980, 206
Museum of Modern Art, The, New York, 122
Mussolini, Benito, 138

N

Nadar (Gaspard Félix Tournachon), *43,* 45, 60-61; photographs by, *60-61;* quoted, 60
Nadelman, Elie, sculptures by, *179*
Napoleon III, Emperor, 26, 28, 36, 47
National Child Labor Committee, 98
Naturalistic Photography (Emerson), 86
Nègre, Charles, 11, 26-27, 28; photographs by, *26-27*
Newman, Arnold, *163,* 164, 194-195; photographs by, *194-195;* quoted, 194
New Objectivity, The, 152
New York Armory Show (1913), 96
New York City, *109, 136-137, 178, 180, 200, 231;* photography exhibited in, 1960-1980, 206
Nixon, Richard, 192
Norman, Dorothy, *108*
Notman, William, *43,* 71-74; photographs by, *71-74;* quoted, 71
Nude photography: 1900-1920, *107;* 1920-1940, *131, 148, 150;* 1940-1960, 166, *167, 192;* 1960-1980, *220-221*

O

O'Keeffe, Georgia, *195*
Oppenheimer, J. Robert, *193*
Orozco, José Clemente, 150
O'Sullivan, Timothy H., *43,* 58-59; photographs by, *58-59*

P

Painting and drawing: photography in imitation of, 44, 45, *66-69,* 78, 86, *103;* relation to photography, 12, 13, 18, 22, 26, 38, 45, 66, 78, 96-97, 102, 103, 120, 154, 188, 207
Panama, *59*
Paris, 4, *25-27,* 44, *47-49, 60,* 97, *112-116, 134,* 141
Paris de Nuit (Brassaï), 141
Pencil of Nature (Talbot), 20
Penn, Irving, *163,* 196-199; photographs by, *196-199;* quoted, 197
Personal vision in photography: 1940-1960, 164-165, *166-202;* 1960-1980, 206-207, *208-240*
Photographic Sketch Book of the War (Gardner), 54, 58
Photography, history of. *See* History of photography
Photojournalism: 1860-1880, 44-45; 1900-1920, 97, *98-101,* 112; 1920-1940, 120, 138; 1940-1960, 164, 165, 166, 176; 1960-1980, 236
Photomicrography, 132
Photomontage, *33,* 120, 132, *133,* 152, 154, *216-217*
Photosculpture, *220*
Photo-Secession Gallery ("291"), 96
Picasso, Pablo, 96
Pictorialists, 45
Poe, Orlando Metcalfe, 56
Polaroid film, 207, 210
Ponti, Carlo, 42, 46; photograph by, *46*
Portrait of an Era (Sander), 142
Portraiture: 1840-1860, 12, 13, *14-20, 24,* 28; 1860-1880, 44, 45, *50, 52-53,* 60, *61-71;* 1880-1900, 79, *84;* 1900-1920, *100-101, 103, 105,* 108; 1920-1940, 124-125, *129, 131, 142-143, 149, 151;* 1940-1960, 164, *172, 190-196, 198;* 1960-1980, 207, *210, 222-225*
Potassium bichromate, 103
Pound, Ezra, *105, 210*
Prague, *144-145*
Public appreciation of photography, 1960-1980, 206-207

R

Ray, Man, *119,* 120, 130-131, 152, 164, 166; photographs by, *130-131;* quoted, 130
Rayograph, *130*
Realism: 1880-1900, 78-79, *80-92;* 1920-1940, 120-121, *122-129,* 146, *152-153*
Rejlander, Oscar Gustave, *43,* 68-70; photographs by, *68-70;* quoted, 68
Renger-Patzsch, Albert, *119,* 120, 152-153; photographs by, *152-153;* quoted, 152
Reynolds, John, 55
Ricordo di Venezia (Ponti), 46
Rivera, Diego, 150
Roberts, Oral, *181*
Robinson, Henry Peach, *43,* 66-67; photographs by, *66-67;* quoted, 67
Rodchenko, Alexander, *119,* 154-155; photographs by, *154-155*
Rodin, Auguste, 96

S

Salomon, Erich, *cover, 4, 119,* 120, 138-139, 164; photographs by, *138-139*
Sandburg, Carl, *124;* quoted, 122
Sander, August, *119,* 142-143, 164; photographs by, *142-143*
Sandwiching, *216,* 218
San Francisco, 19th Century photography of, *82-83*
Sharp, the Reverend Daniel, 15
Shaw, George Bernard, quoted, 105
Sherman, William Tecumseh, 56
Shore, Stephen, *205,* 207, 238, 239; photograph by, *239*
Siqueiros, David Alfaro, 150
Siskind, Aaron, *163,* 165, 188-189; photographs by, *188-189;* quoted, 165, 188, 189
Sitting Bull, 71
Skylights, 19th Century use of, 15
Smith, Adolphe, 88
Smith, W. Eugene, *163,* 165, 176-179; photographs by, *176-179;* quoted, 176, 177, 178
Solarization, 120, 130, *131*
Southworth, Albert S., *11,* 13, 14-17
Southworth and Hawes, 13, 14-17; photographs by, *14-17*
Steichen, Edward, *119,* 120, 122-125; photographs by, *122-125;* quoted, 124, 186
Stelzner, Carl Ferdinand, *11,* 18; photographs by, *18-19*
Stereoscopic pictures, 35
Stevenson, Adlai, 192
Stieglitz, Alfred, *95,* 96, 108-111, 120, 126, 184, 188, *195;* photographs by, *108-111;* quoted, 108, 110, 120
Still-life photography: 1840-1860, 13, *38;* 1920-1940, 120, *128;* 1940-1960, *197, 199;* 1960-1980, 207, 210, *211*
Stowe, Harriet Beecher, 14
Strand, Paul, *119,* 120, 126-129; photographs by, *126-129*
Street Life in London (Thomson), 88
Sudek, Josef, *119,* 144-145; photographs by, *144-145*
Surrealism, 120-121, *130-133,* 164-165, 166, *167, 192, 216-217*
Szarkowski, John, quoted, 206, 226

T

Talbot, William Henry Fox, *11,* 12-13, 20-21, 24; and calotype, 13, 20; photographs by, *20-21*
Thomson, John, 76, 79, 88-89; photographs by, *88-89;* quoted, 88
Thornton, Gene, quoted, 225
Toulouse-Lautrec, Henri, 96
Tournachon, Gaspard Félix. *See* Nadar
Town and Country (magazine), Photo-Secession Gallery ("291"), 96, 121

U

Uelsmann, Jerry N., *205,* 207, 216-217; photographs by, *216-217;* quoted, 216
Utrillo, Maurice, 134

V

Vance, Robert, 82
Venice, *46*
Victor Emmanuel II, King of Italy, 46
Victoria, Queen of England, 30
Vietnam War, 221, *237*
View camera, 8 x 10 Deardorff, 240
Vogue (magazine), 121, 197
Vortoscope, 105
Vreeland, Diana, quoted, 197
Vroman, Adam Clark, *77,* 78, 84-85; photographs by, *84-85;* quoted, 84

W

War photography, 4; 1840-1860, 38, *40;* 1860-1880, 44, 50, *51, 54-58;* 1940-1960, 176; 1960-1980, 236-237
Watkins, Carleton Eugene, *77,* 78, 82; photographs by, *82-83*
Webster, Daniel, *15*
Western United States, 19th Century photography of, 78-79, *80-85*
Weston, Edward, *119,* 120, 121, 146-149, 165, 182; photographs by, *146-149;* quoted, 120, 121, 146
Wet-plate process. *See* Collodion plates
White, Clarence H., *95,* 96, 106-107; photographs by, *106-107*
White, Minor, *163,* 165, 184-185, 207; photographs by, *184-185;* quoted, 165, 184, 185
Whitman, Walt, *53,* 146
Winogrand, Garry, *205,* 207, 226-229; photographs by, *226-229;* quoted, 229
Wirz, Henry, 54, 55
World is Beautiful, The (Renger-Patzsch), 152
World War I, 120, 122, 132, 134
World War II, 122, 143, 164, 170, 174, 176

Y

Yosemite, 82, *147,* 182